River Queen

River Queen

THE AMAZING STORY OF TUGBOAT TITAN LUCILLE JOHNSTONE

~~~~

### Paul E. Levy

HARBOUR PUBLISHING

Copyright © 2006 by Paul Levy

All rights reserved. No part of this publication may be reproduced, stored in a retrieval system or transmitted, in any form or by any means, without prior permission of the publisher or, in the case of photocopying or other reprographic copying, a licence from Access Copyright, the Canadian Copyright Licensing Agency, www.accesscopyright.ca, 1-800- 893-5777, info@accesscopyright.ca.

**Harbour Publishing Co. Ltd.**
P.O. Box 219
Madeira Park, BC V0N 2H0
www.harbourpublishing.com

Cover photo by David Clark, Pacific Press.
All photos courtesy of the family of Lucille Johnstone, unless otherwise noted.
Printed and bound in Canada.

Harbour Publishing acknowledges financial support from the Government of Canada through the Book Publishing Industry Development Program and the Canada Council for the Arts, and from the Province of British Columbia through the BC Arts Council and the Book Publishing Tax Credit.

**Library and Archives Canada Cataloguing in Publication**

Levy, Paul, 1937–
    River queen : the amazing story of tugboat titan Lucille Johnstone / Paul Levy.

Includes bibliographical references and index.
ISBN 1-55017-369-3

  1. Johnstone, Lucille, 1924-2004. 2. Rivtow Group of Companies—Presidents—Biography. 3. Businesswomen—British Columbia—Biography. 4. Accountants—British Columbia—Biography. 5. Volunteers—British Columbia—Biography. 6. Langley (B.C.)—Biography. 7. Vancouver (B.C.)—Biography. 8. British Columbia—Biography. I. Title.

FC3830.1.J64L49 2006      971.1'04092      C2006-903471-0

*To my wife Angela and our children, and especially to my grandchildren—Aston, Daniel, Joel, Gabrielle, Benjamin, Sofia, Raquel, Paul and Jonathan—in the hope that one day they will seek to emulate the qualities of the wonderful person who is the subject of this story.*

# Contents

| | Lucille Johnstone: 1924–2004 | 9 |
| | Preface | 11 |
| ONE | Early Life | 15 |
| TWO | Getting a Job | 30 |
| THREE | The Beginning of a Career | 37 |
| FOUR | River Towing | 45 |
| FIVE | Building the Company | 55 |
| SIX | Expanding the Fleet | 72 |
| SEVEN | Financial Savvy | 92 |
| EIGHT | Rivtow Straits | 102 |
| NINE | Diversifying: RivQuip | 109 |
| TEN | The Family | 122 |
| ELEVEN | The Marriage Breaks Down | 133 |
| TWELVE | BC Place and Expo '86 | 143 |
| THIRTEEN | Moving to the Top | 166 |
| FOURTEEN | Bad Things Happen to Good People | 177 |
| FIFTEEN | Vancouver International Airport | 182 |
| SIXTEEN | The Parting of the Ways | 196 |
| SEVENTEEN | Life After Rivtow | 206 |
| EIGHTEEN | The Ferries | 211 |
| NINETEEN | Columbia Chrome | 218 |
| TWENTY | Rescuing Friends | 223 |
| TWENTY-ONE | Rescuing Charities | 231 |
| TWENTY-TWO | St. John Ambulance | 238 |
| TWENTY-THREE | Fraser River Discovery Centre | 258 |
| TWENTY-FOUR | Final Days | 264 |
| | Epilogue | 266 |
| | Index | 269 |

## *Lucille Johnstone: 1924–2004*

Towboating is not for softies. Yet for forty-five years the guiding hand behind British Columbia's premier towing company was a soft-spoken, motherly woman who commanded the respect of everyone in the industry. Her name was Lucille Johnstone, though she was known affectionately by those who worked for her and with her as "Mother Mac," "The Godmother" or "Tugboat Annie."

Entering the towboating industry in the 1940s as a "girl Friday" for Cecil Cosulich and his River Towing Company—a three-boat, Fraser River-based log-hauling operation—Lucille soon became indispensable as tug dispatcher, payroll clerk, accountant and general office manager. By the 1960s she was steering the company through the mergers and acquisitions that culminated in River Towing's partnership with Straits Towing and the creation of Rivtow Straits. In the mid-1970s she handled the company's diversification into industrial equipment with the acquisition of Purves Ritchie, Western Tractor and Dietrich-Collins and the formation of RivQuip. It was this diversification that allowed the company to successfully weather the recession of the early 1980s that devastated the forest industry. In the later years of that decade she

served the company as chief operating officer and finally as president of the combined companies, which by then had sales of $250 million and 1,500 employees.

If her Rivtow role had been the sum total of her contribution to British Columbia, Lucille would still have warranted a book. But she had an incredible passion for this province and became a leader in dozens of other endeavours here, both during and subsequent to her towboating years. She served as chair and CEO of Integrated Ferry Constructors (where the largest ship ever to be built in BC was constructed). She was one of the founding directors of the Vancouver International Airport Authority and served on the boards of Vancouver's Grace Hospital, Expo '86, BC Place, the BC Forest Foundation, the Fraser River Discovery Centre, the Vancouver Maritime Museum and the BC Aboriginal Business Foundation as well as many of this province's major companies. At age seventy-one she became executive director and CEO of the BC division of St. John Ambulance. Over the next eight years she completely revived that very worthwhile organization and put it on a sound footing. This was one of her greatest achievements; the way she went about it should be required reading for anyone running a non-profit organization.

This is Lucille Johnstone's story.

# *Preface*

I first met Lucille Johnstone in the mid-'90s when I served on the board of the Fraser River Discovery Centre in New Westminster. It didn't take me long to realize what an extraordinary person she was. She seemed to have a solution for every problem, or knew the person who did, and would volunteer to do most of the tasks that needed to be done. In 1997 she took on the chairmanship despite the fact she was seventy-three years of age and already busy as the CEO of St. John Ambulance along with many other interests and activities. It was a new experience for me to attend meetings beginning, in the winter, before sunrise. During those years I came to admire Lucille's utter authenticity and to appreciate that her outstanding reputation was well-earned and completely justified.

In the novel *Life of Pi* by Yann Martel, the main character refers to a teacher who "came into my dark head and lit a match." Lucille was rather like that teacher for me—and I suspect, for many others who worked with her. In my case the light that came on was an understanding of how much one can accomplish with the will to make something happen, and the perseverance to stick to it doggedly.

It seemed to me that Lucille's story was one that should be told. On

the wall of the New Westminster Public Library there is an exhortation from Benjamin Franklin to do something worth writing about or write something about someone who has. I could at least do the latter, so in May 2003 I asked Lucille if she would allow me to write her biography. She suggested that we meet at a restaurant at 7 a.m. for breakfast to talk about it. When I arrived at the appointed time Lucille had papers all over the table. She was working on some project with her ever-present scribbler open at hand. She was very receptive to the book idea and agreed that I should do it with her full help. In May 2004 when I had reduced my workload and participation in my law firm, I began weekly interviews with Lucille with the aid of a tape recorder. The interviews usually began at about three o'clock in the afternoon and went for two or three hours by which time I was usually exhausted from the flood of information and ready to quit. Lucille on the other hand always seemed ready to press on. Eventually she would announce that she had to go home to "cook dinner for Charlie" (her son) or attend some other engagement. I once asked her why she, in her eightieth year, had to cook dinner for Charlie and she replied, "Well I have to eat, too, you know."

Lucille had touched countless people over the course of her extremely active and busy existence. Many people knew of some aspects of her life but it is doubtful that many knew the full range of her activities. She told me on one occasion, "You now know more facts about me than anyone else." The remark surprised me but the range of her activities and involvements was so great that I realized she was probably right.

After the first few weeks of interviewing her I began to notice that she was losing weight and complaining of a lack of energy. Indeed, she was extremely ill and by the late summer she was not able to carry on, gradually weakening until her death shortly after her eightieth birthday.

I regard myself as extremely fortunate to have had the opportunity to get to know Lucille and her remarkable life story and to be able to tell it in this book—with a great deal of it in her own words. I am also glad to know that she was very enthusiastic about this project and happy that it was being undertaken. I will be ever grateful to her for giving me the

## PREFACE

opportunity to tell the story and to her family members, particularly her sister Betty Martel, for their encouragement and support. I wish also to thank most sincerely a number of people who read early drafts and made very useful suggestions and improvements. I think particularly of Kim Floeck and Glenn Gates, Jack Edwards and Roberta Kawasaki, Jaimie McEvoy, Neil Brett-Davies and Dereck Sale, and my lovely wife Angela. I thank also the many interesting people who granted me interviews whose names and involvement will be clear to those who read the text.

I would also wish to express my appreciation to Paul Cosulich whose openness and candour on the matter of Lucille's departure from Rivtow adds interest and poignancy to the account of that event.

A word of thanks also should go to my friends and former partners in the law firm of McQuarrie Hunter, whose attitude and appreciation that there are other things in life than billable hours allowed me the freedom to begin my research and to interview Lucille before it was too late.

Finally, I must thank my long-time assistant Charan Bhachu who transcribed tapes and went through many revisions, largely in her own or spare time due perhaps to the fact that she became so fascinated with Lucille's life that she couldn't wait for the next tape to arrive. A very special debt of gratitude is due to a professional editor, Betty Keller, who did a great deal to improve the presentation and, hopefully, make this an enjoyable read.

—Paul E. Levy
New Westminster, BC
September 2006
*AMDG*

ONE

# *Early Life*

When Lucille Johnstone accepted the first YWCA Women of Distinction award given in the Management and Professions category in 1984, she told her audience that she credited her success to being a self-starter and being willing to work hard. "I simply went ahead and did the job. I guess I didn't really stop to think a woman shouldn't be doing it." At the time she was serving as chief financial officer for Rivtow and RivQuip; it would be another year and a half before she was named the combined companies' chief operating officer and president. She was already the president of the Canadian Association of Equipment Distributors and serving on the boards of Expo '86, the BC Place Corporation, the BC Resources Investment Corporation, the BC Forest Foundation, Northland Bank and Hiram Walker Resources; she had yet to take on the chairmanships of St. John Ambulance and Integrated Ferry Constructors or become involved with the Fraser River Discovery Centre, the Vancouver Maritime Museum and the BC Trade and Development Corporation. But that day, as she accepted her award, she said she did not think she would ever quit working. In fact, she could hardly remember a time when she had not worked. It was in her genes.

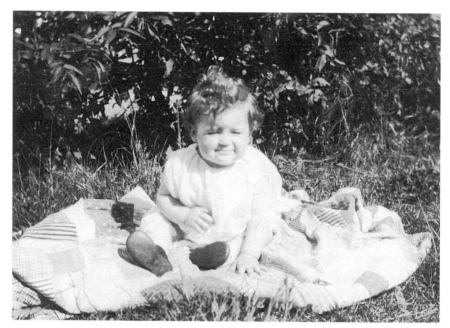

Lucille Muriel Bonar came into the world on November 11, 1924, born to Thomas and Myrtle Bonar. Lucille was the middle child in between her older brother Leslie and little sister Betty. At six months old, she won a prize for being the plumpest baby. Her tendency toward plumpness never left her, nor did her propensity for awards and recognition!

~~~~~

Lucille Muriel Johnstone (née Bonar) came from solid Scottish stock. Alfred Bonar, her paternal grandfather, ran away from his Edinburgh home when he was just twelve years old and sailed for America as a mast boy. His subsequent wanderings took him to Moose Jaw where he married Harriet Tapley and together they acquired a crown land grant and began farming. This farm was so isolated in winter and distant from schools, however, that their sons Thomas (born 1896) and James (born 1898) were forced to give up on education after grade three.

By his mid-teens Thomas had left the farm and moved to Moose Jaw where he took a job in a candy-making store. In 1916, when he was nineteen years old, he met sixteen-year-old Ella Myrtle Ball—known to friends and family as Myrtle. She had been raised in Ontario where her father William Ball had begun working in the potato fields from the age

of five to support his widowed mother and his sister. He never went to school and was unable to read or write, but he grew to more than six feet tall, was immensely strong and hard-working, and never lacked employment. Myrtle's mother Georgena was also very tough, but had fallen and broken both her shoulder blades at the age of six; with no medical help available, she had grown up a hunchback no more than five feet tall. She had acquired some education, however, and it was she who wrote her husband's letters and read to him every evening.

Lucille, recalling these grandparents, added:

> I shouldn't say "every evening" because on Saturday nights, I am told, he would hitch up the Clydesdale horses to their wagon and go off to town for the community hall dance. Georgena stayed home with the children. My mother recalled vividly that the horses would come home through the blizzards in the wee hours of the morning with William inebriated. Georgena would go to the barn, unhitch the horses and bed them down for the night. Such was the grit and courage of this tiny hunchbacked woman.

William and Georgena Ball had four children: three girls, Ella Myrtle, Dorothy and Bessie, and one boy, Leslie, who died at sixteen after a smallpox vaccination. Later the family moved to Saskatchewan and farmed crown-granted land near Moose Jaw while Myrtle went to work in the Five Roses Flour Mill in the city.

~~~~~

Lucille's parents, Thomas Bonar and Myrtle Ball—both raised to be hard-working and self-motivated—married on July 9, 1917, and the following spring moved to Vancouver. Thomas was hired by R.C. Purdy Company to make chocolates, candies and ice cream at its store on the corner of Georgia and Granville streets. Myrtle found a job in a local laundry. Then in April 1918 all their plans for the future were upset when the Canadian government began drafting men into the army as replacements for the high number of casualties on the European war

front. Thomas was caught up in the draft and quickly found himself on a troopship heading overseas, while Myrtle returned to Moose Jaw and the Five Roses Mill to await his return. With the war finally over, Thomas came home in early 1919 and he and Myrtle went back to Vancouver. This time he got a job with Winnifred's Chocolates on Robson Street, a company that not only retailed chocolates but also supplied them to all the Empress ships sailing from Vancouver for Asia.

The young couple purchased a lot near 43rd Avenue and Main Street, and Thomas set to work building a home. Like his father Alfred, who had been an excellent carpenter, and all the Bonar ancestors before him who had been piano makers in France and Scotland, Thomas had natural ability when it came to construction. He built his entire house himself, including the foundation, brickwork, framing, plumbing and electrical work.

Thomas and Myrtle began their family with the birth of a son, Leslie, in 1921. Lucille Muriel Bonar came into the world on Armistice Day, November 11, 1924. Lucille was a bonnie child. In fact, at six months she was awarded first prize at a fair for being the plumpest baby. Her tendency towards plumpness never left her during her long life, nor did her propensity to win recognition and awards. One more child, Betty, would be born in 1931.

Lucille's early childhood memories included going down to the dock with her father to deliver chocolates to departing Empress ships—grand occasions with bands playing and streamers and confetti floating through the air. She remembered when Thomas began working on Sundays to augment the family income selling ice cream, pop and confections in the Stanley Park concessions, and Myrtle would take Les and Lucille to the park zoo or down to the beach to swim.

Winnifred's Chocolates was destined to become one of the first casualties of the Great Depression when fancy goods such as candy suddenly became unaffordable luxuries. Overnight Thomas was out of a job, though the company offered him compensation for unpaid wages by giving him all its copper candy kettles, marble slabs, hand-dipping equipment and recipes. Lucille would later recall:

# EARLY LIFE

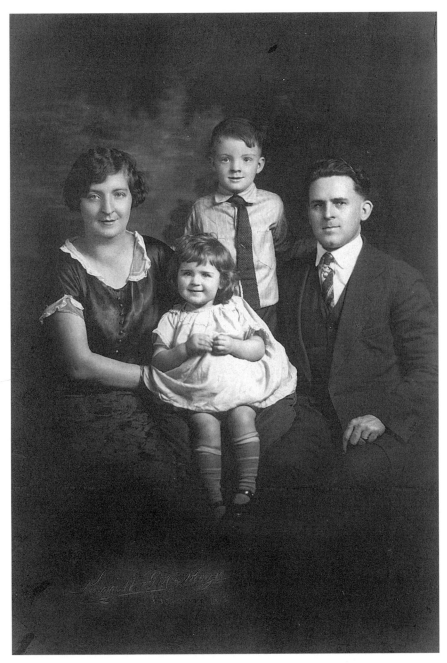

Lucille at age three and a half with her family in Vancouver, 1928—Myrtle, Leslie and Thomas Bonar. Betty, Lucille's little sister, would not be born until 1931. Lucille remembered her parents fondly and remarked how they instilled in her a "where there's a will, there's a way" attitude.

August 8, 1931 (left to right): Thomas, Lucille and Leslie Bonar stand with the family's 1928 Chevrolet. In the 1930s the family car would be stored on blocks in the garage because fuel was simply not affordable, including fuel for the furnace. Lucille learned early how to cut costs and make a little bit go a long way.

Dad set up the candy kitchen in the dining room of our house and, with Mother's help as chocolate dipper, produced wonderful chocolates and hard candies, which in those days were made with fresh eggs, fresh butter, fresh cream and high quality chocolate. The market for these was very limited except at Christmas, Valentine's Day and Easter, so most of the time my parents concentrated on making hard candies, mint patties and peanut brittle made with fresh butter. My mother would walk door to door during the day selling small bags of candies for five or ten cents. After school I would ride my scooter to find her if she was not home yet. To help us survive, Dad would work on the weekends at the Stanley Park concession stand.

My parents managed to keep food on the table but only through the efforts and hard work of both of them. Potatoes were a dollar a hundred-pound sack and carrots were a dollar for fifty pounds. Mother canned cherries from the tree in our yard and apples off our trees were wrapped carefully in pages of Eaton's catalogues and stored in the basement. One luxury we did have was Mother's dandelion wine. We would pick the dandelions for her and she would make the wine, bottle it and store it in the basement. When Mother and Dad went out, my elder brother Les was left to babysit me, and we had great fun going down to the basement, pulling the corks and taking a little out of each bottle to "treat ourselves." After a few such trips I recall Mother saying that she couldn't understand how her wine would evaporate when she had corked the bottles so carefully. She never did learn our secret.

The family automobile, a 1928 Chevrolet, was stored on blocks in the garage since gas was simply not affordable. Although they were sometimes able to buy coal or fir slabs for the furnace, most of the time the Bonars burned wood or stumps they cut in the nearby CPR forest—the area which is today known as Oakridge. Even this fuel was often in short supply, however, and they found they could make better use of it in the

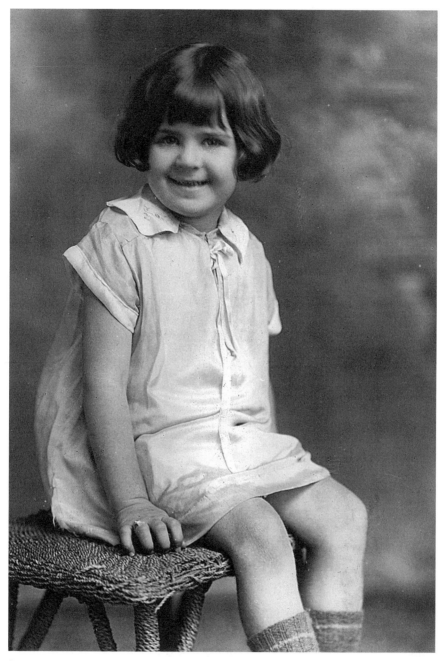

"I was no angel as a little girl." Lucille remembered making mud pies for the family in her mother's Limoges antique ceramics.

kitchen stove or the living room fireplace than in the furnace. For most of those difficult years in the 1930s they were able to pay the electricity bill, keeping it low by lighting only a single room each evening, but at one stage BC Electric cut them off because they didn't have the necessary fifty cents. Lucille remembered:

> Mother didn't want the neighbours to know of our plight, so we had to make sure our homework was done before dusk and we simply sat in the living room by the light of the fire until bedtime. Even when we did have lights, we all sat in the living room to keep warm by the fire on winter evenings and had the radio for entertainment. For a bedtime snack Mother had an old deep pot, very blackened on the outside from the fireplace, in which she would cook milk, sugar and cubes of homemade bread. How good it tasted before we scurried from the living room to bed carrying a warm brick from the edge of the fireplace wrapped in a blanket to keep our feet warm in our beds!
>
> Our clothes were purchased at the Central City Mission behind Woodward's where a good pair of second-hand shoes would cost ten cents, a winter coat about twenty-five cents. These were not new but they did keep us warm.

Myrtle also bought old woollen coats and other garments from the Central City Mission to make into hooked rugs—at least two every winter—and the children would sit around in the evenings cutting the garments into strips a half-inch wide by as long as they could make them. Thomas had made Myrtle a wooden frame on which she stretched burlap sacks and then drew a design—an Indian head or dogwood flowers or the Three Bears. As the children cut, she would sit hour after hour hooking the strips of cloth into the burlap backing. Though the children's hands were sometimes blistered from all the cutting, these were enjoyable times for the whole family. As Lucille pointed out:

Although we were poor, I want to emphasize that we were not unhappy. My mother sang and whistled through every day, and we had friends—adults and children—in for evenings of card games, singing and dancing. Our closest neighbours were Herbert and Lorna Conner and their two sons. They later had a daughter whom they named Lucille (she is now Dr. Lucille Giles). They had no luxuries—their kitchen chairs were apple boxes with two-by-sixes nailed to them for backrests, but Lorna and my mother were great friends and spent many afternoons singing to the accompaniment of Mother's mandolin or Lorna's coronet.

Other neighbours were not so lucky, and Lucille remembered the evictions that took place when some of them couldn't pay the rent or mortgage. The sheriff and his crew would haul all of their belongings out of the house and leave them on the boulevard. As soon as he left, the other neighbours would quickly help them move their possessions back in.

My sister Betty Mae was born in 1931. She was thin and needed special care but she had beautiful blonde hair that curled into ringlets like Shirley Temple's. My brother Les was healthy but also slim and fair. I was the middle one, round as a barrel from day one!

I was no angel as a little girl. When I was two or three, the city was installing sewers along our streets and there were deep water-filled ditches by the road. One day Mother couldn't find me and beseeched the neighbours to walk the ditches. She finally returned to the house to notify the police but as she did so she heard singing coming from the bathroom where I sat comfortably on the toilet. She forever told the story about how she was torn between being happy to have found me alive or flushing me down the toilet! I was also the one who took my mother's prized antique Limoges vegetable dish with its stand of four gold claws outside to make mud pies.

The Conners were evangelists and attended a church at 49th Avenue and Main Street, and Mrs. Conner took me to Sunday school where I learned about Christianity. She once had the courage to ask me to sing a solo at the Christmas concert. I sang "Jesus Wants Me for a Sunbeam" with great gusto and the audience politely applauded, but for some reason I was never asked to sing a solo again! After that, my mother arranged for weekly one-hour piano lessons for me at twenty-five cents a session, and she made me practise every day. When my best friend Peggy put her face in the window where I was practising and teased me unbearably about having to practise, I became angry and gave her a black eye. Apologies were made, but Peggy and her mother didn't forgive me for quite some time.

In 1932, Thomas and Myrtle Bonar landed the job of operating the Kitsilano Beach pavilion and concession stands. There was no salary, just a 5-percent commission on sales, and though this was a very meagre income, it would prove to be enough for the family's survival. There was a catch, however: it was a sixteen-hour-a-day job and they would have to live in the back room of the pavilion from mid-spring until mid-September. So, instead of taking the children to live there with them, Myrtle hired a young woman to look after them at home in exchange for her room and board and a seven-dollar-per-month sal-

> Lucille certainly inherited her father's dogged determination and sense of duty. In the last months of her life she often told her son John to repeat these words to himself when times got tough: "I can, I must, I will." Lucille's sister Betty confirmed that Lucille often woke up feeling as though she couldn't face the day, but she would sit on the edge of her bed and say "I can, I must, I will" and get on with it.

ary. But circumstances improved for the family in 1936, Vancouver's Golden Jubilee year (fiftieth birthday), when the city built a new and expanded main pavilion at Kitsilano Beach with an apartment upstairs. This time the whole family moved to the beach, and the house that Thomas had built was sold for $2,800. It still stands today, though converted into a triplex, and is probably worth two hundred times that amount.

When they moved to Kitsilano, Lucille was just twelve years old but already preparing to enter high school. She had started school when she was just five, her mother having convinced the school board that her precocious daughter was ready. She was the youngest in the class and then, by skipping two grades, she completed eight years of elementary schooling in six. But because there had been little schooling in either her mother's or father's families, none of the grandparents saw any need for further education for Lucille. Myrtle's parents even sent word from their Saskatchewan farm that there was no point in allowing Lucille to go to high school because she would just get married and have babies. Happily Lucille's parents did not accept this advice, and Lucille was sent off to the Seaview High School of Commerce at 4th Avenue and Yew Street for three years. She took her Grade 12 at the Fairview High School of Commerce at Broadway and Granville.

Lucille would later say that she was "hooked early by accountancy and I guess that changed my life." But she also explained that her initial choice of commerce was her brother's fault:

> My brother was older than I was and very smart in school so he never did homework except for French. I thought that if French is that difficult for Les, I am not going to take it, so I switched to the commercial course and that's why I am not bilingual today. It wasn't until Les's eightieth birthday that I discovered the real reason he did French homework: he was in love with the French teacher and wanted to impress her.
>
> As far as my relationship with my fellow students was concerned, I was so much younger than the rest of them and was

regarded as a bit of a nerd—although they didn't use that expression in those days. During study period it was my understanding that we were supposed to study but nobody else seemed to have this understanding. I wasn't in the social swing of partying and all that stuff.

Although Lucille had always been required to help with chores at home, her first real job was helping her parents in the new Kits Pavilion. After school and on weekends during the beach season she peeled potatoes, cooked fish and chips, served in the tea room and sold milkshakes and ice cream at the fountain counter. The pavilion operated seven days a week from 7 a.m. to 11 p.m., just like the original 7-Eleven stores. Lucille was paid the minimum wage of $7.50 per week which, considering that she worked about one hundred hours a week, worked out to approximately seven cents an hour. Out of this she was expected to buy all her school texts and clothes.

Lucille did well at school but her parents felt that if she didn't get all As she wasn't working hard enough. However, she made the honour roll for all four of her high school years and received her purple-and-white-felt honour roll shield with a white star for each year. There were no fancy graduation parties or banquets for Fairview High students in those days, but at the little ceremony held at the Stanley Theatre, Lucille proudly went up on stage to get her final white star. Thus, in 1940 at age sixteen she had completed her formal schooling and was ready to enter the adult working world. In reality, Lucille never did stop schooling. Throughout her long career whenever she came across something new she made the effort to understand it and was always confident that she could master it. This characteristic was a major factor in her successes in life.

Lucille's determination and perseverance came from the examples and teaching of both her parents. According to Betty Martel, Lucille's younger sister, their mother was a very warm person who encouraged her children to enjoy nature and to respect their fellow man. She also taught them to be good listeners; no one ever went to Myrtle's home

without being invited to sit down for a cup of tea and a chat and they always left feeling happier. Both parents encouraged the children to be honest and trustworthy and to try new things. They insisted that when taking on a task they had to do it to the best of their ability, and that when they failed they had to always try again. But Thomas Bonar was the stable influence in their lives. "Father," said Betty Martel, "always told us that if an opportunity comes up, make good use of it, and if you have a job, you never quit until you're sure you have something else to go to. I never ever remember him missing a day's work. Never."

In 1941 with World War II into its second year, Thomas Bonar realized he could make much more money working as a welder in the shipyards of North Vancouver, and he left the pavilion job. But welding was hard on his eyes, and many nights he would need cold compresses and ice packs to reduce the swelling around them. Myrtle would tell him not to go to work the next morning, but he got out of bed and left every morning anyway. "I have a job to do," he would say.

※

About this time the family moved to a one-acre property with a house and barn on Willingdon Avenue near Lougheed Highway in Burnaby. Total purchase price: $1,500. When the war ended and the shipyard laid off its crews, Thomas returned to the candy business, this time working for Pauline Johnson Chocolates until he retired. He and Myrtle lived on in the Willingdon house until 1967, finally selling it for $37,000.

Lucille remembers that her mother was daunted by very little on that one-acre farm:

> She raised her own ducks and chickens, installing coal-oil-fired incubators to hatch them, then selling the mature birds to Chinese restaurants. One evening I came home to find her out in the barn operating on young roosters. She had written to the *Farm Journal* to get the tools and instructions on how to change roosters into capons. She was very successful at it and we enjoyed roast capon for many Sunday dinners. Another day her favourite

male duck tried to swallow a garter snake whole, but the snake got stuck in the greedy thing's throat. Seeing the peril, Mother seized the duck and took it off to the barn where she performed an operation to remove the snake in one piece, then fastened the incision closed. That drake survived for many years afterwards.

In retrospect I think my parents' "where there's a will there's a way" attitude had a great influence on how I face adversities or challenges. As well, I was never allowed to be lazy. I was taught how to work but not how to play. Playing is difficult for me as I see nothing tangible accomplished through playing, whereas work is satisfying and challenging for me.

TWO

## *Getting a Job*

Fairview High School of Commerce graduates had a distinct advantage when applying for jobs in Vancouver. Joyce Sykes, a fellow Fairview grad, writing to Lucille forty-four years after graduation, recalled their commerce teacher, Sheila Mackenzie, and her dedicated quest to turn out stenographers and secretaries:

> In those days $65 a month was the standard and there were one hundred girls applying for every job . . . Do you remember Miss Mackenzie praising grads who had made their mark in "executive secretary" posts with key companies and had hit the brass ring with $100 per month? We all set our sights on such a high level, realizing it might take many years climbing the ladder for such success . . . Miss Mackenzie was enthusiastic about "practical and actual work" on all of the machines and printers and even sought outside community service projects for students to practise their skills, typing envelopes for the Red Cross or the Red Feather agencies, envelopes and circulars that would actually be mailed . . . rather than boring textbook exercises.

# GETTING A JOB

When I think back, we had a lot of respect for the boys at Commerce. They were in such a minority. I remember that of the twelve boys in my class three were Japanese and hauled away out of Grade 12 to the war camps for security. We were so sorry for them, they were indeed part of our group and good students and we were sure had no intent to spy against Canada. The rest of the boys on graduation immediately joined the services . . . so getting a job in Vancouver became a little easier. Many young men employed in various clerical jobs left them for military service and were replaced by girls. Many of the office girls left poor-paying office posts to become "Rosie the Riveter" at the shipyards or at factories getting double the pay and lots of overtime. The war opened up some new trades to women but I never wanted to be anything but a secretary. I still think it's a classy profession that requires every bit of brains and skill you can muster on a day-to-day basis.

By 1940, even with her Fairview education and her honour roll standing, Lucille had difficulty getting a position. Her appearance was against her: she was five feet tall and 195 pounds. At the Sally Shops, owned by Harry Crossman (his father, I.L. Crossman, owned Crossman's Famous Coats & Suits on Hastings Street), the office manager refused to hire Lucille because "as she told me, I chewed my fingernails, was overweight and did not dress well."

But Harry Crossman made it a practice to find new employees by phoning the commercial high schools for names of graduating honour roll students, and he insisted on interviewing Lucille himself. He hired her despite his manager's report.

Lucille became a receptionist, counted the price tags on the garments and did a manual in-and-out stock inventory. She also worked for all the company buyers, lugging a little wooden stool with a Woodward's ninety-five-cents sticker under the seat from one buyer's desk to the next to take dictation. She was so determined to keep this magnificent job that she worked eight hours a day on weekdays and until one o'clock

every Saturday afternoon for the sum of forty-eight dollars a month. Harry Crossman was very impressed with her work, though the office manager was not delighted to have her aboard.

The Sally Shops office was on the third floor of 305 Water Street, a brick building that still stands near the corner where Gastown's steam clock is now located. Across the street was the Cambie Street Rooms, and when Lucille arrived for work in the morning the rooming house residents were already sitting on the curb in front of the building drinking cheap wine. But it wasn't a threatening atmosphere. Lucille recalled:

> I could walk from that building at any time of the day or evening without any concern. My walk took me along Powell Street and over to the BC Electric Railway station at Carrall and Hastings where the Burnaby Interurban ran every half-hour and then, later in the evening, every hour to North Burnaby where we lived. If I was late leaving work, I could have supper in the station coffee shop where I could get a good meat pie, potatoes and vegetables for twenty-five cents. This was typical pricing in the early 1940s.

In those days the ladies' ready-to-wear manufacturers were all in eastern Canada. Less than a year after Lucille was hired, Harry Crossman decided to move the Sally Shops head office to Montreal. It was while he was away making arrangements for office and warehouse space back east that the other staff convinced Lucille to lose weight and encouraged her to diet.

> Once a week I was marched down to the shipping scales to get weighed in, and to make a long story short—or perhaps I should say a fat story thin—I lost fifty-five pounds. When Mr. Crossman came back from Montreal, he was absolutely amazed at the new me, and he decided to move one of the buyers, Edith, and me to Montreal to open the office there and run it. So at the age of seventeen I was taken by my mother to the CPR station

and put on a train for Montreal. She gave me a little pillow with "Home is where your heart is" or something of that nature embroidered on it and a Bible because I think she felt I was going to the big city of sin. Of course, I had never been east of Chilliwack and this was a whole new experience for me. So there I was heading for Montreal and, because my brother had been in love with his French teacher, I had no French! In Montreal Edith and I got a small apartment together within walking distance of the office. It was July or August and I remember the heat and the humidity was oppressive and the office was not air-conditioned.

Lucille ran the new office and was in charge of inventory, packing and shipping to all sixteen Sally Shop stores nationwide. When the work piled up, she hired a part-time helper, but with her capacity for hard work and enjoyment of a challenge, she was very happy. She decided to stay in Montreal. But Edith, the buyer with whom she shared both office and apartment, became involved in an affair with a married man; when word of this reached Harry Crossman, who was now living with his family in Montreal, he was outraged. In those days an employee's private life was not considered private as far as the boss was concerned, and Crossman shipped Edith back to Vancouver in disgrace.

Crossman then had to decide what to do with his seventeen-year-old office manager/accountant/shipper. Certainly she could not be allowed to live by herself in an apartment in wicked Montreal. He insisted that Lucille come to live with them until he found her a suitable place to live.

This turned out to be room and board with a very proper woman whose house was within walking distance of the Sally Shops office. But even then, Crossman was worried about his young employee. He decided she should return to her family in Vancouver as soon as she had trained someone else to take on her responsibilities.

So on December 10, 1941, I boarded the CPR train at Windsor Station to come back home to British Columbia. In retrospect,

> I think that crossing Canada by train is something every Canadian should do at least once. You have no idea of the breadth of this country until you've crossed the Prairies hour after hour after hour with never a hill in sight. Somebody like me coming from Vancouver finds that very odd. When I arrived back at the station in Vancouver, the first thing I realized was that I had missed the North Shore mountains most.

Back in Vancouver Lucille returned to the Sally Shops office where she resumed manually tracking sales and compiling store inventory reports.

~~~~~

Less than a year after she returned to Vancouver, Lucille Bonar married. She was eighteen years old. The groom, twenty-one-year-old Ken MacDonald, was in the Canadian Air Force and stationed at Tofino on Vancouver Island. Although in later years Lucille would never discuss the marriage, her friend and co-worker Cliff Julseth described Ken MacDonald as "a peaceful type of fellow who, after the war, worked for a wholesale drug company." Lucille's friend Mike Dunn described him as "hell of a nice guy. Very quiet, you know." Both men later agreed that Ken had wanted a family and a quiet home life but that Lucille was "more career-oriented." Julseth could see "it wasn't going to work for very long."

Meanwhile, over the next three years the pressure on Lucille steadily increased at the Sally Shops' Vancouver office, where she spent all her days "adding sales slips and deducting credit notes and so on" using "a comptometer with a keyboard that had ten digits vertically and ten digits horizontally." Finally the pressure became too much.

> In those days we didn't know there was such a thing as stress, but I guess I was really suffering from it. I began losing sleep at night and had nightmares of adding and subtracting figures and never ever getting to an end total. Finally I wakened during

> one of these dreams and found I could barely breathe. I had intense pain in my chest and couldn't speak. I nudged my husband awake and he ran to get help from the landlady. Doctors were hard to get, but she remembered that a doctor lived across the lane and hastened to get him. My heart was beating at 250 pulses per minute [rather than a normal 72]. I can't remember what he did but my heart gradually slowed down and similarly the pain, and he arranged for me to have an electrocardiograph at St. Paul's Hospital. They found no damage to my heart but it was still at 98 to 100 pulses per minute and I felt very, very tired.

The doctor suggested Lucille should not return to work and that she curtail any strenuous activity. She quit her job and, still needing an income, applied for unemployment insurance, only to discover that she was not eligible for benefits if she was unwilling or unable to work full time.

Lucille was not the kind of person to sit idle, and it hadn't taken her long to realize that if she simply sat down or lay down whenever her heart rate increased, it would soon subside (though it continued to beat at 98 for many years thereafter). She jumped when the unemployment bureau offered her a temporary job at Jeffrey and Jeffrey, a wholesale automotive and aviation equipment company on Homer Street. They had hired a new girl as secretary to the president, but she couldn't come for three weeks and they needed someone to fill in. Lucille was interviewed by the office manager, Miss Kibblewhite.

> I was to take dictation from the president every morning and do phoning or writing or anything else he wanted. So that's what I did and by nine-thirty or ten o'clock I was finished. I went to Miss Kibby and said that I needed something to do because I just couldn't sit there without any work. She asked if I would post the accounts receivable ledger. This was a manual ledger at least seven inches thick. My training was that if you didn't

get a sight balance, you would have to go back and find your mistakes. I wasn't about to go through this seven-inch book for errors, so I posted every entry very carefully, working on a ten-key adder, adding and subtracting credit balances. Jeffrey and Jeffrey sold big things like radiators but also lots of little things like gaskets and belts, so some of the amounts were just fiddly little pennies but there were hundreds and hundreds of entries. When I finished, I took an adding machine tape of all my balances to Miss Kibby to ask for the general ledger control account balance for accounts receivable. She looked at my balance and went to the ledger. She was shocked. "Lucille," she said, "I've been here seven years and we have never had a sight balance." She was delighted, but disappointed she had hired someone else and couldn't keep me.

But Miss Kibblewhite did the next best thing. She sent Lucille to an office on West Hastings near the Terminal City Club to be interviewed by chartered accountant Bob Young, who had just been engaged as controller of a new company, Silver Skagit Logging. Young immediately hired her as a receptionist/typist at the princely wage of ninety-five dollars per month—almost double her wage at the Sally Shops. Lucille thought she had died and gone to heaven.

The year was 1945 and Lucille Bonar MacDonald was only twenty years old. She didn't know that this day would mark the start of her forty-five-year association with the tugboating industry in British Columbia. An ironic post for someone who always got seasick.

THREE

The Beginning of a Career

Silver Skagit Logging had been formed for one specific purpose: to clear the right-of-way and build a road from Hope to the area that was to be inundated when the Ross Dam on the Skagit River was raised to its full height. It was owned by a consortium that included the Morrison Knudsen Corporation—a huge company headquartered in Boise, Idaho, which specialized in engineering, construction and mining management services—and a brand new company called DeLong Engineering. The company's new Canadian logging operation was managed by the principal of the latter company, Colonel Leon B. DeLong, who had just received his discharge from the US Corps of Army Engineers.

Leon B. DeLong was an austere, unapproachable man. He had gained renown shortly after D-Day when the floating causeway at "Omaha Beach" in Normandy had been wrecked during a storm. He was inspired to design a portable pier that could withstand rough seas. The company he created at war's end constructed "DeLong piers," 50-by-250-foot floating platforms that would be used as the basis for the first prototype jack-up oil-rig pier—installed in the Gulf of Mexico in 1950, by the US Air Force in Greenland for offloading

supplies in 1951 and during the war in Vietnam as the basis for loading docks. DeLong also developed the original concept for containerized shipping.

Bullet-headed and sporting a Yul Brynner haircut long before it was fashionable, DeLong wore a perpetual scowl and spoke to his staff only when absolutely necessary. Lucille remembered that "being a colonel he didn't have to speak to the privates, but I determined that as receptionist I would get more than a mumble out of him in the morning. I gave him

In 1917 the City of Seattle had been given approval by the US Department of Agriculture to develop that river's hydroelectric resources for the benefit of the city, and by 1925 Seattle Power and Light was receiving electricity from both the Newhalem and Gorge power plants on the river. At that point Seattle City Council decided that the Skagit should be further harnessed by building a dam in the Gorge and two more dams, the Diablo and the Ruby (later called the Ross), farther up the river. There was only one slight hitch in their plan: the proposed Ruby Dam would flood Canadian as well as American territory because the Skagit River rises in British Columbia's Manning Provincial Park near Allison Pass, flows north and west paralleling the Hope–Princeton Highway, then meanders south through the beautiful Skagit Valley before it crosses the border into the United States. In spite of this problem, Seattle received permission from the US Federal Power Commission (FPC) to proceed with the project, and by 1937 the Gorge and Diablo dams were also generating power. The FPC's permission for construction of the Ruby Dam, however, required that it should be completed in stages, delaying the need to face the problem that would be caused by its final stage: flooding into British Columbia.

In 1940, with the first stage of what was now called the Ross Dam finished and standing at 305 feet, a reservoir was created behind it that reached 1,380 feet above sea level. At this point Seattle applied to the International Joint Commission (IJC) for permission to raise the dam again so that the level of the reservoir would reach 1,725 feet and flood

my best smile and greeting every day, and I finally got him to say good morning. A big success!"

It wasn't long before Lucille's supervisor, Bob Young, realized that Lucille MacDonald was capable of much more than just answering the phone and typing letters. He transferred her to the company's towing division where she became "secretary" to Cecil Cosulich, towing superintendent and owner of a small tugboat company Silver Skagit had bought to complete its operations: River Towing.

British Columbia's portion of the Skagit Valley; the IJC gave permission, subject only to the city making an agreement to compensate British Columbia for the flooding. At the same time that those negotiations were beginning, the dam was being raised another 170 feet. In 1945, in preparation for the next two stages of dam construction that would raise the reservoir's height first to 1,582 feet—which would halt flooding at the Canadian border—and then to 1,725 feet—which would flood eight miles into Canada—the City of Seattle invited bids on the job of removing some 318 million board feet of timber from the lands that would be submerged. These included massive acreage on both sides of the border. The only privately owned land on the Canadian side of the proposed Ross Lake Reservoir was a 640-acre parcel known as the Whitworth Ranch. It had been purchased by Seattle in 1929 to be ready for this eventuality.

The major difficulty to be faced in logging this tract was the rugged topography on the American side of the border that precluded transportation of the logs in that direction. It was therefore decided that the logs should be trucked north to the town of Hope, BC, dumped into the Fraser River and floated down to the coast. The logs from the Canadian side of the border would be sold on the Canadian market; those from the American side would be bonded and towed south by large tugs that would come up from Puget Sound. To log the right-of-way and build the road from Hope to the Ross Reservoir, Morrison Knudsen formed a partnership with DeLong Engineering and created Silver Skagit Logging.

Cecil Cosulich was twenty-eight when he joined Silver Skagit in 1945. His roots in the tugboating industry ran deep.

The Cosulich family, most of them shipbuilders and fishermen, originated in Lussino, a small island off the Dalmatian coast some hundred miles south of the city of Trieste. Romolo Cosulich was just twenty-three years old when he left Dalmatia in 1890 to come to British Columbia where he settled in Canoe Pass near Ladner and became a fisherman. His wife followed a year later with their children, including a son, Romolo Nicholas (Robert or Bob), born in 1889 in Dalmatia.

Like his father, Bob Cosulich became a fisherman, but after he married, his wife persuaded him to take up something less perilous. In 1918 he went to work for the White Rock Tug Company as master of the tug *Blaine*. Within a few years he had become a minor partner in the company, which by then operated the *Altmore*, the *Hustler* and the *James Carruthers*, supplying logs to the Campbell River Lumber Company's sawmill and towing logs from Seattle to sawmills in Vancouver. But when Campbell River Lumber went bankrupt in 1931, so did White Rock Tug, and Bob Cosulich lost everything. During the next few years he was involved with Bill Dolmage on the *Green Cove* and worked some time for Maritime Towing. Then in 1935 he went on his own and built the *Celnor*, named after his two sons, Cecil and Norman, and the two boys often accompanied him on tows. Though not a great businessman, Bob Cosulich was always considered to be an excellent towboater and is reputed to have single-handedly run the *Celnor* for days at a stretch.

In 1938 Captain Bob Cosulich formed a partnership with Harry Burt of Marpole and invested one thousand dollars in the little company's first shallow-draft riverboat, the *Red Fir I*. Designed by George Peebles especially for towing on the Fraser River, it was thirty-five feet long, twelve feet wide and only drew three feet of water. The propeller was located in a recess toward the stern to give the boat greater clearance in shallow water.

Recessed propellers had been used previously on small lake tugs, but what made the *Red Fir I* unusual was the fact that this feature was

used in combination with a powerful high-speed diesel engine, a 165-horsepower General Motors that Cosulich and Burt installed to replace its original Vivian engine. With this amount of power in such a small, shallow-draft boat, it could be run upriver at nine or ten knots and run easily over sandbars and into shallows while at the same time manoeuvring relatively large log booms.

Though the *Red Fir I* was a great success, by 1940 the partnership was in trouble. Burt was drinking more than he was towing. Captain Bob's solution was to bring his elder son, Cecil, who had just left university economics, into the company. Cecil was offered his father's share of the investment in the company if he agreed to take over its management. Somehow, the young man managed to save the company, which he christened River Towing, and he and Burt scrounged enough money to build *Red Fir II*, a small assist boat for the upper reaches of the Fraser. When the volume of their business increased, they built a third tug, *Red Fir III*.

By 1945 River Towing was still in a very precarious financial position. Fortunately, it was at this point that Silver Skagit Logging began looking for tugs for their Ross Reservoir operation and they bought all three of River Towing's boats. Cecil became Silver Skagit's towing superintendent. Wisely, he had an option included in his contract that allowed him to repurchase the boats when Silver Skagit no longer needed them.

Cecil's younger brother Norman was also involved in tugboating and Silver Skagit. While in the army he transferred to Western Air Command's Marine Squadron, and by 1944 he was master of the M535 *Nimpkish*, a sixty-foot vessel that ran supplies, equipment and personnel to radio detachments on Langara Island and Masset on Graham Island. In 1946 Norman Cosulich was mentioned in dispatches for navigating his ship "through Hecate Strait, a particularly treacherous piece of water, and landing supplies and personnel on Langara by work boat as no docking facilities existed." He was noted for his "devotion to duty and

high ability as a seaman." With his military service behind him in 1946, Norman was immediately hired by Silver Skagit to manage the tugboats at the Hope end of the operation, which was known as the "Fast Water Towing Division."

Jimmy Gibson, who worked for Cecil Cosulich for many years, explained, "Cecil was kind of an impatient person. He didn't lose his temper often but when he did, you sure knew he was around." And his friend Mike Dunn added, "We used to call him Mr. Blowtop behind his back. That was the name of a comic character back then and that's what we called Cecil because it fit pretty good."

Lucille MacDonald would get to know Cecil's personality well in what was to be a long working relationship. But for now, as his new secretary at Silver Skagit, she obviously made a good impression. Cecil quickly discovered Lucille already had a complete grasp of the entire operation. He decided to leave all the details—including the dispatching of the tugs—in her hands.

Dispatching tugboats is not a simple job, and was even less so in those days without help from computers or global positioning satellites. The job took considerable knowledge of the conditions on the river—tides, water levels at different times of the year, weather, river traffic, clearance under the various bridges—as well as of intricate details such as where each tug was at any particular time, which tug should take which boom, who the booms belonged to and where they were to be picked up and tied up. The circumstances were constantly changing.

As Silver Skagit's dispatcher, Lucille was expected to keep on top of all the details. Initially she got help from Harvey and Eve Forrest, who had inherited two small boats. The Forrests were only eighteen and sixteen years old when their father died in 1935. The logging industry was slowly coming out of the Depression years slump, and by 1939 they

As it turned out, logging the Ross Reservoir became highly controversial, both in British Columbia and Washington state, because of the politics involved in the fourth stage of the Ross Dam—what was by then known as the High Ross Dam. Logging was delayed at first because Silver Skagit's road into the proposed reservoir area from the north proved to be more difficult to build than anticipated. Then problems arose with the actual logging on the Canadian side of the border. Decco-Walton Logging of Everett, Washington, the company that had won the contract to log the reservoir area, contracted out the Canadian end of the operation to logger Curley Chittenden, who became convinced that the flooding was wrong and began instead to lead the fight to save the Skagit Valley. In the meantime, negotiations between the City of Seattle and British Columbia's government for flood compensation had been progressing, and in 1947 the Skagit Valley Lands Act was introduced in the BC Legislature, authorizing the Cabinet to sign an agreement with Seattle.

But as pressure to stop the flooding increased on both sides of the border, the Cabinet delayed signing. Canadian environmentalists were determined to prevent this deal because it would ruin a beautiful recreation area, and Americans who owned cottages on the upper Skagit were even more vociferous in their opposition to the High Ross because their cottages would be submerged with no compensation. Thus, when the politically savvy W.A.C. Bennett and his Social Credit government were elected in 1952, they refused to sign the agreement, even though the province was compelled by the IJC's ruling to compensate Seattle by providing power at ridiculously low prices for the next eighty years. In the end the American cottages were saved, but British Columbia was left with a bare river valley that becomes a lake for two months each year and is ringed with tall, blackened stumps, the remains of the logged-off cedars that were all cut above the "taper."

had plenty of work and even managed to add a new and larger tug, the *Wayfarer*, to their little fleet. In 1945 Silver Skagit bought them out. Nellie Forrest, the widow of the late Harvey Forrest, recalled that for two months that summer Lucille came to their home near Pitt Meadows to get instructions from Eve on how to dispatch tugboats:

> Eve had learned to do dispatching but she was going to university to become a doctor, though Harvey was still running the tugboats for Silver Skagit. Lucille came pretty nearly every day for a while, and we became very friendly with her. Everybody liked her tremendously, of course, because she had such a cheerful outlook. Eve worked with her on the radiophone and on the telephone. The whole idea was to have the tugs taking payloads up and down the river with the tide. You had to utilize the tide so that it assisted in stopping those long booms when it came to storing the logs and also in disposing of them further down the river. There were a lot of intricacies in this business, and Lucille worked very closely with Eve to learn as much as Eve and Harvey had learned in their own struggle to master the problems.

Ken Mackenzie of Harken Towing was one of the people she was dispatching in those days. He remembers:

> I helped her on dispatching because she didn't know anything about it and yet it was her job to tell me what to do. I showed her how to read the tide book and explained what we did and how we did it and all that sort of stuff. She caught on fast and she didn't ever forget.

FOUR

River Towing

Early in 1948 Silver Skagit Logging completed its role in the Ross Reservoir project and the company was dissolved. Cecil Cosulich exercised his option to repurchase his three tugs and bought three larger tugs Silver Skagit had used for deep water towing. The price for this whole fleet was $165,000, but Cecil had only set aside $5,000, and thus his company, River Towing, began its second life with a debt of $160,000.

By this time Decco-Walton was moving its logs, both American and Canadian, over the road that Silver Skagit had built from the Skagit River to Hope. There was plenty of work for Fraser River tugboats, although the competition from the myriad of one- and two-boat fleets was intense. Cecil's little company could barely afford wages for the tug crews, let alone salaries for secretaries and bookkeepers, but Cecil knew there was one office employee the company could not do without: Lucille MacDonald. She became River Towing's entire office staff.

> I was Girl Friday. I did everything. Cecil would come in on Mondays, then go up the valley and reappear on Friday. He

didn't work on the tugs himself. He just made sure everything was running, got us contracts and so on.

Now I have to tell you, in those very early days we were broke. We just didn't know we were bankrupt! I used both sides of the adding machine tapes, and if Cecil were here, he would tell you I used carbon paper until he could read through it. Local postage was three cents but four cents for out of town. It is hard to believe this today, but I used to post the New Westminster mail in Westminster and then put three-cent stamps on the Vancouver mail and post it in Vancouver to save a few cents a day. I think most tugboat companies had at least ten percent overhead but ours was one percent because I did everything—the purchasing, the rate negotiations, the billing, the collecting, the dispatching, all the accounting. I was it.

In fact, according to Clifford Julseth, who became dispatcher in 1956, Lucille "looked after all the functions that were required—hiring, firing, keeping employee records, invoicing, accounts receivable, accounts payable, purchasing, arranging financing, looking after payroll, looking after personnel. She did all the dispatching and kept the records of all the log booms that belonged to customers that were in our custody." For Lucille it was even more than a nine-to-five job; she took River Towing's calls at home as well:

> This was postwar, of course, and you couldn't get residential phones, so Cecil said, "You know, Lucille, if you would take an occasional phone call at home in the evenings, we could get you a phone." I thought that would be kind of convenient so I agreed and got a phone at home. It was a party line and the number was Bayview 9990R. Well, that was perhaps the biggest mistake of my life because my phone rang any hour of the day or night seven days a week for the next forty-five years!
>
> I never even thought of having the company pay for my telephone at home. That's something that never came to my mind,

RIVER TOWING

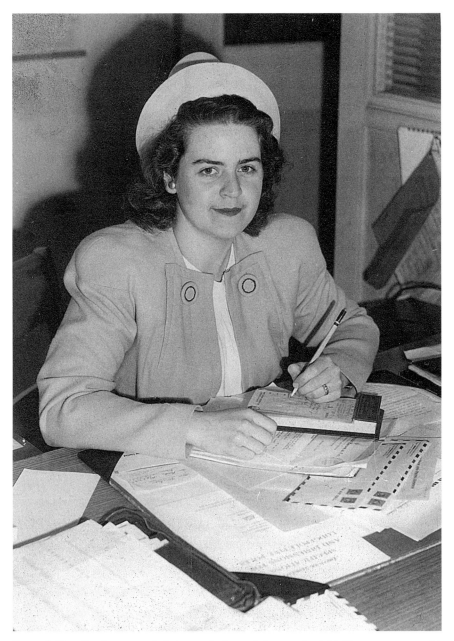

By 1948, River Towing owned six tugs—but was $160,000 in debt. The company could barely afford to pay the tug crews, let alone office employee salaries. Lucille, the company's "girl Friday," made up River Towing's entire office staff, doing everything from purchasing, to negotiations, to accounting. To cut costs in the early days, she used both sides of adding machine tape and used carbon paper until she could see through it.

and since I couldn't afford an extra dollar-fifty a month for an extension phone, when it rang in the middle of the night, I had to jump out of bed and run to the hallway to answer it. I look back at a dollar-fifty a month now—you can't even buy an ice-cream cone for a dollar-fifty anymore—and I think it was so stupid but that is how we survived.

Cecil and I were supposed to take the phone calls on alternate weekends, but often he would go fishing on his weekend, and when the crews couldn't find the boom they were supposed to be towing and didn't know what do, they would phone me. So after five years of answering the phones around the clock, I decided I might as well take all the calls.

River Towing's first office was in Silver Skagit's old quarters on Hastings Street in Vancouver, but it was too expensive and too far from the river, the tugs and the crews, and they soon moved to what had been the Imperial Oil dock at 63 Duncan Street in Queensborough, just below the Star Shipyards on the north arm of the Fraser. The rent for docks, office and parking lot was fifty dollars a month—a real bargain. But there were problems with the site, such as missing planks on the dock. Lucille remembered:

> You didn't want to go out there in the dark. If crews were coming to pick up a manila line or a 32-volt generator or something of that nature, I would pack them out to the end of the dock before I went home for the day so that the men wouldn't have to come ashore and possibly have an accident.

There were also drawbacks to the new office itself. In 1948 the big Fraser River flood saw water rise to twenty-five feet at the Mission Bridge, about fourteen feet higher than usual. The river became a raging torrent with houses, barns, dead livestock and huge trees and stumps rolling and boiling in the current. The flood took out the train bridge at Mission. Although dikes had been erected after the previous big flood

of 1895, they had not been well-maintained and water seeped right through them. It covered farmland on both sides of the valley and the roads and rail tracks for miles along the north side.

In New Westminster, River Towing's new office was behind the dike, but Lucille found that the water was still a problem.

> The office was built up even with the dike so you could see the river from the windows, but this meant there was space under the building and, when the river flooded, tidewater seeped through the dike and under the building. This was no problem in the summer months, but that winter it froze the plumbing. I had to go to the washroom before I went to work in the morning then wait to go uptown at noon in order to find a bathroom. Apart from these defects, it was pretty comfortable. We even had an oil heater, but most importantly, we were right there at the scene of the action.

This was a very colourful period in towboating, especially for a small independent company like River Towing. Most of the log booms the company handled came from the Hope area or from Harrison Lake. River Towing established booming and storage grounds all along the banks of the Fraser. It used shallow-draft boats between Hope and the Vedder River where the river deepens, and bigger tugs to pick up the booms at the Vedder, bringing them down either to the Pitt River or to storage areas lower on the Fraser. At the same time a power line was being built from Bridge River all the way down the side of Harrison Lake and on to Vancouver. Other companies got work bringing in scow loads of cable and equipment, while Raake Marine's water taxis carried workers back and forth across Harrison Lake almost twenty-four hours a day. When the workload got too heavy, jobs were contracted out to other tug companies.

River Towing had at least ten men working on their boats at this time, two on each one, a captain and a mate or a mate/deckhand combination. These men were non-unionized employees and could be worked

any day of the week and any number of hours a day. In general, these labourers worked twenty-eight days on and three days off. The pay was not great; the average skipper earned $125 a month.

Every day Lucille made two conference radio calls to the boats, one at 7:15 in the morning and the other at 4:00 in the afternoon. Each skipper would report where he was, what he had done and what he was about to do, the number of booms he had in tow, who they belonged to, where they were being taken and any problems that had come up. Lucille's job was to coordinate and plot all their activities before the next call. Many of the men knew her from these calls, and most thought she was considerably older than she was. As they were all young—actually around Lucille's own age—they started calling her "Mother Mac" and the name stuck, even after they met her in person. They took their problems to her. If they needed money to buy their first cars or an engagement ring for the girlfriend, they went straight to Mother Mac for a solution.

Jimmy Gibson, who began working on River Towing's boats in 1951, found Lucille to be "a really wonderful person."

MICHAEL DUNN: When Lucille asked you to keep towing after you just worked all day, you couldn't say no because you knew damned well she worked as hard as you did or harder. Only once did we say no. It was Bobby Edwards and I, and I think it was 1952. The river was about twenty-two feet at Mission and we had gone down with three Decco-Walton booms, and made it in about two-thirds of the normal time. I think we put ten years on our lives that trip! Those booms were made up of eight sections, so this was about twenty-four sections long, and the sticks were about seventy feet, so it was probably about fifteen hundred feet. Anyhow, we phoned Lucille to say we were done, and she said, "Well, I guess you are taking another one down." Poor Bobby was just sputtering and he said, "I don't think so. Maybe in the daylight, not in the dark!"

She really wasn't that much older than a lot of us, I guess, but she treated us, like . . . well, like we were a bunch of kids. She put money away for us from our paycheques, and she would buy our boots for us at a good price so our feet didn't get wet. If we needed clothes, she would order them and have them down on the dock so we could pick them up. Our food was ordered through Lucille, always delivered to one of the docks we would be passing so that we didn't ever go hungry. I don't think she ever turned down a food order that we put in, and believe me, some of those orders were pretty generous. Even in those days, believe it or not, tobacco and cigarettes and beer were provided. We had all the comforts we could wish for. Of course, we cooked our own meals on board and did our own laundry.

She was a really marvellous, marvellous lady. She never lost her sense of humour, never lost her willingness to sit down and talk, and if you had a problem and you wanted five minutes to talk to Lucille to get your head on straight, it didn't take her long to put it there. She always had the time. Her office door was never closed or locked. No matter how busy she was, she would take five minutes to get your problem discussed and let you go

JIMMY GIBSON: I broke my elbow in an accident, slipped on the rocks while fuelling up the old tug and landed on my elbow. Managed to knock a chip off the bone, so I spent that first winter [1951–52] on compensation—which was fine really because I would have been laid off anyway and this way I was paid for the winter. But even before spring came I got a call from Lucille saying, "Could you come down the North Arm and work?" I said, "I still have my arm in a sling, Lucille, but I'll come."

"Well, we really need you," she said. So down I went and I got by with one arm. I was certainly healing up and so it really wasn't a big problem.

on your way and solve it yourself. And you could always go back and say, "Lucille, it didn't work, now what do I do?" And she was always there.

Michael Dunn, who signed on with River Towing in late 1948, remembered Lucille giving him and another skipper a night off but warning them not to get into any trouble because they had to be on the job early in the morning.

> Some of us were less than angels in those days but we told her we wouldn't get into trouble and that just to make sure we would phone her every hour. So we did. Every hour faithfully till about

NORMAN COSULICH: We had a particular pump that we used on our smaller boats, and we had to buy it at Simpsons-Sears. I went in there to buy a pump one time and they were reluctant to give it to me because they said we were slow in paying. I phoned Lucille. "Let me talk to them," she said, and when I put them on, she told them "We are not slow. We are slow but satisfactory."

I got my pump.

Our boats on the river around Hope and down to Chilliwack got a lot of propeller damage because the river there is so very very shallow, and these were planing boats and fairly fast. They had to have good propellers. There was a fellow there, Bob Osborne, we used to call Mr. Propeller. When I first knew him he was beating up propellers with a big sledgehammer down in Coal Harbour. I remember his hammering and grinding. He was a good friend of my dad's and he built that business up from scratch, even developed a computer system for it in the end though I don't imagine he had much education.

Lucille could twist his arm with great skill and make sure he put everything aside and got us a propeller when we needed one. He would always shake his head. "Don't turn her loose on me," he'd say, but he really liked and respected her a lot.

> four o'clock, and she finally said to quit it. She was the type of person you could do that to and she would laugh about it afterwards.

After a half-dozen years of trying to help the men budget their paycheques, one day Lucille came up with the idea of starting a River Towing credit union. She met with seven employees and convinced them that this would allow them to save their money, apply for loans and repay them painlessly via payroll deductions. They elected a board of directors and an executive, and each put in five dollars to purchase shares. Lucille persuaded most of the other crewmen to join; the credit union flourished for many years and was later absorbed into Vancity Credit Union, now Canada's largest.

But while Lucille worried about the welfare of the men, she had to be equally aware of the welfare of the company.

> It was really important to keep the tugs working. Any time lost in the season was critical because we couldn't tow in the upper reaches of the river until probably April/May and we were closed out of there by September/October [when logging ceased because of the depth of the snow]. So we had to keep these vessels going when they had breakdowns. The boys would phone in on a Friday night and say "We have a leaking gasket" or "We've got a water pump malfunction." Sometimes they would ask for things that didn't exist just to pull my leg, but I got to realize when they were putting me on and when they really needed help.

According to Michael Dunn, when they pulled tricks on her, they "usually paid for it in the end." But at first they got away with their jokes because Lucille knew very little about engines:

In those early days I didn't even know that the "wheel" was the name for the propeller. But we had all these war surplus 671 engines at the time and Cecil said, "You should take home the Detroit Diesel 671 manual so you'll know how they work and what the parts are." So I took the service manual home and I soon became pretty knowledgeable about 671s. Fortunately, Hoffars Limited on West Georgia, the local agency for General Motors marine engines, had a wonderful mechanic by the name of Norman Garret who lived up by the city hall. He was a great guy who didn't have a driver's licence. So my arrangement with him was that, if I needed an engine fixed, I would pick him up and drive him out to the tug, wait for him there and drive him home when he was finished. Sometimes I would get home at sunrise, have a shower and go to work. I had to, since there was nobody else in the office.

FIVE

Building the Company

Soon after Cecil Cosulich bought his tugboats back from Silver Skagit in 1948, River Towing began building more boats. These were steel ships constructed in a workshop in Hope where, according to Norman Cosulich, a single welder turned them out "as fast as he was able, though there wasn't any hurry."

During the 1950s, however, it became far more efficient for Cecil to expand River Towing by buying out other companies, taking over both their boats and their contracts. In the beginning he initiated most of these acquisitions. But Lucille was the one who had to find a way to pay for them. "It's really a matter of how to acquire assets when you don't have that much money," Lucille once explained to a reporter. "It doesn't take much talent to buy with cash. But when your cash flow is low, it takes a little more imagination."

The first time Cecil and Lucille put their teamwork into action was for a pair of companies that had dominated the boom towing on Harrison Lake since the early 1930s. Inland Towing and Raake Boat Services were both owned by Paul Raake, a former ship's carpenter from Hamburg who was rumoured to have jumped ship in Vancouver soon

after World War I. With partner Leonard Wilson, he had slowly built and acquired a fleet of small tugboats, freight boats and passenger craft and kept them busy on Harrison Lake with everything from general towing and supplying logging camps to providing fishing and hunting excursions for tourists. For years he operated from a sturdy offshore floathouse, and in 1946 he built a huge new one—fifty feet by seventy feet, on a seventy-by-ninety-foot float. It provided new offices, sleeping quarters, kitchen and dining room for his crews, as well as a repair shop and slips for some of his boats.

Cecil Cosulich had been watching Raake's business grow, always intending to move his own tugs into Harrison Lake and go head-to-head for contracts. But in the spring of 1951, Raake—in failing health—suddenly offered both businesses for sale. River Towing was in no financial position to buy them, but Cecil approached Bill Dolmage, Ron Wilson and Bill Atwood, owners of Pioneer Towing, to join forces with him. It was a good fit; Pioneer had a small fleet of tugs doing much the same work that River Towing was doing on the North Arm and up the river. Lucille juggled River Towing's finances to make it happen, and the two buyers then consolidated Raake's two companies as Raake Marine Services.

Unfortunately, the summer of 1951 was one of BC's worst fire seasons on record and all the coastal forests were closed to logging. With little towing to be done, River Towing's crews were put to work rebuilding Raake's dock at the end of Hot Springs Road. Raake's new floathouse was used as it was for another sixteen years, after which the whole unit was hauled up onto dry land at the east end of the bay and settled on a concrete foundation. It is still known in that community as the Rivtow Straits Building.

The partnership between River Towing and Pioneer Towing existed for only four years when Pioneer purchased Towers Towing and its five tugs. Bill Dolmage left Pioneer to join Kingcome Navigation in 1956. This provided Cecil Cosulich with the opportunity to step in and buy Dolmage's shares in Pioneer, thus making him a partner with Bill Atwood and Ron Wilson in both Pioneer Towing and Raake Marine Services.

BUILDING THE COMPANY

No 'Tugboat Annie' type, Lucille still spent plenty of time on tugs working the Fraser River from Hope to the Gulf of Georgia. She got to "know the ropes" so well that t o d a y, and particularly amongst Fraser River tugboat men, she's recognized as . . .

B.C.'s TOP FEMALE TOWBOATER!

LUCILLE MacDONALD

First-hand knowledge of towboaters' problems was first acquired by Lucille after her transfer to towing division from purchasing office of Silver Skagit Logging Co. She soon learned that being roused out of bed by urgent night calls from up-river tug skippers was "all in day's work" for towboat operator.

Fraser River towboaters ribbed her unmercifully at first before accepting her in "man's world" of towboating. In beginning she fell for gags like ordering left-handed wrenches and red oil for port steaming lights.

46 HI-BALLER

In a 1962 magazine article Lucille was recognized for her skills at dispatching tugboats, but also because she was a woman in a primarily male industry.

Lucille, meanwhile, quietly signed a purchase deal in 1953 with Kester Towing, the first time she negotiated an acquisition entirely on her own. This small tug outfit owned by brothers Mark and John Kester had been unsuccessfully competing with River Towing on the upper Fraser for years and finally admitted defeat. The deal not only gave River Towing a few more boats but also eliminated its competition.

Ken Mackenzie of Harken Towing points out that Cecil and Lucille were not preying on other towing companies. "It wasn't that they went out and gobbled anybody up," he said. "They weren't vultures. These other people were floundering so they came to River Towing to get bailed out."

Lucille recalled:

> I helped a lot of tugboaters to retire by taking over their operations and paying them so much a month. I did primarily all the river towing deals in those early days. For example, Griffiths Towing had four boats, but the owner developed a back problem and he couldn't go out on them anymore. He didn't want to sell the boats piecemeal because he would have to worry whether the buyers were going to pay him and whether they were maintaining them. When he came to me, I told him I had no cash but I would pay him a thousand dollars down and cover the provincial sales tax, then put three thousand dollars a month into his bank account till I paid off the agreed price of one hundred thousand dollars. He said he trusted my word and that's the way it was done. Later we used to say this was dealing in "Lucille Dollars"—it takes a little time but you get 'em eventually! So I bought this whole fleet for one hundred thousand dollars with virtually no down payment. A few years later I sold one of those boats for seventy-five thousand dollars!

Gradually Lucille became involved in all the company acquisitions—for both river and ocean-going tug companies—then finally did them largely on her own:

I would negotiate and then sit down and tell Cecil what the deal was and then we would get the documentation prepared. He said I was to read the agreements, make sure they were right and sign them. My signature on them meant that he didn't need to read them because I was vouching that they were all right. He hated reading agreements. And that was the relationship we had for the next forty years. Cecil and I never had formal meetings. We just sat down over coffee and decided what we were going to do.

Finally, I had to ask him for some level of authority because he was away so much and things would come up in the business that needed immediate decisions. Some of these matters went well beyond running the office, such as new opportunities to expand the business. His response was, "You're doing fine. I'll let you know when you've gone too far."

After I had been there for five or six years doing the payroll, it suddenly dawned on me that I was running all these things and getting paid less than a deckhand. I think I was still at $110 a month at that time, so I gave myself a raise to $125. Cecil came in on Friday to sign the payroll cheques, and I heard the roar from his office. "Woman," he yelled, "what are you doing?"

"What's the matter?" I asked.

"You've given yourself a raise. Now you've gone too far!"

I was there forty-five years and Cecil never volunteered a raise to me in all that time. When we got bigger and had a payroll clerk, I would review the salaries of all the employees from time to time and give the clerk my adjustments. Then she would phone Cecil and say, "Lucille's done everybody's review and salary adjustments. Don't you think you should do something for her?" He would tell her a figure, but he never gave me a direct raise in forty-five years!

Lucille's paycheque was extremely important during these early years; all was not well at home. After the war Lucille's husband Ken had

taken a job with Western Wholesale Drugs, first as a clerk and then as an "order filler." But in 1950 he suffered a nervous breakdown and could no longer work. Recalling those difficult years, Lucille said:

> Ken couldn't get on a bus and he couldn't go to the barbershop or anything like that. He was pretty sick. But he could drive a car so I had to get a second vehicle. Well, I bought a 1946 Chev, a marvellous model, but it needed a paint job. And since it hadn't been looked after very well inside either, my husband refused to drive it. He said it looked like a derelict piece of junk, so I ended up driving it. Once a month I would drive this old wreck up to Harrison after work, stay overnight to do the books for Raake Marine Services and the next morning drive to Hope and do the Canyon Towing books and drive home that night. On one occasion the men at Hope needed a cylinder head for an engine overhauled, so rather than paying the freight to send it, they put a piece of canvas on my back seat and put the cylinder head on it so I could take it down to the shop. When I went to register at the Harrison Hotel for the night, the bellhop said, "I'll help get your bags out of the car." I said that I only had one bag and really didn't need any help, but he came out, opened the back door to get my bag and saw this oily cylinder head. He gasped and took my bag up to my room. When I offered him a tip, he said, "Oh no, no tip. You can buy me a beer sometime." He must have thought I was as derelict as my car! First time a bellhop's ever turned down a tip!

A year after his breakdown, Ken's condition had still not improved and doctors suggested he might never be able to work again. Lucille began looking for a way to stay home and take care of him while bringing in an income. She had just decided that a home accountancy practice would be the answer when the General Accountants' Association announced a new five-year program at the University of British Columbia that would lead to a certified general accountant's degree (CGA).

The program was intended specifically for working people, with three-hour lectures held one evening a week. Lucille enrolled, one of only five women among 107 students. She approached the program in her usual organized fashion:

> There were, of course, no computers so everything had to be done manually with a ten-key adding machine. Changing a five-budget forecast in one column necessitated manual changes in every subsequent column. The home study was extensive and to cope with it I developed a system. Over my breakfast toast and coffee I read a chapter and thought about it en route to work. Over lunch I read another chapter. Two or three nights a week I went to bed at nine and set the alarm for midnight, got up and studied from midnight to three, went back to bed and slept to six then went to work. On weekends I finished my homework. It was a tough routine but I stuck with it, relying on that early teaching from my mother—where there's a will, there's a way.
>
> My first-year marks were an average of 93 but that was because I got a very poor rating on my English exam. My boss [Cecil Cosulich] didn't say, "It's nice that you achieved 93 percent." He said, "It's too bad you can't speak and read English properly." It was rather discouraging. Anyway, in the third year I got the student award, a fact duly reported in the *Vancouver Sun*. In our final grad year, 1956, Joyce Loutet and I were within one point of one another and she got the gold medal. By that time the group of 107 students who started was down to twenty-three and Joyce and I were the only two women—quite interesting when you compare it with the fifty-fifty ratio of today—and she got the gold medal and I was second, one point behind. I didn't try harder because I was a woman; I tried harder because I wanted to make sure I achieved my goal.

Within eight years of becoming a CGA Lucille was elected president of the provincial board of CGA governors in Canada. And though she

never did develop a professional practice at home, her training became invaluable to River Towing. For one thing, she had a better understanding of tax laws and was able to use that knowledge to the company's advantage—even before she graduated.

> One year when it began to look like we would make a profit, I realized that if I didn't do something we would have to pay tax. At that time there was a very special depreciation on vessels: you could write off a third of the capital cost in the year you bought the vessel. As our year-end was coming up, I went to a barge-building company and told them I wanted a barge this size, that wide, that deep, and with this capability and asked for a price. They said it would be eighty thousand dollars. So I said, "I would like you to start construction. I know you can't have it finished by December 31 but that doesn't matter as long as you get it started and get it measured and registered before then, and I will give you some cash and a mortgage." That way I would have title to it even though it had a mortgage on it, and I could claim a third of eighty thousand dollars off my taxable income that year even though the barge wasn't delivered yet. So that was where I started.

Still, income was a continuing problem for the company, and Lucille had to be very inventive to increase cash flow. Cliff Julseth, who began working in the River Towing office in the mid-'50s, described Lucille's billing system:

> When we took a log boom from its source to one of our booming grounds, the owners would leave it there until it was sold. That meant we had to tie it up there for security and we sent them an invoice right away for that part of the job. Then if the owner succeeded in selling that boom, we started it on a new journey on behalf of the new owners, and as soon as that happened, that invoice was sent out. There were some companies

that sent out the invoice the month after they finished the job, but we liked to get the invoice out almost ahead of the job.

Lucille was always conscious of the fine line between profit and loss:

> We were getting just ten cents a thousand to bring a boom from Pitt River to New Westminster. It was peanuts, perhaps ten dollars a haul. But I would raise the towing rates to customers as often as the market could bear it. I happened to have a very interesting, very colourful beret at that time with stripes of various bright colours, and I called it my "rate-changing hat," and I would put it on when the time came to raise the rates. Our customers were so fascinated with this crazy hat of mine, they forgot I was putting the rates up!

By 1955 the company had about thirty-five employees and was towing 160 million feet a year, but Lucille was still the only person in the office. Even with her remarkable capacity for work, it was obvious she could not continue to do all the dispatching, negotiate acquisitions, arrange for engine and boat repairs, hire, fire, pay wages and bills, do the purchasing and keep up with all the paperwork on booms and boats and crews by herself. Promoting from within was an established policy at River Towing by this time and, as a result, before Christmas 1955 Lucille put the word out that the job of dispatcher in the head office was open. She specifically wanted a tug skipper to fill the post because he would know half the job already. The first hire started the job in January 1956 and left two weeks later; he wasn't ready for a desk job. The second to apply was Clifford Julseth, who had been with River Towing since 1948—the first two years as crew, the next five as skipper. He had run all five boats used on the upper river so knew the capacity and capabilities of them all.

Julseth recalled:

Lucille was basically my teacher and I found it extremely exciting. I knew the boats and the men but all the procedures that went on in the office were new to me. But the more I learned the more impressed I was with Lucille, who was doing everything in that office.

We were the only company towing between Hope and the

CLIFF JULSETH: I had been working in the woods around Hope for two years. In January 1948 there was a very heavy snowfall, and since most of the logging operations were up at the 3,000 to 3,500 foot level, it became obvious that the crew I was working with wasn't going to get back up there very early. So I went down to Bristol Island and met Norm Cosulich and applied for a job on the tugboats. That was a Saturday and I went to work on the Monday. The spring was very late in coming and the water stayed down. We did what we could to move logs partway down the river, storing them all up and down both sides, and finally the river started coming in about mid-April, and once it started it just didn't want to stop. That was the beginning of the famous 1948 flood.

I got to know Norm Cosulich quite well—he was the manager at Hope. I met Cecil and saw him maybe twice a month when he came on business. But Lucille was a bit of a mystery. She was the lady in the office in New Westminster who made everything work. When I got to meet her I was surprised how young she was. For some reason I had thought she was older, and I found out she wasn't that much older than I was. Anyway, she was very pleasant, always interested in all of the employees. She had the knack of making them all feel important—which is good.

Time passed, and after seven years I was still towing logs and beginning to think seriously of going back to logging because I was getting bored on the tugs. And then towards the end of the towing season in 1955 word was passed along the grapevine that they needed a dispatcher in head office.

mouth of the Vedder River by that time, and most of our logs came from the Hope area and Harrison Lake, and to a great extent all the sawmills depended on that production. It was a very large marketing area for logs.

Dispatching was a complicated business, but basically it meant you lined up work for the boats and the people. First, you had to find out what work was out there, that is, where logs had been made up into booms, and you'd get a notice or a telephone call and start a record on that boom—how much wood it contained and what kind. You had to know the volume each one of the boats could handle so you could assign a boat and a crew, and then you followed up on that. For example, from 1956 to 1960 there might be five boats leaving Hope each with a tow, strung out one behind the other. They would each report what they had on the towline and who their booms belonged to. That was recorded in our head office and in the Hope office. We had a telex by that time and those reports would come in every morning. The same with the towboats on Harrison. It would take them a day to tow one of the smaller booms from Hope to Sumas [the Vedder River], and then they would transfer them to one of the deep-water boats to take them to storage on the Pitt River or the mouth of the Fraser, and you would have to dispatch them as well.

Anyway, we were growing fast as a company, and as I got better at dispatch, I handled other things and ended up doing a lot of the purchasing and a lot of the personnel, but the more I took away from Lucille the more she took on.

Lucille was delighted to have Cliff Julseth onboard. He was soon doing all the dispatching and handling of the crews and even taking towlines and equipment out to the end of the dock—a job she had been doing herself all these years. Around the time he started in the office, Lucille was also attempting to hire secretarial help, but finding the right fit was difficult. Many applicants didn't want to take a job in such an out-

of-the-way location, and most who did were unskilled. When at last a new secretary was found, she became a problem for Julseth and he went to Lucille for help. Julseth was a good-looking and eligible young man, but rather shy. While he sat at his desk, the young woman began leaning over him from behind and resting her bosom on his shoulder. "Mother Mac" resolved this distraction for him with her usual tact.

Julseth continued:

> So we ended up with four of us in that little office—though Cecil wasn't there much. He was basically a travelling ambassador, putting deals together. Most of our days were twelve hours long: six in the morning to six at night, though mostly seven to seven. Very often Lucille would beat me in. Sometimes she was still there when I left. It was a tight operation but it had to be because there just wasn't the money. I know there were times that she didn't even cash her own cheque because the money was so tight.

By that time Lucille had received a raise from the $125 that had so appalled Cecil Cosulich a few years earlier.

> I think I was probably making $200 or $250 a month by that time. If I had been a man, I'm sure I would have been making at least double that, but in those days women had this glass ceiling, perceived or otherwise. Today you hear about women still feeling they are not getting paid equally, but they have no idea what it was like in the '50s, no idea at all.
>
> For example, at that time the BC Towboat Owners' Association was part of the Vancouver Merchants' Exchange, but I was not permitted to represent the company because I was a woman. I wasn't even allowed to be on any committees. It wasn't until the crews were all unionized and it was necessary to come up with some innovative system to keep their time records that I was allowed to be on the task force because I had kept track of their

twelve-hour days and knew how many days they had banked and so on.

At the time, Lucille had no sense of the injustice of being paid less than a man. "I was brought up in poverty, so my expectations started out very low, below the floorboards! If I was making two hundred dollars a month by that time it was a long way from where I had started."

Lucille's job title changed as River Towing's business increased. "It wasn't so much a matter of promotion within the company," she would explain later, "as it was simply keeping abreast as the company grew." But Cecil Cosulich's stock comment was, "Lucille didn't rise through the ranks. She hired the ranks as we went along." His brother Norman added, "By the time the company was large enough for anyone to take titles seriously, she had to be vice-president of finance and administration. Whatever we were doing, she was always able to find the money."

But Mike Dunn discovered that you had to prove that it was a wise investment before Lucille would find the money for it.

> You had to deal with Cecil and Norman on the practical engineering or feasibility side of something but when it came down to getting the money to do it, then you had to talk to Lucille and you got told how much to spend. When I was managing the Harrison end of it, if I wanted to buy something I would think it all out very carefully before I went down there to see her. Lucille would ask about four questions and I knew I was dead in the water if I had left something out somewhere. She would be sitting there writing in her book, talking on the telephone and carrying on a conversation with me, and still be able to pick holes in my arguments. But if I could justify needing the money for a viable project or to purchase something, she would see I got it. In her quiet way she taught us all an awful lot about budgeting, money management, planning and everything else. She was certainly a lady to respect.

In the early 1950s River Towing had acquired a former mill site at the foot of Victoria Drive. It was a typical Lucille deal: River Towing wanted the land but couldn't afford it, so Lucille persuaded Ken Mackenzie of Harken Towing to buy it, then later purchased it from him for $22,500. Mackenzie never worried about getting paid because Lucille was "as straight as you could get them. That's from coming from a good Scottish family, I guess."

When by 1958 the rented office on the Imperial Oil docks could no longer accommodate River Towing's staff, it was time to make the move to the new property. Raake's original floathouse office was towed from Harrison Lake down the Fraser River and placed on a cement pad just up from the beach where Victoria Drive intersects Kent Street. The address was 1990 Kent. Lucille recalled:

> We didn't invest very much in that office. In fact, my desk was so terrible we had to put green felt on it and a piece of glass over that. It was a ten-dollar desk, and I kept it for years.

~~~~~

After River Towing moved to the foot of Victoria Drive, Lucille found that in the course of the company's daily business numerous documents needed to be notarized. There was no notary public close by and she had difficulty getting one when needed. In typical fashion, she decided to apply to become a notary public herself to save the company time and money. But becoming a notary was not just a simple matter of applying. There was a considerable amount of study involved and a stiff exam to pass. Lucille also had to wait since only four hundred notary seals were permitted in the province at any one time, and new applicants had to wait for someone to give up their seal or die. It would be years before Lucille was successful.

> I had almost given up when in 1970 I received a call to say that if I could be ready to write my exam in thirty days, I would be able to get my notary seal. At that time we had just merged Straits

# BUILDING THE COMPANY

Lucille at the window of a company vessel—not quite dressed the part of a crew member.

Towing and River Towing into a company that was virtually double the size that we had been and I was the vice-president of administration, so I was very busy. Then every day at twelve o'clock I would get into my car and drive to a quiet side road and study for an hour. I would read again in the evenings and weekends. It was an interesting course and I was ready in three weeks. I went down and wrote my exams and passed.

So I became a notary public and got to sign all the passports for the crews and all the ships' documents and contracts. I never practised as a notary other than for people in the community who needed some help. I drafted a lot of wills for people who didn't want to go to a lawyer and became pretty good at it, as a matter of fact. When my friend Margaret Goulich was ill, she asked me to write a will for her, which I did. She had all kinds of bequests to fellow workers for her special jewellery items and so on. But she kept amending it so that when I finally got it finished and took it to the hospital, she was too weak to sign. I left it with the nurses so that if she became rational and could sign it, they could witness it. Unfortunately, she died without signing it. When her brother flew up here from Texas, I explained to him the amount of thought that Margaret had put into this will but had never signed and he said, "Well, if that is what my sister wanted, that's what she will have," and he honoured her bequests. I have always respected him for that.

When I left River Towing, it would have cost about six thousand dollars a year for bonding and I felt I didn't want or need to be a notary any more, so I gave up my seal.

<center>〰〰〰</center>

But while Lucille was forging briskly ahead in the business world, her private life was falling apart. In 1953 Ken MacDonald returned to his job as an order-filler with Western Wholesale Drugs—eliminating the need for Lucille to set up a home business and take care of him—but she had not stopped working toward her general accountancy degree.

She continued attending classes, spending hours on homework and even getting out of bed in the middle of the night to study. At the same time she was putting in twelve-hour days at River Towing. Ken's resentment of Lucille's passion for her job grew as his desire for a home life and family was steadily thwarted, driving a wedge between them.

In the fall of 1958, having learned that her husband had found someone else, Lucille moved out of their small home at 2275 East 41st Avenue and rented a little apartment at 302–7884 Knight Street, conveniently close to River Towing's new office. Their divorce was granted in 1960; Ken MacDonald remarried a year later.

SIX

# *Expanding the Fleet*

Murray Robertson Cliff was a New Brunswicker who went west in 1908 to work as a boom man on the Fraser River. Nine years later he started one of the coast's most successful log-towing companies with a single boat, the fifty-foot steam tug *Brunette*. By 1956 M.R. Cliff Towing was operating twenty vessels and had log storage and booming grounds in Howe Sound and at Gowland Island in Discovery Passage. The company also provided employment for Cliff's brother and nephew and Cliff's son Wilmot in executive positions at its head office on Hastings Street and its wharf office at the foot of Dunlevy.

The *Brunette* was the company's pride and joy, but it took six men to crew her. In 1934 Cliff re-powered her with a semi-diesel engine and then a full diesel in 1953. By then she was down to a crew of three: master, mate and engineer. For at least twenty years of the time Cliff owned her the *Brunette* was skippered by "Simmy" Simpson, who once estimated that he had put a couple of million miles on her, most of them on the run between Howe Sound and the Fraser River. Simpson came to view the *Brunette* as the company's lucky talisman and he cautioned Cliff never to sell her:

The *Brunette* is probably one of the finest and most famous tugs that ever sailed out of Vancouver. She was a lucky boat for me, and for just about everybody else who was her skipper or owner.

*Brunette* had a few accidents, but once in the early 1920s her skipper had a few drinks too many and took her inside some pilings on the Fraser River and she was holed. Rescuers found the skipper snoring in his bunk and timbers through the shattered wheelhouse a few inches from his head. *Brunette* was soon refloated and that skipper went on to other service.

"Simmy" left Cliff Towing in 1945. In the mid-1950s Cliff's son Wilmot took over most of the company's management and decided to sell the *Brunette*. Disaster soon followed—though not really because of the lost talisman. As Norman Cosulich explained, "They didn't modernize their steam fleet, and the second generation didn't like working as much as they liked playing, so they got into trouble and had to put the company up for sale."

In fact, Cliff Towing's troubles were so serious that when Cecil Cosulich teamed up with Bill Atwood and Doug Maitland to buy the company, Lucille worked out a deal in which they got the company and its debts for ten dollars, plus a pension for Murray Cliff and a lesser pension for his widow upon his death. On September 7, 1959, in the midst of this turmoil Murray Cliff passed away.

River Towing now had a fleet of forty tugboats and numerous barges with offices in Vancouver, Prince Rupert, Harrison and Hope. Lucille persuaded Cecil to continue operating Cliff Towing as a separate entity since absorbing it into River Towing would have jeopardized the main company's ongoing financial obligations. With Lucille's guidance Paul Cliff, Murray's nephew, managed the new Cliff Towing and within a few years it was financially stable enough to begin expanding its services. The company had been hauling log booms to Vancouver Island mills from Howe Sound and the upper parts of the island, and in October 1962 Cliff was able to announce that they would be setting

up an office and wharf facilities in Victoria and basing two or three tugs there.

Around this time Lucille also completed a deal to buy Bill Cogswell's two-vessel Kitimat operation, Coast Cargo Services, for $65,000. This purchase took River Towing into new territory because Cogswell's boats were used primarily for docking ships and assisting in pile-driving operation. With the acquisition of Cliff Towing and Coast Cargo Services, River Towing was operating on the entire coast of British Columbia. But while towing log booms had proved the cheapest and most efficient way to get logs to market in the comparatively sheltered waters of the south coast, this method would not do for the rough seas and stormy weather on the west coast of Vancouver Island, nor the north coast. It was clear the company would have to invest in self-loading, self-dumping barges. Predictably, the ball was thrown into Lucille's court:

> By 1963 Cecil determined that River Towing should own an eleven-thousand-ton self-loading self-dumping log barge and a suitable tug to tow it. As usual, we didn't have the money so we had to be innovative. I started with the barge because it could be built here on the coast, and at that time the federal government would grant a 40 percent subsidy for new vessels built in Canada and allow the net capital cost to be claimed for tax purposes at a third per year over three years. The price for the barge was about $1.4 million plus soft costs, leaving us with a net cost of about nine hundred thousand after the subsidy.
>
> We met with logging customers from the Queen Charlotte Islands, Kitimat and Bella Coola who needed log barge service. There are sixty-four shares in a registered vessel, so we could offer shares in this barge for $14,000 and the shareholders could take the tax writeoff. This was such an amazing opportunity that we ended up with eleven owners, one of them being Cecil, who took two shares. Of course, he didn't have any cash, and so an innovative funding method had to be found. At that time a private company could provide funding to its principal shareholder

to purchase a house, and River Towing had already provided $38,000 for Cecil's house on Southwest Marine Drive. As a result, he held clear title so we simply arranged for first mortgage funding on that house and used the cash to pay for his shares in the log barge. One could not do this today, but it was the right thing at the right time.

That log barge, which was built at Yarrows and named the *Rivtow Carrier*, moved millions of feet of logs down this coast for almost forty years from 1965. And it all came from this little Mickey Mouse way of getting $38,000 into Cecil's hands because of this capability within the tax law. I didn't get any shares in the barge and neither did Norman. In retrospect I should have seen the writing on the wall but I was too busy building, buying or trading something to worry about fair treatment.

It was a different kind of challenge to acquire a suitable tug with adequate horsepower to tow this new barge, but we decided to go after one of the Assurance Class tugs in the UK because this type of hull had proven extremely stable in severe storms on Atlantic convoy duty during World War II. They had delightful names like *Cautious* and *Prudence*. We optioned *Cautious*, which was still under steam power, in London for $25,000 and then contracted for her to be stripped down to her hull, engines and boilers and delivered to Vancouver for a similar sum. An interesting sidelight of this tug delivery was that the captain had an international master's certificate and his wages for the voyage from London to Vancouver was less than a BC deckhand was earning at the time.

Lucille continued:

> Fortunately for us, the M.R. Cliff Tugboat Company owned Gowland Island, which lies off Quadra Island's April Point in Discovery Passage, and we acquired it when we bought them out. We were using the inside shoreline for storage of log booms

Assurance Class rescue tugs of World War II were a daring and distinguished little band of ocean-going salvage vessels with a fine reputation for pulling through in difficulties and dangers. They worked under bombardment in the blitz, on the North Atlantic convoys under U-boat attack and in gales and blizzards, and carefully towed damaged ships through minefields at D-Day.

Many of the salvage and rescue tasks they undertook demanded extraordinary skills, enterprise, courage and fine seamanship. Their skippers and crew were proud of the tugs and they often achieved the near impossible.

Assurance Class rescue tugs were built by Cochrane and Sons Shipbuilders of Selby, Yorkshire and designed by them for the Admiralty. One of these tugs endured three days of constant bombing and made eleven successful rescues without the loss of a single life.

Captain William "Bill" Dolmage, distinguished British Columbia marine personality and manager of Kingcome Navigation Company for many years, had first-hand experience with these sturdy tugs when he was in charge of the Royal Navy rescue tug section of the Iceland naval base from 1941 to 1943: "They were terrific sea boats and rescued damaged freighters, Navy vessels and tankers in the North Atlantic in all kinds of weather and conditions," he said. After he left Iceland and supervised salvage and rescue operations in the Mediterranean, Captain Dolmage was decorated for outstanding service.

He advised River Towing to obtain Assurance-type tugs for its fleet in the 1960s and thus the *Rivtow Lion*, ex-*Prudence*, ex-*Cautious* came to British Columbia. In addition, the *Rivtow Viking* is one of the famed Cochrane-built Assurance Class sisters. She had several name changes and has also been known as *Tenacity* and *Diligent*.

to keep them safe from storms but we didn't need the rest of the island so we subdivided off a sixty-six-foot-wide strip along the foreshore to protect our log storage rights and sold the rest of the island to the Folgers [Coffee] family of San Francisco for forty thousand dollars. This was enough to break the back of our costs for the vessel and its delivery.

But the big expense would be the installation of a Stork Werkspoor diesel engine and bringing the *Cautious* up to Canadian safety standards; this would cost about $1.2 million. To raise that amount we applied for a loan to the Industrial Development Bank. The bank sent two of their staff—one of them a young man named Dennis Hurd—to review our loan application in the fall of 1963, and they recommended that we receive the loan. However, final approval for a loan of that size in that era had to be handled at the head office in Montreal. Weeks went by and more questions came forth, but no loan approval.

By the end of December 1963, when the tug had already arrived from London and the log barge was due to be delivered in March 1964 (after which charter fees of ten thousand dollars per month would accrue), we had no alternative but to proceed with the tug conversion and hope for the best.

The conversion was overseen by William Ballentyne, River Towing's marine superintendent, and Norman Cosulich, then River Towing's general manager. It was carried out by Burrard Dry Dock, Vancouver Pipe and Engine Works Limited and May Marine Electric. When completed, the new tug would have a 3,200-horsepower Stork Werkspoor diesel to drive a four-blade propeller 119 inches in diameter. River Towing also ordered the latest in navigational aids, including the capacity to be steered from both fore and aft and a towing winch that would carry 2,500 feet of cable. It would be, as the *Province* newspaper said, "the most powerful direct reversible engine towboat on the coast." The only glitch in the proceedings was River Towing's lack of money, and Lucille was the one on the front lines in that department:

Vancouver Pipe and Engine Works was contracted to do the repiping and insisted on being paid in full every Friday or there would be no further work. And every morning Cecil would announce firmly, "This time you have really plunged the company into bankruptcy!" Not a happy way to start my day! Finally on March 23, 1964, a letter arrived from Industrial Development Bank approving the financing of $1.2 million as per our

---

**Dennis Hurd:** It was about the second year that I worked for the Industrial Development Bank that I met Lucille. We were a bank that tended to lend money in places where traditional chartered banks wouldn't go, and River Towing was one of our big clients at that time. I worked in the engineering department and we would look in some depth into loans that required a bit of technical knowledge, which was the case with River Towing because they were essentially vessel loans and Lucille and the company were doing some fairly innovative things with log barges. I am not sure if they were actually the first to invent them but they were one of the very first to get into that method of moving logs down the coast. So the financing was a little bit out of the ordinary.

I didn't make decisions on the money. I provided the technical background and in some cases an assessment of the company's ability to repay the financing—typical banking reports on a company. In any event I met her at that time and on some subsequent occasions. She was highly regarded in the Vancouver financial community. She always paid her loans. She was an impressive lady, innovative and well-liked in the marine world. I dealt only with Lucille because she was the VP of Finance. I didn't know the Cosulichs, though I suspect one or two other people in the bank knew them, but she was the primary person who handled it all. It appeared to the outsider that she took care of a whole lot of stuff and the elder Cosulich was sort of the marketing/sales guy. Lucille was a very significant client and very successful too and she had a great reputation.

application. I can't tell you what a joyous moment that was to put it on Cecil's desk and no longer have a daily "downer" about us being on the verge of bankruptcy.

That tug was renamed the *Rivtow Lion,* and it was a marvellous success, moving that log barge on many occasions through storms of one hundred miles per hour.

―――

But 1963 had much more in store for Lucille than log barges and new tugboats. She recalled:

After eighteen years of my life totally focused on River Towing and with River Towing expanding, buying out other companies, building vessels or scows and moving out into coastal rather than just river towing, I reached a point where I needed to get re-energized and expose myself to new ideas and new industries. So I prevailed upon Cecil to allow me to enrol in the six-week annual program at the Banff School of Advanced Management.

Her enrolment was duly noted by the *Banff Herald*:

### BANFF MANAGEMENT SCHOOL "ROLL CALL" ANSWERED BY 70

The fourteenth session of the Banff School of Advanced Management was opened officially Sunday by Senator Donald Cameron, director of the school. Among the class of seventy senior executives who registered were the first woman to attend the school for some years, the first former graduate to return for a refresher course, and one of the board of directors of the school.

The woman is Mrs. Lucille M. MacDonald who is area manager and comptroller of River Towing Company Limited of Vancouver. Wesley Van Dusen, president of Van Dusen Bros. Limited of Edmonton who graduated from the school in 1954 is

back to brush up on management and the member of the board who is enrolled is Charles W. Gibbins, president of the Saskatchewan Wheat Pool. For six weeks the students will work from 7 a.m. to 10 p.m. with few breaks, studying accounting, financing, marketing, production and human and labour relations, as they pertain to the executive. Operations research, taught by Dr. Arthur Porter, department of industrial engineering at the University of Toronto, and Canadian taxation, taught by Jacques Barbeau of Vancouver, are two new courses.

Lucille was only the third woman to attend in the school's fourteen-year history:

There was a $950 enrolment fee, travelling expenses there and back and six weeks of salary to think of, so it was quite a fair investment for any company. In those days employers were generally reluctant to spend that kind of money to send their women employees. Margaret Kane of Calgary, who was in the oil industry, had attended in 1951, Margaret Goulich of the Medical Services Plan in Vancouver went in 1957 and I was the third enrollee in 1963. It was Margaret Goulich—who happened to be my best friend—who encouraged me to think of going.

As for the men, they had been identified within their organizations as having a future and needing to round out their management capabilities. There were more than sixty of them and me! They came from all across Canada and even from overseas. They were from banks, oil companies, all kinds of industry and businesses with a wide variety of backgrounds.

At the end of the course the *Banff Herald* reported that:

For six weeks Lucille MacDonald was the only girl in an all-boy school. And on Thursday at the end of the course, she says two of the students paid her a compliment when they told her "You

are just one of the fellows." She says that she was quickly accepted on equal terms by the men at the school and that she has very few difficulties in her regular job because of her sex.

"I don't think it matters whether you are a man or woman in an executive capacity as long as you like people," says this woman executive.

But for Lucille the experience was about more than acceptance. It was about renewal.

That six weeks of exposure to the experiences of other seasoned management people in a variety of industries and commercial enterprises was so enlightening. It was a great experience for me and created the spark that I had hoped for, and I came back feeling much more knowledgeable and confident about moving ahead.

Lucille had barely returned from Banff when for the first time she was noticed by the Vancouver media. She was interviewed in her office by Pat Carney of the *Vancouver Province* for a profile that appeared on April 5, 1963, which said in part:

Lucille MacDonald is an alert, attractive lady with an unfortunate tendency toward seasickness. She is also area manager and controller for River Towing Company, a situation which does not seem strange to either Mrs. MacDonald or her associates in the towing industry.

Her office at 1990 Kent is on the bank of the Fraser River, with its boats and booms and beehive burners, its whining sawmills and the smells of mud and creosote and tidal water. When Lucille MacDonald looks out at the scene from her office window, she says, "It must be ghastly to go to work every day and cost tea bags or something."

There is nothing mundane about the towing industry the

Lucille convinced her boss Cecil Cosulich to permit her to "re-energize" her batteries at the Banff School of Advanced Management, a six-week-long course. In Banff, Lucille was the only woman in an all-male school, but she soon became "one of the fellows."

way Mrs. MacDonald describes it. She says, "This business is never the same two days in a row."

The towing industry has experienced some tremendous changes in costs, labour relations and competitive conditions in the last ten years, Mrs. MacDonald says. "The whole cost picture is changing. There has been a revolution in the type of boat operated. To offset higher labour costs and remain efficient and competitive, you need vessels with more horsepower output per man. Where before you might have a three-man boat with 200 horsepower, you now have a five-man boat with 600 to 750 horsepower to handle more sections of logs." The switch from wooden to steel-hulled boats has cut down maintenance costs. "We are changing over to steel completely," she adds. River Towing builds its own hulls and riverboats at Hope.

Although she went into the towing business simply because she needed a job and River Towing had an opening, Lucille MacDonald has found it a wholly absorbing, challenging career.

"I have to work," she says. "If you are going to spend one-third of your day at work, you might as well enjoy it."

~~~~~

In June 1963, just two months after the publication of this story in the *Vancouver Province*, thirty-nine-year-old Lucille stunned her family, friends and colleagues by announcing that she was about to marry again. The groom was Joe Johnstone, a forty-five-year-old American who worked as a superintendent in the logging division at Whonnock Timber. He had been previously married and had three grown-up sons living in the US. By all accounts he was quite a good logger, but his real passion was horses. He was also a smoker and a very heavy drinker, but he clearly had the ability to charm and Lucille had fallen under his spell.

Jimmy Gibson remembers being at the regular Wednesday noon meeting in Cecil's office at which Lucille announced that she and Joe were getting married. "I tell you that you could have heard a pin drop. I can still to this day remember the look on Paul Cliff's face and him saying, 'You got to be out of your mind, woman!'" Mike Dunn was also pretty outspoken in his view of the marriage. "I don't know how the hell Lucille ever got tangled up with him. Smart as Lucille was, I think that was one of the dumbest things she ever did in her life." And Cliff Julseth commented, "I think one of the attractions to Joe was that he needed help, and she was going to save him from himself."

They were married in Las Vegas and that November they bought a small farm in Maple Ridge at 12607–216 Street. But Joe's cavalier attitude became evident to Lucille's family even before they were settled in. Her sister Betty Martel remembers:

> We didn't meet Joe until after they were married and we went down to the airport to meet them. Once they got their place in Haney [Maple Ridge] we saw a lot of them. I remember we were burning the boxes after they moved into their home there, and Joe unpacked the box with Lucille's china in it and put it outside

where we had this big bonfire going. My husband, Auguste, picked the box up and threw it on the fire. Well, guess what? Joe hadn't unpacked all the dishes and there was Lucille's beautiful American Rose Royal Albert china still in there wrapped in tissue paper, so we ran down and rescued it! Later we laughed about it but it wasn't funny at the time.

Joe continued on the job at Whonnock for four more years and during that time he and Lucille worked on their property on holidays and weekends to turn it into a horse-boarding facility and hobby farm. After he left Whonnock in September 1967, Joe directed his energies into owning and training racehorses. Not surprisingly, this was a money-wasting rather than a money-making enterprise. He went back to logging briefly before finally giving it up in 1971 and returning to the wasting and spending of even more money—though now it was Lucille's income he spent. He was also gambling and drinking very heavily by this time.

Lucille's sister remembers the lifestyle at the Maple Ridge farm:

Our whole family went out there on weekends. There were always projects going on there and everyone had fun, everybody laughed, there was lots of food and nobody ever went home hungry. Lucille has always been a very early riser and she would be up and have all the food prepared first thing in the morning—the meat ready to go in the oven, the potatoes peeled, the vegetables ready—and when we came to have dinner she would seat twenty-five people around her dining-room table and it would never even fizz on her that she was doing this monumental thing. It was just part of her lifestyle.

Lucille's memories of the Maple Ridge farm, however, centred on the collection of animals they raised:

Lucille's second marriage came as a surprise to everyone. At age 39, in November 1963, she married Joe Johnstone, an American who worked as a superintendent in logging. Joe and Lucille were married for eighteen years and brought up three adopted children together.

Life would not have been complete at our Maple Ridge farm without the menagerie that chose to call it home. Most of them arrived on our doorstep through the auspices of our city friends who grew tired of their pets or found their habits were not acceptable in the big city. Where else would Teddy Osborne bring Sam the pigeon? Teddy was a logger on the Sechelt Peninsula and the local bar had a pet pigeon. Teddy grew fond of Sam and decided to take him home to his place in the British Properties where Sam was banished to the outdoors. He frequented the hanging baskets around the pool and frequently pooped in the pool. So Sam ended up in Maple Ridge. He moved back indoors and flew happily throughout our house, perching in the beams on our high open ceilings. It was best to inspect the floor of the shower carefully before stepping in just in case Sam had been there ahead of you. My husband thought this was hilarious, though I was not of the same mind. However, Sam sealed his fate one day shortly after arrival. My husband's pride was the seafood cocktails he created in special dishes with cracked ice in the bottom. These cocktails, complete with his own Thousand Island dressing, were made with lemon wedges draped daintily on the side and set out on the table ready for dinner. It was at this crucial moment that Sam decided to look down from the ceiling beam above the table and—purposely or otherwise—make his daily deposit where it should never have been made! It was the end of Sam's retirement to the farm.

But peace was not to last. Along came a huge white turkey gobbler called "The Duke" who was a hater of women—particularly me. If I was up the ladder painting, there was The Duke at the bottom waiting for me to descend to get me on the leg. When I left the house to go to the barn, I would hear The Duke after me, and one day when I was en route with two cups of very hot coffee in my hands, he came after me. I poured both of them over his red head and he didn't even flinch. My husband finally taught me to drop whatever I had in my hands, grab the

gobbler by the throat and squeeze until he ran out of breath and fell gasping. Then I could escape.

When our friend Ernie Kehler sold his Surrey farm, the purchasers did not want the lovely white swan that inhabited his pond, so it came to our Maple Ridge pond. It looked particularly lovely drifting across the water within sight of our kitchen and living room windows. The only problem was that it was lonely and would frequently take off. Everyone in the neighbourhood knew we had a swan and would phone to say they had locked it up in their garage, and I would go rescue him and pay a finder's fee. Then one day the swan went missing. And in that week's local paper there was a front-page story about folks having found a swan. They had phoned the Stanley Park zoo curator, who came out, immediately recognized him as being from Stanley Park and took him back to Lost Lagoon. I don't know how he recognized him because Ernie had that swan for years before he came to us, but how grateful I was to no longer have to rescue him and bring him home.

Our pond was strangely empty thereafter—until the wild ducks took up residence in it. These mallards were very prolific, and once between the house and the barn I spotted a large nest of their eggs. They were stacked two deep and I counted forty-five in all, and there were two female ducks taking turns sitting on them. I was concerned that the lower layer of eggs would never hatch so I decided to help Mother Nature along and prepared a wider nesting area with the eggs single layered. The next morning I went out to see how the ducks liked my help and found they had worked diligently to roll the eggs back on top of each other and were happily sitting on them. Ultimately they all hatched and what a sight it was to see two mother ducks going down to the pond each morning with forty-five ducklings in a single line waddling down to the water and providing entertainment for us and for our guests.

Then there was Captain Bligh, the three-legged goat. As

people who have been involved with horses will know goats are often used in the stalls of racehorses to calm them down. Such a goat lived in Exhibition Park but he was unusual because he had but three legs and only one eye. When his owner decided not to keep him any longer, my husband brought him home in the back of his Buick convertible. What a sight that must have been on the freeway! The Captain wandered around our property at will—which was clear to all who came to visit because there wasn't a green leaf left on any shrub up to four feet from the ground, the precise distance that he could reach to devour them.

Tismine was a lovely mare but at age eleven had been retired from racing and my husband decided to breed her. Tismine, however, had no desire to participate in such a performance, and I was enlisted to assist. My job was to hold a hundred-pound potato sack over Tismine's face so she could not see what was happening—an embarrassing involvement! But what made it even more embarrassing was that a housing development had been constructed along our driveway and the housewives sat having their coffee and getting great entertainment from this unusual show. Tismine eventually produced a lovely foal.

Joe did not pull his weight in managing either their home or the farm. Lucille's brother Leslie tells the story of a barn raising at the Maple Ridge farm:

> I went out there one Sunday and they were building a sort of barn. My dad was there, Betty and Auguste, also Lucille, of course. We were putting the roof on this thing. It was a nice day but pretty hot and we were working hard and I said, "Where's Joe?" Lucille said he was lying down. I went up to the house and there he was lying on the chesterfield watching TV. I never went back, not me.

(Left to right) Lisa, Charlie and John Johnstone, the three adopted children of Joe and Lucille Johnstone. Charlie, the oldest, was adopted in 1967, after Joe found him standing alone in diapers in a gravel pit near Hope, BC. John was adopted in 1969 and Lisa in 1971.

Betty's husband Auguste remembers Joe as quite a storyteller:

> You never knew what was true and what was not. You never knew whether to believe him. He liked to make a splash and create an impression. If he wanted to impress anyone, boy, he could. He had a big convertible and he loved to go to Vancouver and he would be dressed to perfection. He was a big spender. Once at a restaurant dinner, he insisted that everyone drink champagne all night. When it came time to tip the staff, he tore a fifty-dollar bill in half and told the waiter and waitress that they would have to get together if they wanted the tip.

Betty agreed:

> My mother used to get so upset with him but if you met him, he was a charming fellow. My kids loved him when they were young. Oh yeah, Uncle Joe was a really fun fellow. Uncle Joe was good to them. They didn't see the other side of Uncle Joe.
>
> I just think of all the projects that he started and Lucille tried her best to make sure that they went through. He built a moat with a bulldozer and had water all around this island. Then he decided to build this four-storey chicken house on the island and put a walkway over to it. And we went up there to help put this together!

One day in 1967 Joe Johnstone spotted a small Native boy in diapers standing in a gravel pit in the Hope area. He piled him into his convertible and took him to the home of Norm Cosulich. "He said he was taking the kid home to Lucille," Norm explained. "So our kids and the neighbour's kids who were there at the time put the kid into the bathtub and cleaned him all up before Joe took him home." The child, Charlie, was from the Ts'kw'aylaxw First Nation and suffered from fetal alcohol syndrome. Lucille and Joe arranged to adopt him. That Christmas Joe bought a pony for Charlie, marching the animal right through

the house to the Christmas tree. It was the first of many extravagant and often inappropriate gifts that Joe gave the boy.

In 1969 the Johnstones adopted another Native boy. John was from the Leq'á:mel First Nation and already two and a half when he came to live with them. Lisa, their third adopted Native child, came to them as a baby in 1971.

SEVEN

Financial Savvy

Although River Towing had been known for years as "Rivtow," it was not until 1964 that all of the companies Cecil Cosulich had acquired were consolidated under the name of Rivtow Marine. The company's ships began flaunting the Rivtow colours: black hulls and turquoise and white cabins. The name was also a subtle way of announcing that the company was now operating outside the confines of the Fraser River. The combined assets of River Towing, M.R. Cliff Tugboat, Canyon Towing, Towers Towing, Pioneer Towing, Coast Cargo Services and Raake Marine Services gave Rivtow eight tugs on the Skeena River and twenty-five on the Fraser, as well as the beginnings of a coastal fleet of tugs and barges—more than sixty boats in all. Rivtow was now a serious contender in the fight for control of the towing industry.

But the company wasn't out of the financial woods, and Lucille still carefully weighed out who could be paid and who couldn't. Myrna Eager joined Rivtow in 1964 to handle payables.

At a dinner put on in Lucille's honour by the Fraser River Discovery Centre Society in June 2004, Myrna said:

FINANCIAL SAVVY

When I came to Rivtow I had a background in truck transportation and inside sales for a national manufacturer of building products. My most relevant job had been a year in accounting with a national construction firm where I obtained some scant accounts payable experience. However, after only a day and a half at my new job, I realized that nothing in my past had prepared me for Rivtow.

Accounts payable in the construction industry is basic: you pay the accounts timely or construction stops. At Rivtow I was quickly introduced to the fine art of managing aged and aging accounts payable. Rivtow reconciled and recorded supplier invoices in their A/P ledger or synoptic ledger. However, these vouchers did not result in issuance of cheques immediately. They were stacked in baskets, and the baskets were then stowed on shelves in a long narrow windowless room called the vault where they remained until funds were available to pay. That is, there would be a February basket, a March basket, April, May and June baskets, et cetera. Most suppliers had past due accounts and they telephoned biweekly; the larger key accounts called weekly.

My instructions were basic: in addition to recording the invoices, it was also my job to advise suppliers that I had included their name on Friday's cheque run. This I did. For the first couple of weeks, the job went well. Of course, the following week when they did not receive a cheque, they called me back, often sounding a bit brisk and curt. I would be more specific during this follow-up call. I would confirm that they were definitely on the next week's listing. I also included related notes—for example, that they were missed off the last cheque run—and I noted the amount they requested. I would also include detailed notes of what they said and their tone of voice.

It didn't take these suppliers long to figure out that I was not going to be of much help. If they were exasperated enough, they would raise their voices and use tugboat language. Some even told me to advise my management that, if they did not receive

a substantial cheque immediately, there would be "hell to pay" which I knew translated into "no more deliveries."

The first time this happened, I shook in my boots! I remembered that "hell to pay" in the construction industry meant that construction would stop and that the national president from Toronto would be on the phone and/or on a plane and my boss might be fired—but that first he would fire me. At Rivtow I learned to report this kind of supplier message to my immediate supervisor, one of Lucille's accountants, who referred to Lucille as "Moneybags"—an endearing term I soon adopted. He considered this a fitting name since she was the only one to decide if we had enough cash to mail cheques when Friday rolled around. So I continued to add each customer to my growing Friday list complete with the urgent details concerning "hell to pay" or whatever. Soon, however, the most exasperated key suppliers would go on up the line and get right to Lucille, right over my head and the head of her accountant. But he said this was okay as Moneybags herself managed the cash at Rivtow, and she could handle any supplier all by herself.

I was in awe of Moneybags. I learned that Lucille knew all the suppliers and would in most instances accept or return all of their direct calls. And I often heard her talking to them. She would graciously appease them with lots of understanding as to why they needed cash on their accounts immediately. I thought at the time how she often sounded more like she was their bank manager, not the debtor. She was not at all embarrassed, not apologetic and never appeared nervous and squeamish as I did.

Then one time a very upset supplier who we had obviously dropped off our previous Friday list called me direct. He had my name, and by this time I sensed he thought *I* was the reason they hadn't got their cheque. This time, Moneybags—as I now privately and reverently referred to her—was in a meeting. So when I got the call, this irate supplier really took off on me when I got to the part where I said I would be sure to have his name

on the next Friday cheque list. He was using all kinds of tugboat language, and then finally he made the dreaded threat: "Effective this date Rivtow's grub supply is cut off!"

It was just me there with this hot call! I knew he was a biggie: he had a whole basket to himself. And I knew by this time in my tenure at Rivtow that the tugboat business needed certain key suppliers for basic goods because the purchasing agent had clued me in. Fuel, engine parts and grub were the key components of running a tug business. "Don't ever screw around with those type of accounts," he had tipped me off in my very first week. But the head dispatcher had told me that "grub accounts" were the most critical item. And for dramatic effect, he had also added, "If you screw up and grub deliveries are delayed or cut off, God help you." He said those big bruisers on the tugs would be down and clean my clock, et cetera.

I went into silent hysteria, affecting my respiration and my colouring, and went off to track down Moneybags and tell her the whole nine yards. She remained calm, but I knew she must have been irked. Then she asked me to bring my coffee into her office and together we would call him. Wow! I was invited into Moneybags' office. Bad news. I would hear her apologize for my ineptness. This would be embarrassing. But not so. How cool it was to watch her at work in the fine art of gentle persuasion. Moneybags got him on the phone and even called him by his first name. God, she even knew him, too. They had a nice chat about one of his kids graduating, about Rivtow's newest and largest ocean-going vessels and about how this meant more crew to feed. Clever Moneybags. I chuckled.

Pretty soon she was saying, "I have my accounts payable supervisor here and she advises that you were upset with Rivtow." There was a long pause while I squirmed. I expected she'd let me take the fall. But then she said "and we always pay and we always will" and "things are slow for us right now, too" and "yes, and we appreciate your support also" and "yes, we too have noticed that

our costs are creeping up, and by the way we did accept your recent price increase." And next thing I knew she was writing fast and talking at the same time and advising him she would review his account with me and we would authorize a payment for him. She had not blamed me. She told him goodbye and hung up. Then she told me to resume breathing! Everything would be fine, and she passed me her notes with the details of the payment arrangement.

I was dazzled! But I was also relieved and grateful. I got back to my desk and looked down at her notes, the first of many I was to receive from Moneybags over the course of the next twenty-two years. The note was half in English; the other half I would learn later was Pitman shorthand. The only info I could fathom was the numeric symbols for 50 percent and three times a reference to the number 3 and three times the fraction 1/3. Her secretary deciphered for me. It was typical of future notes I would receive from Moneybags. Generally they were instructions to pay 50 percent of the oldest statements in three separate cheques, mail a third today, a third next Monday and a third later. Later? It was already late! But I was well underway in my apprenticeship and I was surviving.

I would learn that Moneybags was more than just your run-of-the-mill CFO—much more. Here was a brilliant cash manager, managing cash we never had! I soon discovered she was also the most creative problem-solver and deal-maker I would ever meet—and after forty years I have met many! It so boggled my mind what she could propose and what she was able to sell to her associates, her bankers and to people whose businesses she acquired. She designed, proposed and finalized deals that would so boggle their minds that they would be left with gaping mouths long after the ink of their consenting signatures had dried and faded.

She was able to stretch a buck further than anyone could ever imagine. You can talk about expanding the soup by doubling the

water, or you can compare what she did to the miracle of the two fish and the five loaves, but when it came to our Moneybags, she was magnificent! In fact, at some point in her Rivtow career, her prowess in successful loan applications was evidenced by a beautiful gold plaque displayed in her office. It was given to her from her favourite bank at that time, who recognized their best customer, their best friend and the largest loan in their history!

It's no secret that it was Moneybags with her creative deal-making that enabled Rivtow's amazing growth into the very successful mini-conglomerate it became.

~~~~~

Lucille, who at this point had already been juggling the company's finances for nearly sixteen years, looked on these transactions much more calmly:

> We had major accounts with Hoffars for our GM parts and with Sid Vernon down on Marine. In the winter we had reduced revenue so at the end of October I would figure out how much we owed them and how much a month I could afford to pay each of them until spring, and then I would phone and say, "Sid, I need your help. I can only send you $150 a month. You know you will get it, but will you carry me one more winter?" He would say, "I will think about it and let you know." Then I would phone Norman at Western Machine Works and tell him how much a month I could give him. "We'll talk it over and see if we can carry you," he would say. The same thing would happen at Auto Marine. It wasn't until twenty-five years later I met Sid Vernon socially one evening, and he said, "Lucille, you didn't realize what was happening. Pete and Norman and I would go down to the Terminal City Club and have lunch and say, 'So, shall we carry her one more year?' and we'd agree to go along." It was friends like that who were so loyal and helped us to grow. You know you never really forget it.

Lucille performed the inaugural swing of a champagne bottle at the *Rivtow Norseman*'s bow as the mammoth barge was added to Rivtow's fleet.

Imperial Oil was absolutely fabulous to us. They gave us 120-day credit, no questions asked. And so in the later days when we were buying eight million gallons of diesel a year, Cecil always insisted that the crews buy from Imperial Oil because without them we wouldn't be in business.

I remember one of our creditors phoning me when his dad died and saying, "Lucille, we have to pay some estate taxes. Do you think you could pay something on your account?" I said, "I will certainly throw something together, Art. How far back are we?" And he said, "Some of it is two years old." So we paid something. We always paid whatever we committed to. I think that's what people respect.

While Lucille was known throughout the industry for her "creative deal-making," she was also a legend for the innovative ways in which she saved Rivtow money. One of those opportunities came along in the mid-1960s. Every year Rivtow paid taxes to the provincial government on its log storage water leases, based on the surface area the company's log booms occupied. (One single standard log boom is sixty-six feet wide and about four hundred feet long and therefore covers over twenty-five thousand square feet of storage area.) For Rivtow the total tax was more than $250,000 annually. Then a friend of Lucille's happened to read the fine print in the provincial legislation covering water leases and realized that all the government could rightfully charge for was a much smaller area—the part of the seabed or riverbed penetrated by the dolphins or pilings to which the booms were fastened. Lucille appealed Rivtow's assessment and won the appeal, saving the company $250,000 that year. It was a one-time win, however; before the next year the legislation was revised and charges were assessed on water surface used.

***

Adequate log storage leases were a continuing problem for towing companies like Rivtow and it fell to Lucille to find new ones in the right places. As business in Howe Sound grew, it became apparent that the company would need more tie-ups there, but the best ones were already held by Straits Towing. In particular, Straits had considerable holdings in West Bay on Gambier Island and held the leases along the waterfront of these properties for log storage. These leases, however, covered only narrow strips to accommodate a single line of booms, and aerial photographs showed that Straits was storing its booms four to six deep into the bay, far outside the lease limits. Lucille realized that this provided an opportunity for Rivtow:

> I focused on West Bay to find a solution to Rivtow's need for storage. Near the outer end of the bay, Winram owned 120 acres with some waterfront on the West Bay side, so I made a rental deal with him for his foreshore with an option to purchase the

entire 120 acres for $1,000 per acre, a total of $120,000. How I wish we had been able to exercise the option!

I also discovered a rocky islet in the bay a modest distance from Winram's property and deduced that this islet could be made into a significant "anchor" for boom storage. I hired a surveyor and we filed a plan for log storage in West Bay that would encroach significantly on the water area being used by Straits but on which they had no lease or rights. My plan did not go near the Straits-owned foreshore and didn't block its access to their legally filed foreshore lots or their upland. Thus their consent was not required.

When this application was processed and approved, Straits were very annoyed—and understandably so—but the fact remained that they had tried to save some modest lease fees, and in doing so they lost considerable storage space and the exclusive use of West Bay for log storage.

---

On October 26, 1968, Cecil Cosulich told reporters that Rivtow had just signed a ten-year contract with MacMillan Bloedel to haul logs from its expanded Kitimat operation to sawmills on Vancouver Island. Yarrows shipyards in Esquimalt would be receiving his order the following week for the four-hundred-foot barge that would do the job. The largest barge on the coast, it would be equipped with two cranes for loading and unloading and would carry three million board feet of logs. Estimated cost was between two and three million dollars.

Cecil and his brother Norman then set off for Sweden to look at the 158-foot tug *Tenacity*, the sister to the company's *Rivtow Lion*, which the *Province* newspaper described as "one of the most efficient deep-sea salvage ships afloat." Originally a steam tug, the *Tenacity* had already been converted and was powered by twin Ruston & Hornsby diesels, 2,050 brake horsepower each, geared to a single screw. After the purchase on January 18, 1969, the new tug was rechristened *Rivtow Viking* and brought home to tow the barge under construction at Yarrows.

# FINANCIAL SAVVY

On Saturday, May 31, 1969, Lucille Johnstone, now Rivtow's vice-president of administration, swung the customary bottle of champagne at the bow of the new boat—the world's largest self-loading and unloading barge—before it slid down the ways at Yarrows. The *Rivtow Norseman* was four hundred feet long and eighty-four feet wide, could carry 3.5 million board feet of logs—and cost the company $2.5 million.

# EIGHT

## *Rivtow Straits*

Straits Towing was a very successful coastal company, specializing in scow and barge, booming ground and shipbuilding; the company's holdings included BC Marine Shipbuilders, the first shipyard constructed in the port of Vancouver in the 1890s. The company had thrived under the guidance of Senator Stanley McKeen; with his death George McKeen had become the company's president and Fred Brown was chairman of the board. Though publicly owned, most of the shares were held by the Brown and McKeen families. But by 1969 the company was in trouble, and just before Christmas that year Fred Brown phoned Rivtow to arrange a meeting with Cecil and Lucille. She explained:

> Straits had aging, non-aggressive staff, and we were the young upstarts. Mr. Brown saw that by putting the two companies together he could move Straits up into the upper echelon of coastal towing. In January 1970 we started negotiating to merge the two companies, being very careful to keep the talks secret because if it didn't pan out it would be disruptive to our customers. When Cecil and I would go down to Mr. Brown's office, we wouldn't

go together and we wouldn't even go up in the elevator together. I did all my work on the project at home so that the office staff wouldn't know what I was working on. We had agreed not to tell our families either, so when my husband asked what was keeping me so busy at home, I couldn't tell him. Then finally on June 30, 1970, at 4:00 p.m. we signed a deal for a share exchange that merged Rivtow and Straits. Afterwards we went back to the office and announced the deal to our staff. And that was a very interesting scene because it was a great surprise to everyone.

With the merger, Rivtow Straits became the largest tug and barge company in BC with 225 pieces of equipment, 750 employees and assets of more than $20 million. At the time Rivtow had two self-loading, self-dumping barges, the *Rivtow Carrier* and the *Rivtow Norseman*; Straits added a sister barge to the *Carrier*—the *Straits Logger*—as well as two other self-loading, self-dumping barges of lesser capacity.

The positions of board members and key officers had been predetermined during negotiations so that was not a problem. Fred Brown would continue as chairman of the board and George McKeen would become vice-president of finance. Cecil would be president of the merged company, Norman would be vice-president of operations, and I would be vice-president of administration. However, to persuade the tug crews to bury the competitive spirit of the past and become a single entity was a pressing challenge. It was apparent that neither crew wanted to change the fleet colour. Psychologically if Straits crew painted their wheelhouse in Rivtow's turquoise blue they were conceding that they had been taken over by Rivtow, and Rivtow's crews resisted painting their wheelhouses the emerald green that identified the Straits fleet.

A simple solution was found. We sent a couple of quarts of Rivtow turquoise blue and a couple of quarts of Straits emerald green to the General Paint Company and requested they blend the two in equal parts and send us a sample of the resultant

colour. We were pleased with the result—a pleasant green with a tinge of blue—and issued a bulletin that all fleet units would bear the new fleet colours as per sample. In a remarkably short time the entire fleet was freshly painted, all of them were flying the new house flag bearing the letters RSL and we moved on as a consolidated fleet.

I knew from disclosures during negotiations that Straits had been paying regular dividends to its shareholders but they had not maintained their boats. After the merger we discovered that some units were as much as two years beyond the due date for major maintenance. So we stopped paying dividends and started to rebuild the fleet. As usual, the problem was how to pay for the work. However, Straits had an extensive fleet of chip barges, and when I analyzed the rates being charged for these units, I was astounded at how low they were. I recommended an immediate increase from eight cents to fourteen cents per unit, a rate I felt was thoroughly justified. I also knew that it would be impossible for the mills to find other barges to replace the thirty-eight chip barges in our fleet, and that if they had to build new ones, they could not do so and operate them for the figure we were asking.

When our competition, Seaspan—which had been formed by the recent merger of Vancouver Tugboat Company, owned by the Jones family, and Island Tug and Barge, owned by the Elworthy family—heard about our outrageous increases, they reviewed their own pricing structuring, which was also in the eight-cents-per-unit range. It wasn't long before I got a call informing us that our figures were wrong—we only needed to go up to thirteen and a half cents, not fourteen cents! We didn't even bother to challenge their figures!

Sixteen months after the merger of Rivtow and Straits Towing, the new company suffered a near disaster. On October 21, in the midst of a sixty-mile-an-hour gale off the northwest tip of Vancouver Island, the

towline of the *Rivtow Viking* snapped and the $2.5-million barge *Rivtow Norseman*—carrying 3 million board feet of logs destined for mills in Port Alberni—was swept onto tiny Cox Island. Her bow rested firmly on the rocks in perfect condition but the hull had broken in two and the stern lay at right angles where it was battered by the pounding seas. The logs were salvaged from the beach but attempts to salvage the barge had to be abandoned. Lucille recalled:

> It was beyond salvage, a complete writeoff. It still sits on Cox Island to this day.
>
> At this time the shipyards of the world were fully booked building supertankers for the oil industry. The best quote I could get for replacing the *Norseman* was $10 million—four times the barge's original cost on which our contract rates with MacMillan Bloedel were based. And here we were locked into a ten-year contract with no equipment to fulfill our obligations, and MacMillan Bloedel would not release us from the contract. There was the smell of disaster in the air!
>
> However, where there's a will there's a way. It turned out that MacMillan Bloedel had two 7,500-ton flat-deck self-dumping log barges, the *Powell Carrier* and the *Alberni Carrier*, out on the East Coast that they no longer needed. We bought these two barges and brought them to the West Coast, then purchased a Manitowoc 4600 crane and mounted it on a separate barge in Kitimat. The solution was to load one of the 7,500-ton self-dumping barges in Kitimat and while it was being towed to its destination and returned to Kitimat, the crane crew would be loading the second 7,500-ton barge ready for tow and delivery. This system worked out fine and we were able to move the logs quickly enough to satisfy the customers' needs and complete our ten-year commitment. After the contract was completed the *Powell Carrier* was used to deliver pulp from Powell River to Los Angeles. The *Alberni Carrier* was used to move various commodities such as gravel and sand.

**ANNE M. STEWART, Q.C.:** I met Lucille in 1975 when I was an articled student with Davis & Company. Though John Pearson was Rivtow's principal lawyer, he introduced me to Rivtow, and Lucille and I did all kinds of transactions together. I would get information on a transaction; it would come in typed up as if it was meant to be an agreement, but there would be typing mistakes and half-completed thoughts because it had been typed from Lucille's shorthand notes. I would start delving into it and it would be like an onion, layer upon layer upon layer of transactions, not necessarily just involving those two people. It might be that one person had this, so they would trade this to this other person and this other person would provide something to help with the transaction.

Lucille had some remarkable traits—this amazing ability to accomplish what she wanted, a dogged determination to get things done. The will. The vision. She saw where she wanted to go and nothing would stop her from getting there. It did not matter what happened, she would just keep going on that path. I don't think that fear of failure was within her framework. And she had this creativity—"if I can't get there through this straight line, what kind of roundabout path do I have to take that will eventually get me there?" But I think one of her biggest strengths—which people did not necessarily recognize as a strength—was her willingness to ask for help.

We had a dinner years and years and years ago to celebrate the closing of one of the transactions. We gave her a big book with a title in gold on the front: "Lucille M. Johnstone, My Negotiating Secrets." The whole book was blank. We told her that she should fill in the blank pages. Unfortunately, she never did.

Meanwhile, all was not well in the merged company and because most of the conflict centred on money it became Lucille's task to find solutions. She explained:

> In the merger we were the poor church mice and our partners were the wealthy ones, so we had wanted protection in case they might want to buy us out or vice versa. We didn't think we would ever be able to take them out because we didn't have the money. So we arranged that if we received an offer from them and we didn't want to accept it, we would have the option to buy them out for the same price, but we would only have to pay 25 percent down and the rest over two years.
>
> After a few years our partners became a little unhappy that all we wanted to do was to keep growing the company and not pay out dividends, and they made a cash offer to buy our shares for $2.85 each. This would have given our shareholders about $5.5 million, if I remember correctly. Cecil, Norman and I [who owned most of Rivtow's shares] talked it over, but what it came down to was: what would we do with all that money? Did we really want to start anew at our age?
>
> As it happened, one of the people who had bought some shares in Rivtow Straits when we merged had applied to borrow money from Royal Bank on the security of his shares. The bank manager said he would take them as security only if Cecil, Norm and I would buy them for an agreed price if and when the bank demanded. We had consented to do this but only on the condition that, if we ever had a call from our Straits partners, the bank would lend us 25 percent of the cost of the shares so that we could buy them out. And the bank agreed in writing. But when that day came and we went to borrow the 25 percent, the bank's head office said no, and I had to remind them that we had a letter of commitment to make the loan. So we got the 25 percent but Norm, Cecil and I had to personally guarantee the loan.

Now we had to figure out how to pay that back to the bank as well as pay the remaining 75 percent on the shares because as usual we didn't have the money. Well, it turned out that in that particular year Revenue Canada had brought in a ruling that, if you had a pre-1971 surplus, you could distribute it as a dividend without tax consequences. We declared a dividend of $3.10 a share out of the surplus of the company and borrowed the money from the bank to pay the dividend. Then we used some of these funds to pay off the balance due to the sellers of the shares.

The bank forced us to retain the rest of the funds in the company as shareholders' loans so we never got any of the cash dividend, but we now owned the entire company. That tax deal was just a little fluke I found out about in the Income Tax Act. I went to our auditors at the time and they confirmed it would work, so that's how we managed to buy them out. That was one of my better moves actually—my training as a CGA had paid off!

Back when we first merged with Straits we had become a quasi-public company because Straits was listed on the Vancouver Stock Exchange, but the amount of trading in the stock was very light. But try as we might, we hadn't been able to acquire more than 50 percent of the stock, and we had ended up with something like 48.7 percent. So between Norman and Cecil and I we would buy every share that came on the market until we had 50.1 percent. That was something I had felt much more comfortable about. Being minority shareholders was not what we wanted to be.

In 1978 Cecil, Norman and Lucille acquired the stock held by two estates that had been major Straits shareholders, applied for delisting and re-privatized the company.

NINE

## *Diversifying: RivQuip*

Back in the late 1960s a slump in forest product sales caused Rivtow to look at diversifying its business. Within a few years Cecil and Lucille had managed to reduce the company's forestry-related business to about 65 percent. Lucille recalled that this was accomplished first by "buying shipyards, small shipyards. We had seven small shipyards at one time." Among them were John Manly and West Coast Salvage, which did vessel repairs and built fish boats, boom boats and other specialty craft. "Then," said Lucille, "Cecil decided that we should own gravel pits because then we could move gravel on our barges when they were idle. This was not a bad idea."

Rivtow's Pacific Rim Aggregates on Sechelt Inlet was the second-largest concrete aggregate producer in BC. But in a profile that appeared in the *Province* in September 1974, Lucille downplayed the scope of the operation:

> "When I first got into this business, I thought gravel was, well, gravel. But I've since learned the hard way that it's just not so. There's ready-mix, paving sand, asphalt mixes, some just for pit

runs, some not—and they're not all the same." And why should it be necessary for a vice-president of administration to be able to tell one kind of gravel from another? Because Lucille Johnstone's periodic checks of equipment pointed up the necessity to keep all of it working as much of the time as possible to have loads accessible which could be moved on otherwise-idle scow days. Some deliberation and discussion, then the decision to buy into aggregate pits, so that Rivtow would have its own sand and gravel to move when its barges and scows weren't already booked by a client. That, in turn, led to a ready-mix business in Prince Rupert, then a shipyard, and so it went.

In fact, Rivtow had bought three ready-mix plants—one in each of Prince Rupert, Kelowna and Nelson. Unfortunately, Rivtow's merger with Straits in 1970 pushed the consolidated operation's percentage of forestry-related business up again, this time close to 93 percent of revenues. Cecil and Lucille were once again concerned they would be in a vulnerable position if there was a major downturn in the forestry sector. When BC's first towboat strike occurred later that year, a badly shaken Rivtow Straits decided to diversify as quickly as it decently could. As a result, by 1974 it was well into the industrial equipment business and had set up a new division of the company called RivQuip. Lucille explained how it got started:

> Cecil's friend John Maier and a partner had acquired Purves Ritchie Limited, which focused on the distribution of light industrial equipment as well as the rental and servicing of this equipment. The company had knowledgeable management staff so it was a profitable enterprise for us to buy into. We negotiated the purchase, giving Purves Ritchie shareholders Rivtow Straits stock in exchange for Purves Ritchie equity.

Rivtow followed this with the purchase of Western Tractor in Saskatchewan. But it was their next move into the heavy

equipment business that Lucille would describe as "a courageous gulp":

> There was a company in Vancouver called Dietrich-Collins Equipment that sold large equipment to major mining, forestry and oil companies. It was run by John Richmond and Terry Godsall and by 1975 it was on the verge of bankruptcy, due in part to the loss of the Terex franchise.

Though a global company now, manufacturing a wide array of construction, road-building and mining equipment, Terex was primarily known in those days for its mining trucks and excavators. This equipment had been the mainstay of Dietrich-Collins' business during the 1960s and early '70s when the extractive industries were becoming increasingly automated. However, when North America slid into the downturn of the mid-1970s, mining companies were the first to cancel orders for new equipment. When sales fell off, Terex refused to renew Dietrich-Collins' franchise contract. Lucille recalled:

> Dietrich-Collins was left with existing large overheads but insufficient sales volume from its other franchises for derricks, trucks and drills for support. Its biggest account was with the Harnischfeger Corporation, which made and sold P&H Mining shovels; Dietrich-Collins was doing about $1.4 million in annual sales of P&H parts alone.
>
> Rivtow Straits negotiated to purchase 49 percent of Dietrich-Collins Equipment's equity for $1,000 and the assumption of the company's debts, with an option to buy the remaining 51 percent for $51,000. We were well into the acquisition when we found a lot of problems that hadn't surfaced when we had examined the audited statements, but it was too late to back out. It turned out that when Dietrich-Collins was about to falter into bankruptcy, it had on hand about $3-million-worth of Harnischfeger parts, which the company hadn't paid for and which were

unsecured. Cecil and I flew down to Harnischfeger's head office in Milwaukee and made them an offer: Rivtow would pay the $3 million for the parts over five years with no interest, provided that Harnischfeger guaranteed that Dietrich-Collins Equipment could keep the P&H shovel franchise for Western Canada for a minimum of ten years. This was highly unusual because representational agreements of this sort are usually cancellable at the option of the manufacturer on thirty-day notice. Even more unusual was the fact that Dietrich-Collins had been the only distributor of P&H shovels in the world; in all other countries they were sold direct from the factory. But our proposal suited Harnischfeger because they knew they would recover the $3 million for the parts over time rather than face a substantial bad debt, which they could ill afford. It was a win for us because we would have ten years to make enough to cover the $3 million obligation—and more. So the deal was signed and we sold P&H shovels exclusively for the next ten years, and during that time there were no other shovels of this type sold in BC.

During the period that we were committed to monthly payments to Harnischfeger for the $3 million in parts inventory, we were also indebted to them for new purchases of P&H parts, so it was not infrequent that the month-end cheques going to Milwaukee would be about $1 million. We were often hard pressed to cover them. The company accountant assured me not to worry. He would put the cheque in the mail and guarantee that it would not arrive in Milwaukee in less than six to seven days, by which time our cash receipts would cover the cheque. I was apprehensive as the mails were uneven and sometimes deliveries were virtually overnight, but our accountant proudly explained his system to me. At the roadside in front of our office was a bright red Canada Post mailbox. One simply opened the lid and dumped in the mail, which was then picked up by Canada Post between 4:00 and 5:00 p.m. each weekday. The difference in our accountant's system was that, if he had an envelope which

he did not want to be picked up in a hurry, he opened the lid and stuck the letter to the inside top of the mailbox with chewing gum. His tests of this system had given him comfort that the letter would not drop into the mailbox for at least five days. In the meantime he could honestly and safely assure the accountant in Milwaukee that the cheque was in the mail! Unfortunately for the accountant, his system offended my ethical principles, and there was no more use of chewing gum after I heard the story.

But the story of P&H had an unexpected ending. Lucille continued the story:

> At the end of the ten-year period Harnischfeger announced that we had done a terrific job of selling P&H shovels, so terrific, in fact, that they were terminating our franchise and would be selling their shovels directly on their own. We were cut off on thirty-day notice after doing such a good job. I was enraged. Cecil and John Rumble, who was general manager of Dietrich-Collins, flew down to Milwaukee to meet with the new CEO of P&H, whose name escapes me—but he was referred to by a nickname that was far from flattering. This hard-nosed businessman would not budge and Cecil and John came back and said they wouldn't give us ten cents.
>
> After how hard we worked to pay off that $3 million, I wouldn't accept that. Cecil cautioned me that I would get the same treatment they had received, but I was determined and made an appointment to meet this man. When I got to P&H's offices in Milwaukee, he was waiting for me at a table in their large boardroom with six other P&H executives. I had drafted a position paper and delivered it, making it clear that I had every intent of suing if a fair settlement was not achieved. I don't remember exactly what I said but I was pretty adamant. And I must have looked convincing because at the end of the meeting we were offered 5 percent of all parts sales in Western Canada

for the next two years, to be paid monthly. As it turned out, this came to only slightly less than a million dollars. It wasn't everything that I had wanted but I felt a lot better!

When I returned home, John Rumble suggested that we try to get the franchise for Marion shovels as we no longer had P&H shovels to sell. Marion Power Shovels had been trying to sell direct into Western Canada with no success because our P&H shovels had shut them out. We discovered they had no representation in Canada so John and I flew down to Marion, Ohio, to persuade them to make us their distributor for Western Canada—not a hard sell because of our success with P&H. We got the franchise and from that point forward P&H shovel sales ceased in BC and Alberta. Marion won the day and turned out to be very profitable.

In the late '70s Rivtow also acquired the Komatsu franchise, whose products replaced the Terex products that Dietrich-Collins had lost. But in selling Komatsu heavy equipment, which was made in Japan, Rivtow was challenging Finning Tractor & Equipment, which held the franchise for Caterpillar products, made in the US. The competition was minor at first because Finning had been selling Caterpillar tractors since 1932 and had built up a tremendous service and supply system, vitally necessary to the industry because customers could not afford to have expensive equipment sitting idle awaiting delivery of a three-hundred-dollar part. But as Komatsu sales began to cut into Caterpillar sales in the 1980s, the battle was on. The headline in the *Vancouver Sun*'s business section on Saturday, October 19, 1985, read: FINNING, RIVTOW GO HEAD-TO-HEAD IN BOISTEROUS BATTLE OF EQUIPMENT GIANTS, and it featured a photo of Lucille standing atop an enormous Komatsu tractor. She is quoted as saying, "The Komatsu line is actually the broadest range of construction machinery in the world. That's a fact that most people, even though they are familiar with the Komatsu name, have not really grown to appreciate." As for Finning and its investments outside Canada, she said, "We [Rivtow Straits] are not lumbering off around

the world with other ventures. This is the whole focus of where we're at and where we're going." But Lucille had great admiration for Finning's CEO, Vin Sood:

> An unsuccessful attempt was made by Finning Tractor to break into our market in the mining industry. Vin Sood was that company's very astute and aggressive CEO, and in my mind he initiated the growth that was the foundation for the tremendous success of Finning today. Unfortunately, he died at age fifty-two before he could enjoy seeing the fruits of his dynamic work, but during the period when he was at the helm of Finning, he realized that the Dietrich-Collins Equipment combination of P&H shovels and Wabco haul trucks along with Komatsu products was marring Finning's market for Caterpillar products. Vin, therefore, approached Harnischfeger to ask them to take the P&H franchise from Dietrich-Collins Equipment and give it to Finning. With our ten-year agreement in place, they couldn't give him what he wanted.
> 
> However, Vin was not a man to be daunted by little hurdles like that when he was focused on a goal. He returned to Vancouver and developed a strategy to buy the whole P&H (Harnischfeger) operation for the world, reasoning that if Finning owned the company surely he could sell P&H shovels in Dietrich-Collins Equipment's backyard. That deal was never consummated, but my admiration and respect for Vin was raised a few notches for his resilience and for thinking outside of the box.
> 
> During the ten years we held the franchise for P&H shovels, John Rumble realized that we urgently needed a franchise to sell large haul trucks for the mining industry, so we could sell trucks and shovels as a package deal customized to meet the buyer's needs. We wanted Wabco Haulpak mining trucks, but Rendell Tractor held that franchise and relied heavily on their sale to balance their books. Then we learned that they were giving up the Wabco line because they had run into difficulty when the

mining industry hit the low end of its cycle. They had about a half-million dollars in Wabco parts on their hands, and they wanted to be rid of the liability to pay for them, but Wabco was reluctant to take them back. This was an opportunity for us.

I went down to the Wabco factory in Peoria, Illinois, to meet their credit manager, a man by the name of Mr. Sumner—who turned out to be a very nice gentleman and later a good friend. Of course, I wanted the Wabco franchise, but as usual, Rivtow had no cash or credit line available to do the deal. However, where there's a will there's a way, and I opened the meeting by impressing on Mr. Sumner and the other Wabco staff who had joined the meeting what we could do for them as their distributor. Then I said, "That's the good news." The bad news was that I didn't have the cash to purchase the five hundred thousand dollars in parts that remained in Vancouver—I could not add five hundred thousand dollars in liabilities to our balance sheet or we would be in non-compliance on our covenant with the bank. However, I had a proposal to guarantee payment: the parts could be transferred to East Pacific Industries, who would issue Wabco a promissory note for the price. [East Pacific Industries was a shell company with ten dollars in equity.] Dietrich-Collins Equipment would sell the parts for East Pacific and would pay Wabco for those parts on the last day of each month. Wabco's security was Rivtow Straits' undertaking that, to the extent any of those parts went missing and/or were not paid for, Rivtow would make the payment. Mr. Sumner agreed to the deal, and I returned to Vancouver with the Wabco franchise and five hundred thousand dollars' worth of parts in inventory. We never put up one cent!

It turned out to be a wonderful deal. Wabco trucks became a much larger revenue producer for Dietrich-Collins Equipment than P&H shovels. At the time of acquiring the franchise, Wabco was producing 120-ton and 160-ton trucks, and they later developed a 190-ton truck, which was a great improvement in

# DIVERSIFYING: RIVQUIP

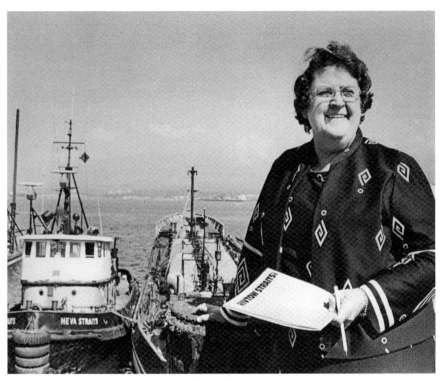

In the mid-1970s Rivtow Straits began to diversify its assets into heavy machinery and industrial equipment. They acquired the Komatsu franchise based in Japan, and began a serious competition with Finning Tractor & Equipment, based in the US.
Brian Kent / The *Vancouver Sun*.

reducing costs. The real breakthrough, however, was their design and successful testing of a 240-ton truck model that provided major cost reductions in truck haulage in places such as Arizona and Nevada. Mine operators in BC and Alberta, however, felt they would not work here. These large trucks were usually custom-produced for specific mines, but obviously we needed to have two or three of them operating in Canada to prove they would be beneficial here. So John Rumble and I were determined to rent three trucks out to some company in BC, preferably to Westar [which operated coal mines at Sparwood in the East Kootenays]; we knew they could not afford to purchase and that they were desperately trying to reduce costs. At last Westar

agreed to rent three trucks for six months at least, and Sam Belzberg at First City Capital agreed to finance the trucks and receive the rental as payment of principal and interest. Wabco agreed to carry the interest on the unpaid portion of the trucks if they came off rental and were not sold or re-rented. Thus we had a deal that Dietrich-Collins Equipment could live with.

As it turned out, those three 240-ton trucks rented to Westar proved their worth, and while the six-months' rental was still in

---

*John Pearson was a partner at Davis & Company and did legal work for Rivtow and associated companies from 1968 until he retired in 1987.*

When it came to acquiring companies, which Rivtow did on a regular basis for quite a number of years, Lucille, Cecil and Norman would decide what they wanted and then Lucille would try to figure out how to pay for it with a dollar down and a promise to pay sometime. My job was to check out all the titles to the assets and to make sure that, when they entered into an agreement, they would be getting what they were bargaining for. She knew all about taxation. In fact, she knew far more about taxes than I did, and I had studied taxation for two years at university. She had a mind that seemed able to handle numbers with great ease.

After I had been working with Lucille for some years she became interested in a company from England, and an Englishman came to Canada to negotiate the deal. I can remember taking him out to lunch with Lucille at the Vancouver Hotel, and after lunch I had a few moments of discussion with this charming gentleman. He said, "You know, Lucille is a really wonderful person, but she is actually two people. One of them is a kind, gentle motherly soul, but when the conversation turns to business, her face changes and she looks at you with gimlet eyes and rather stern demeanour."

It was true that Lucille had very strong willpower. She never seemed to have any reluctance to go into businesses that were quite different from the tugboat business. And she was not only very knowledgeable in

effect, Fording Coal [which mines metallurgical coal through its subsidiary Elk Valley Coal] asked to have them when Westar turned them back. And Fording not only took them but purchased more for their operations in BC and Alberta. Others did, too. I am not sure how many have now been sold in Western Canada, but by 2001, 175 of this 240-ton model had been sold at a price of about $2 million Canadian each, for a total of $350 million. Although the profit on the initial truck sale is only a

> acquiring these businesses but also in solving the problems related to the actual assimilation and development of businesses. You have to keep in mind that when you acquire a business, you also acquire the employees. You have to look after them—you get their pension plans, you get their internal management style, and you have to learn all about those details and live with them. Lucille deserves an incredible amount of credit for the fact that there was almost never any problem in those areas of the acquisitions.
> 
> Cecil used to develop the long-range plans and would spend time in the Vancouver Club meeting other businessmen and come up with new ideas and new companies to acquire. But my opinion is that, without Lucille, Rivtow simply could not have developed in the manner which it did, though I think that it would have carried on its tugboat business quite satisfactorily. What I am saying is not an adverse reflection on Cecil or Norman in any way, but the company became so extremely complex, and Lucille was the one who would burn the midnight oil to work out the details to make sure that there were no unpleasant surprises. In all the years that I worked with her, I never heard one word of criticism in any way related to her sound business advice or her honesty or any suggestion that she ever went back on her word in any matter and I never saw that in any way. She gave her word and then that is the way it went.

small percentage, there is a significant spinoff. A truck fleet costing $350 million will consume that amount in parts and body replacements during its first seven years, meaning a parts sale volume of $50 million annually on which a much higher margin of profit is achieved.

This was a great legacy for the Transwest Group, which purchased Dietrich-Collins Equipment from Rivtow, and for John Rumble, Al Cloke and Dennis Mathewson, the partners who all took comfortable early retirements in their fifties. I am reminded of the old adage that "giant oaks from little acorns grow," and I hope somewhere along the way those gentlemen remember the courage of Mr. Sumner in accepting my "Mickey Mouse" deal that became such a resounding success story for Wabco and for Dietrich-Collins Equipment and Transwest.

By 1978, as the result of industrial acquisitions, Rivtow Straits' traditional marine orientation had been reallocated to 37 percent of total revenue. To outsiders, everything looked perfectly rosy for Rivtow. On October 17, 1981, the *Financial Post* reported Rivtow's latest buy: Coneco Equipment of Edmonton, an equipment supplier with branches in Alberta and eastern BC. The Coneco purchase added three hundred workers; with the acquisition, Rivtow Group's gross revenues would be an estimated $274 million that year. In the article, Lucille surmised that revenues would top $1 billion by 1990 and said there was no plan to depart from the company's industrial equipment division. She also anticipated that Rivtow would not attempt further acquisition for a least a year while it got accustomed to the Coneco purchase.

"Rivtow has financed all but one of its takeovers using a mix of internal funds and bank borrowings," the article stated. "Johnstone, who has responsibility for financing acquisitions, is hoping that interest rates will have fallen by the time Rivtow is ready to renew its expansion through purchase." It concluded by stating that Rivtow could develop its six hundred hectares of waterfront holdings for recreational or industrial use.

By the time Rivtow's last acquisition took place in 1981—of Topper

Floats, a builder of floating docks—the company's non-marine operations had risen to about 50 percent of the total, a level they were able to maintain during the 1980s recession.

Lucille became a member of the Canadian Association of Equipment Distributors and, despite being the only woman in an association of over a hundred men, was elected president for two consecutive terms. As CAED president, Lucille was a director and a vice-president of the US-affiliated Associated Equipment Distributors—the first woman to hold a vice-presidency in AED's seventy-year history.

TEN

# The Family

Throughout the '70s while Lucille was steering Rivtow through the pains of its merger with Straits Towing and its expansion into industrial equipment, she was also dealing with a full range of family problems. In 1967 her parents had sold their property on Willingdon Avenue in Burnaby and moved to Maple Ridge to be closer to their daughter. Lucille was happy with this arrangement but her mother Myrtle's health soon began to deteriorate and she died in April 1975 at age 75. Soon after, Lucille's father Thomas had a stroke, though he recovered sufficiently to remain in the house for several years. However, when his memory started to fade, he moved to a ground-floor suite that Lucille's sister Betty and brother-in-law Auguste prepared for him in their Langley home.

Meanwhile, in October 1970 the Johnstones bought a new farming operation in Langley at 10032–201st Street near 96th Avenue, and moved there with their three children, their entire menagerie, Joe's stable of racehorses, and a number of the characters Joe had attracted to work on the farm. Lucille's son John remembers, "There was Shorty, Coyote Bill, Two Beers and Gus—all drinkers. Mom did not have an easy time with Dad or with most of his friends." Coyote Bill established himself

in one of the two trailers on the property and Shorty came to live in the Johnstones' basement. Betty Martel remembered:

> Joe brought Shorty home, I guess. He was a drinker but he knew a lot about horses. He called Lucille "the Missus." He came to work with the horses but he looked after Charlie and the other kids, too; he was good to them but he disciplined them. He wasn't hard on them but he made them do what they should. They loved him. He was with the children a lot because Lucille worked late. She had a housekeeper but Shorty was the one that got the kids going in the morning, made their meals. He cooked and made pies. He did everything, and he was wonderful to those kids. If you ask them, they will tell you that Shorty was very special. He was a tough old guy but he was something special. He did what he could to make things easier for Lucille too. When he died, Charlie had a hard time of it.

Charlie Johnstone had learning problems as a child. Lucille got him tutors and spent hours working with him herself, but these efforts made very little difference to his school progress. In his early teens Charlie found alcohol and drugs. The two younger children, however, were involved in sports, and Betty Martel remembered:

> As everybody knows, Lucille was always an early riser but she would get John up at four in the morning to take him to his hockey practices. And she put Lisa in ringette and took her to practices—of course when you have children in sports you have to participate as a parent and she did that as well.

Despite having a mother who left for the office before seven o'clock in the morning and arrived home at seven-thirty or eight o'clock in the evening, the Johnstone children did not seem to have felt neglected. John Johnstone recalled a very caring mother:

> I don't remember a lot of the younger years with Mom, partly I guess because with the business career she had she was not a stay-at-home mom, so we always had house-sitters and housekeepers. As I began to get a bit older, I remember Mom was certainly there for activities on the weekends. Track and field, all my hockey stuff, she was always there for that, very supportive. She would take us out for movies on the weekends. She did what she could do when work would allow. I don't think you can get to achieve the business status that she did and have a perfect family life and home as well. There has got to be compromises but I know I always felt very loved by Mom, very protected—maybe over-protected. She felt we could do no wrong I suppose, and would pretty much protect us at all costs. That was even being displayed in the last months of her life when she was trying to look after my brother. That almost, I think, cost her her health but she just carried on with it. She never gave up on him. I think of things that me and my brother and sister did wrong and yet Mom fully stood behind us and protected us.

John Johnstone and his wife Jennifer now have two children, a son Aiden, born in 1995, and a daughter, Teagan, born 1998. John has his own business, a fabricating shop for race cars called Chief Chassis, which he operates out of a shop on the family's Langley property.

> I was at a track and field meet when I was about thirteen, doing the shot put and discus, and there was another boy there who had been working with a trainer and he was on the track. He was supposed to break all the records and his dad was all excited. Well, when I went up and put the shot, I beat his distance by two metres or something—a pretty good distance in shot put—and his father accused me of cheating and said I wasn't putting it properly. This guy stood probably a foot and a half taller than Mom because Mom was not a tall lady and he was a pretty big man, and she just went up to him, pointed her finger at him and

said, "You know, if you want to do judging, you need to go up there and get your judge's ribbon on! Otherwise, you need to get over there and shut up!"

By the time I was sixteen or seventeen, I was almost six-foot-three and 250 to 260 pounds. I remember once Mom had asked me to cut the lawn and do the weeding, but I was in the house vegging out, watching TV. She asked and asked but it wasn't getting done. She came into the house and she was pretty mad—I think she might have even sworn, and you knew she was angry when that happened—and she was chastising me, and I stood up and kind of towered over her and presented a "yeah, right!" sort of attitude. I was challenging her, like "What are you going to do about it?" She just bent down and picked up my shoe because I had taken my shoes off to lie on the couch. She picked up that shoe, slammed her forearm against me, knocked me down onto the couch and beat me with my own shoe. I mean, the beating wasn't harsh but it said, "This is what I am going to do about it! You are not that big that you rule the roost yet!" That's the kind of thing that really sticks in my memory of who my mom was.

John recalled that at seventeen or eighteen he would have huge parties on weekends with "a hundred kids in the basement playing rock 'n' roll and partying."

The neighbours started complaining because of the cars all packed in the driveway and down the road both ways and the noise. When things would get out of control Mom would come downstairs and kick everyone out. I think one time she even had a stick in her hand and she was whacking them as they went out the door—"Get out of my house." Determination, I guess. No fear.

John's wife Jennifer recalled Lucille's kindness not only to herself but to numerous friends.

I have been Lisa's friend since I was thirteen and John's girlfriend since I was fifteen so I have been around Lucille a lot. She took good care of me, too, kind of adopted me into the family when I was fairly young because I hung out there all the time. She always adopted everybody. I could have studied anything I wanted at school and I think she would have paid for it. Even my friends were welcome to come and spend the night, to eat the food. There was never "No, we don't have enough or we didn't cook enough." It was always "Come on in. We'll make something else or we'll add this to what we've prepared." There was always enough food for everyone and she was always welcoming. I can't think of how many people she put through school—friends, her children's friends, just anybody. If it was something that would further someone she would help.

John adds that her kindness extended beyond his circle of friends:

She would help not just my friends but their parents. If there were financial problems she would try to help them out. And strangers. There was a guy who came in off the train tracks—a bum. He had nothing. I think it was Thanksgiving and he knocked on the door, and Mom invited him in and fed him and clothed him in some of Dad's clothes and off he went, totally happy.

When John was about sixteen he wanted to buy a motorcycle.

I went in there and I talked to the salesman the best I could, but I wasn't getting anywhere, so I thought, okay, it's time for the heavy hitter to come in. So Mom came along and the guy tried a bit of salesman talk on her about the costs and tariff and whatnot, and Mom told him, "No, that's not the way it is. I import equipment and I know how this works." It was kind of funny because at the end he was actually asking Mom, "What about if

we do it like this?" and was asking Mom how it could be done better. The smarts just oozed out of her. People always wanted her help. But when I started setting up Chief Chassis and Mom would try to help, I would think, "Yeah, yeah, whatever, Mom." Then she offered to pay my way to this small business seminar, so I went, and I would come home all pumped up and start telling her what they had said. She would just look at me and smile. She had already told me all that stuff, but just hearing it from someone else was more acceptable because Mom was just Mom. It seems so stupid to struggle with something like that when other people were dying to get information or advice from her. I kind of didn't listen to her or turned away from her advice, and then finally after a few years of trying to do it my way, I would have to come back and say, "All right, okay, you were right."

What Mom said, she did. She didn't hide things. She didn't cheat. My sister's friend smashed our car, a little Chevy—rolled and totalled it. Instead of lying and saying that Lisa only drove the car to school less than three times a month—because that's what was allowed by the insurance—she took a total write-off on the car and never took any insurance on it. She was just honest. There was no alternative for her.

One day she had a suitcase all packed and I said, "Mom, where are you going?"

"On a business trip."

"But where are you *going*?"

"Well, I don't want to tell you that because if someone phones you will have to tell them. If you don't know, you can't tell them and you won't be lying."

Lucille never dressed flashily or drove fancy cars, John explained.

> It was always a station wagon so she could put my hockey gear in the back and it had to be something that was functional. I don't know that I ever saw her spend extreme amounts of money on herself.

*Charlie's daughter, Bonnie, is twenty-five and has two children: a three-year-old named Jack and a two-year-old named Lucille.*

She was always so busy but she managed to have everything done. The house was clean, the laundry was done, dinner was made, everything and she still worked. I don't know how she did it. She was always there. She always had an answer to everything. I could always call her in times of need, whether it was for money or just someone to talk to, she was there. She always thought about everybody else first. Taught me all her values, do unto others as you would like done to you, respect yourself and respect others. I don't know where I would be without her. She practically raised me. I had her to rely on. I spent weekends over at her house and she would take me on trips with her to Victoria when I was a little girl. We used to sing together. She would take me to work with her and I would pretend that I was a big business person, sit at that big table while Grandma did her work. I loved to be around her. She used to cook me breakfast on Sundays. She would just give me what she was having or what was easy to make. She would ask, "What would you like?" and I'd say "Waffles," and Grandma Lucille would make me waffles.

    I lived with Grandma Lucille a lot. I can't believe she put up with me, especially after having to put up with her three kids. I am just glad that I turned out quite well, I started to listen to her and hear what she said. I lived with her for a good four of the last seven years. I used to cook her dinner and do her laundry and stuff. I contributed to say thank you for everything she had done for me, which was a lot.

*Charlie now lives with Bonnie and his grandchildren. Bonnie remembers Lucille as always being loving and supportive of Charlie and "very, very forgiving ... you couldn't do anything to knock her down. She stood strong." As of 2006, Bonnie says Charlie is doing well.*

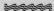

His wife Jennifer adds:

> When she would lose weight, she would just stitch her pants in tighter. Anyone else with anywhere near her money would have gone out and bought a bunch of new clothes, but clothes and cars were not important to her. Her values were so core to what the Good Book says: you can't take it with you.

John agreed:

> When Lisa was having her wedding at the house and the caterers came to the door, they asked me, "Can you get the lady of the house?" Mom went to the door and they said, "No, we're looking for the owner."

John had just one criticism of his mother: that her tolerance of Charlie's behaviour didn't allow him to hit rock bottom. On one occasion Charlie actually pushed Lucille. John went to the house and told him he was no longer welcome to stay there. The police came but Lucille was forgiving, telling Charlie that if he settled down he could come back. As John put it:

> It was that whole "Mother Hen" thing. Come on back under my wing, and everything will be all right. Charlie was not the person he had been as a child and Mom so wanted to cling to who he used to be. Part of the problem I think was that Mom, with all her "mother henning," was a bit of an enabler. Chuck always had a place to stay, he always got food, he always had stuff to fall back on so that he could never hit bottom. But it was pretty hard to tell a mother hen how to look after her chicks.

John acknowledged his mother did not have an easy time with his father.

Dad would bring people home on a weekend after the races or something, just bring people home and expect Mom to be able to feed them and entertain them and she would. Then she would get up on Monday morning and go to work. Dad was always racing his horses down in Portland and just wasn't home a lot, but Mom never made a big stink about it—in front of us anyway—because as a child I don't remember Mom and Dad fighting a lot, so I wasn't really aware that there was a problem. She kept certain things to herself—her business life, her bank accounts and marriage problems—and we never knew anything about them. She totally protected us.

***

In September 1977 Lucille sold the property on 201st Street for industrial use and bought a fifty-acre farm at 9260–222nd Street. The new house was three storeys high with ten thousand square feet of living space and a huge swimming pool. However, Lucille arranged to keep the old house itself and move it to a new piece of property for her sister. Betty Martel recalled that adventure:

> That house was huge—4,500 square feet on the main floor alone—but she decided we could move it, put it on another piece of property and put a basement under it. This was a very big project. One night while this was going on, she got a phone call from two young boys who were friends of Charlie's. It was two in the morning and they were at the Vancouver Bus Depot. "Lucille, can you help us? Our mom and dad will not come and pick us up and we have no way of getting home." So Lucille got out of bed and went to the bus depot to bring them home, and on the way back when she got to 88th by the freeway, a police car stopped her. They said, "I'm sorry. You can't go through. They are moving a house and they have to get it over the freeway and the road is completely blocked." She told me, "I just sat there and laughed. I said, 'Okay, I know. That's my house. It belongs

to my sister, but it's my house they're moving.' And she laughed even though she had to back up and go a long way around to take the boys home. But that's just the way she was. Her house had swinging doors, I swear it. The kids brought anybody home they wanted to and she always had time for them.

Needless to say, the house did get moved and a basement was put underneath, and Lucille came up and cleaned bricks with us so we could use them to build the new fireplace.

Though Joe mostly ignored his sons and lavished attention on Lisa, Lucille made sure she had a good relationship with her daughter. She took Lisa on a number of business trips, and when a vacation weekend at the West Edmonton Mall had to be cancelled for business reasons, Lucille sent the housekeeper with Lisa so she wouldn't be disappointed. On another trip Lisa locked her mother's briefcase in the mini-bar at the hotel so she could have her to herself for a few days. But her favourite trip with her mother was to Washington, DC, for a heavy equipment distributors' convention when Lisa was about fifteen.

Like John, Lisa is grateful for all the opportunities and advantages she was given by being raised by Lucille.

I figure I was put where I was for a reason and I don't want to question that reason. I don't think I could have gotten anything better than I did. She wasn't around a lot but she was an amazing mom. She gave me every advantage and did everything she could for me, not just in schooling but in life and support too. She was as supportive as she could be, despite everything she had on her plate. I am amazed she had the amount of strength to do everything that she did and still deal with all of us because I think we were all probably more than the average handful.

When [my son] Harvey was born at Langley Hospital, I went into labour at two in the morning and it lasted a full thirty-four hours. Mom was there from six the same morning until the next day when he was born at 2:30 p.m. The hospital gave her the

room next to me to sleep in because she had been there for so long. If I had a contraction or freaked out I didn't even have to yell "Mom!" She was there. And she didn't really have to be. I don't know many moms who would do that.

***

Lucille told a reporter in 1981 that she had just two objectives in life: to work hard as long as she could and to help her family. When asked what careers her children would choose, she said her son Charlie, who was then eighteen, might become a tugboatman or a fisherman (though she was aware by that time that his alcohol and drug problems probably precluded a successful career). She said Lisa, then ten, had told her she wanted to become a businesswoman like her mom, but "she is at an age where she thinks the best entry into business is to begin at the top. I believe in everybody starting on the ground floor and making it from there." Fourteen-year-old John was undecided, but Lucille said she was hopeful that whatever her children chose as careers, they would bring their maximum energies to bear. "I think hard work is essential in life if you are going to be happy. It brings satisfaction and helps keep away boredom and despondency. I see some people who have opted for early retirement and I feel sorry for them. You do need a challenge in life."

ELEVEN

## *The Marriage Breaks Down*

By the time the Johnstones moved to the new farm on 222nd Street, Lucille and Joe's marriage was in the final stages of breakdown. He was spending more and more time racing his horses in Oregon and California and carousing with his racing friends. And it did not help his marriage when Lucille learned he had told his friends while drinking that she was his "pension plan."

The year 1980 was a particularly bad one for Lucille. One day early that spring John was in his bedroom when he heard a scream and ran out to find his mother on the ground, unable to move. She had been up a ladder cleaning out the eavestroughs when the ladder slipped; she tumbled one and a half storeys. John ran to the pasture where Joe was exercising a horse, and they took her to hospital. When Lucille's sister Betty went to see her in hospital a few days later, she found her "black and blue and yellow and swollen." But she had a phone at her bedside and was carrying on business as usual. Fortunately, x-rays showed no serious damage, probably because she was in good shape—she swam in the family pool every day and was physically very strong.

A month later when Lucille concluded that her husband's horses

were spending more time in the California sun than she was—and on her money—she told Joe to get out, and sued for divorce and custody of the children.

~~~~~

The Family Relations Act had come into effect in BC in 1972, providing that family assets should be split fifty-fifty unless there were valid reasons suggesting otherwise. This act was intended to redress hardships that many homemakers had suffered in the past. Prior to the Act, upon divorce men were entitled to retain most, if not all, of their assets with no regard for the substantial contributions of their wives, which had made it possible for them to succeed. This new act differentiated between "family assets" and "business assets"; "family assets" referred to property owned by one or both spouses that was used by a spouse or child for a family purpose. Thus, a car owned and paid for exclusively by a husband but used by the whole family was a family asset.

Business assets were another matter entirely. The Act stated: "If property is owned by one spouse to the exclusion of the other and is used primarily for business purposes and if the spouse who does not own the property made no direct or indirect contribution to the acquisition of the property by the other spouse or to the operation of the business, the property is not a family asset."

Joe, who had admitted adultery, wanted 50 percent of Lucille's assets. He sought for court ruling that some of Lucille's $4 million in assets be classified as family assets and so subject to an equal division. It would be a tall order for him to satisfy the court that he had made some direct or indirect contribution to Lucille's acquisition of any of her business assets, but he had the gall to try.

Since 1968 all of Rivtow's legal work had been done by Vancouver's Davis & Company, and she turned to them when looking for a divorce lawyer. She wanted someone who would understand Joe's "back stretch" mentality and be a match for him in a dirty fight. She selected Davis & Company's Marvin Storrow. She chose well.

Storrow remembered the case very clearly.

THE MARRIAGE BREAKS DOWN

I represented Lucille and I had with me Paul Albi and Frank Borowicz as my colleagues. Joe was represented by Tony Pantages—a very distinguished and splendid lawyer and person—along with Bryce Dyer. Prior to the commencement of the trial Lucille offered Joe a very generous settlement proposal which involved, I believe, some assets and some land and a certain amount monthly—I think it was three thousand dollars—but that was turned down.

The trial was very lengthy for a divorce—thirteen days, I believe—and it was highlighted by the interesting people that were called as witnesses. One of the persons that was called was a man called Shorty who I think looked after the horses for Joe, and another one was called Coyote Bill. I remember Jack Diamond being a witness called by Joe Johnstone because he knew Jack from the racetrack. The case was a little bit one-sided, of course, because Lucille was so much better as a witness than Joe was, and the judge, Mr. Justice Dohm, obviously grew very fond of her. He often asked me about her after the trial.

One incident described in the trial was an occasion—or occasions—when Joe would bring one of his horses into the kitchen of the family home and turn the tap on, causing the horse to urinate in the kitchen. That I think quite shocked the judge and it certainly shocked me that anyone would do such a senseless thing. But that was Joe Johnstone. Judge Dohm saw the inequalities of the situation at home and he wasn't willing to give Joe Johnstone one cent more than the minimum. I think he was quite correct in doing that on the evidence before him. Lucille ended up getting 93 percent of all the assets. That was a hard result to beat—I can't imagine many people getting much more than that. So you can see what the court thought of Joe and what the court thought of Lucille.

Following the trial Lucille, as I understand it, was more generous to Joe than she was compelled to be under the terms of the order of the judge. She had a very deep sense of generosity about

her. She was kind to everyone, even to Joe, who hadn't treated her that well. The other quality about Lucille that was readily apparent to anyone who met her was her natural intelligence and instinct about people and issues. She was a good problem-solver who got to the point quickly and usually solved problems in a very correct and direct manner.

Part of Mr. Justice Dohm's judgment is quoted here because it sheds so much light on the marriage. (Anyone interested in this important case can find it in *British Columbia Law Reports, 1982*, vol. 33, pp. 368–390. References to "the Petitioner" and "the Respondent" have been replaced here with the actual names.) Justice Dohm described the marriage and then continued:

> The only fair comment I can make about this relationship is that it is terribly unfortunate that these two people ever joined hands in holy matrimony. The picture I have painted of this eighteen-year union is certainly not an encouraging one—nor is it a complete one. Certainly, I intend to round out the picture as I go along. But before putting brush to paper, I think it only fair and proper to point out that the credibility of the parties is a paramount consideration. On some important matters, for example, the work done on the various properties and by whom it was done, there is a large discrepancy in the evidence of the parties. In some instances, there is independent evidence that may be helpful in resolving the matter. But, in cases of this kind, I think the court ought to endeavour to glean an accurate picture from the two people who had, as it were, first-hand knowledge; namely, Lucille and Joe. I had ample opportunity during the trial to observe the Johnstones. Both of them were examined and cross-examined at length on every facet of their marriage. I found Lucille a most trustworthy witness—not only in the financial matters which arose in the marriage but also in the matters affecting the children and the farm. No doubt she was

aided in being able to recall the events of the past eighteen years by the records which she dutifully kept from the outset of the marriage. I found too that she had a complete picture—there seemed to be nothing that escaped her about the properties, the racehorse operation until 1974, the children and everything else that occurred in the marriage.

The explanation for this keen observation is, I think, simple. She was present and she participated. Lucille is, I think, a kind, sincere and thoughtful person who tends to paint with a somewhat narrow brush. I very much doubt that these characteristics could be found in someone trying to mislead me. Joe, on the other hand, tends to paint with a very wide brush. Certainly, I cannot conclude that he is intentionally trying to mislead me—I would be very slow to conclude that—but I think he understands what is at stake here and with the passage of time he has either forgotten the details of the events or he has convinced himself of the accuracy of his view of the events. In either case, I do not feel that I had a complete picture from Joe. He was anything but responsive both to questions of his counsel and in cross-examination. He tended to gloss over those things and events that damaged his case. I found Joe to be irresponsible, to be selfish and to lack sincerity, all traits which raise questions of his credibility.

The matter of access to the children by Joe is a more difficult matter. Lucille's view, and I accept her sincerity in this regard, is that Joe should have only limited access. Certainly, since the separation in April 1980, there has been very limited contact between Joe and the children. It is only recently that he has shown any interest. During the marriage, the picture appears to have been the same except for the daughter Lisa. It was upon her that Joe showered his affection and attention. Everyone else in the household came second. I think the greatest sin that one person can commit against the other parent insofar as child-rearing is concerned, is to not be supportive. Charles Johnstone, since

coming to the Johnstone family, has been for much of the time a source of great worry for Lucille. He had a very serious learning disability which required private tutors and endless hours of assistance from his mother. In addition, within this ten years Charlie (as he is known) became acquainted with the use of alcohol and marijuana that brought out the very worst in him. He became belligerent and violent. As a consequence, he has been involved in criminal matters, he has attempted to commit suicide, and he had been expelled from school. On one occasion, when Charlie became violent, Lucille was left to take care of the matter—Joe left and took Lisa so that she would not view the tragic event. In each instance, it was Lucille who had to face the difficulties with Charlie. Joe's contribution was to utter "too bad about Charlie." If there is such a thing as a minimum of affection and attention, Joe failed when it came to the two boys. Indeed, he placed himself beyond their reaches. He played no part in their lives save for a harmful one, by setting a bad example in the home in various ways. He refused to participate in their activities and he ignored his obligation as their father. In this regard, there is a great deal more required of a father than purchasing the odd motorcycle. The very least that one might expect from a father of two boys would be a genuine interest in them and in their activities. Joe failed to meet even this minimum. On the other hand, the child Lisa could do no wrong—at least as long as her father was in the household. Certainly one can understand a closeness and a desire to spoil the only daughter, but when the effect of that attention is harmful to the child and upsetting to the rest of the household, surely such attention ought to be channelled in other directions. In spite of Lucille's and the housekeeper's pleadings with Joe, he persisted in his conduct toward Lisa, to the point where the balance of the household looked forward to Joe's absence at the racetrack. Fortunately for the child, Lucille has been able to salvage the situation. Frankly, I can see very little good coming from continuing the relationship, but in the hope

that Joe's newfound interest is genuine, some access ought to be granted. The access, at the outset, must be limited and must take place away from the former matrimonial home. The access shall be as follows: on the first and third Saturday of each month, beginning February 1, 1982, between the hours of 12 noon and 7 p.m. Joe shall advise Lucille of his intention to exercise the access at least seven days prior to the proposed date of the access. Unless the parties otherwise agree, the access shall take place in such a fashion so as to avoid any contact between the parents. I think it advisable for the time being that there be no other access, either physically or by telephone.

By way of a general comment, the financial matters of the marriage were handled exclusively by Lucille. One might expect that in this case. However, I very much doubt that there are many examples of the kind of records which are exhibited here and which tell the "financial history" of the marriage. Throughout the early years of marriage and while Joe was employed, his contribution to the "family" account was three hundred dollars monthly. The balance of his income [he was earning $18,000 annually] was supposed to be used to pay maintenance for his first family. In fact, only four hundred dollars per month was used for this purpose. Lucille's monthly income was deposited to the family account. The records kept by Lucille were in the form of ledger entries and the various operations—the logging, the farms (including the horse board), the home, the horse racing and training—and Lucille and Joe were each assigned a place in the ledger . . . The records were audited by the tax department . . . An analysis of the records for the period 1967–79 shows that up until the end of 1979, there was a gross imbalance between Lucille and Joe, with Lucille having a credit balance of $154,928 and Joe having a debit balance of $121,712. This kind of information is probably not very useful in the overall picture, but it does show beyond any doubt that Lucille was responsible for the financial success of this marriage. Joe, on the other hand,

seems to have followed a checkered career; for the first five years gainfully employed and thereafter until separation in 1980 in various endeavours, none of which produced an income for the family unit. I should make one other comment by way of general application and that is that Lucille did not involve or discuss with Joe her employment or her business affairs. Early on in the marriage, there had been some discussion but Lucille found that Joe was telling others of her business activities. In many instances the acquisition of the assets was not made known to Joe.

In the circumstances, I am not inclined to make any order for the maintenance of the children or for Joe. The usual reasons for granting maintenance, whether to the children or Joe, do not exist here. I cannot say that success has been shared by the parties. The usual order, therefore, that costs ought to be borne by each party, is inappropriate. Costs will be payable by Joe.

When the divorce settlement was announced December 8, 1981, it garnered huge headlines in the Vancouver newspapers. Under the banner "Wife Wins $4-Million Divorce," the *Province* told its readers that Joe had received "only four hundred thousand dollars or about 10 percent of the combined business and family assets," and that Judge Dohm had said that "even the 10 percent might be considered generous by most right-thinking people." Lucille, the report said, had kept all her business assets and about $1.4 million in family assets. It quoted Judge Dohm as saying "Certainly, if [he] had been supportive of his wife by being available, by showing love and affection, by being faithful, by being a good listener, by being reliable, by being a good parent, by being interested in her work, by caring and by being honest, consideration might be given to converting some of the business assets to family assets. The evidence is precisely to the contrary."

The *Sun* reported that Judge Dohm had said that "under the circumstances, it would be grossly unfair to divide the family assets according to Section 43 of the [Family Relations] Act. If ever there was a case for reapportionment of those assets, this must be it. The scales cannot be

left in the balance." The report then went on to explain that Lucille had owned one farm in Maple Ridge and two in Langley, and that "while the rest of the family assets went to the wife, Johnstone was given one of the family's farms (valued at $205,000), $200,000 from the sale of another property and racehorses, breeding stock, yearlings and horse equipment valued at $26,000."

Following the publication of the judgment, many women called to thank Lucille for putting up a fight and to say that the result had helped them in their own divorce battles. For Lucille's lawyers and friends, however, it was celebration time. Marvin Storrow recalled:

> After the end of the trial when judgment came down, Lucille had a big party in her home for the lawyers and her friends. Quite a few people were there, and Frank Borowicz, who has the gift for it, wrote a short song about the divorce. Frankly, it wasn't flattering to Joe, but he had put Lucille through a lot of misery so it didn't seem to be as distasteful as it might have been several years later. Lucille took it in great stride. But I remember that just as we were singing it in the den of her home in Langley—I can't remember what line we got to—there was a huge burst of thunder from the heavens. It seemed almost ironic that the heavens were falling on us as we were singing the song.

After the divorce, though Joe had only been granted access to Lisa every other Saturday, he met her at school every Friday and took her out for lunch. Lisa doesn't think that Lucille knew this was happening at the time. However, as Lisa became a teenager, her bond with her mother strengthened and she saw less of her father. In 1990, when Lisa was nineteen, Joe entered the Royal Columbian Hospital and gave her name as his next-of-kin, although they had not spoken for six months. A little later Lisa got a call from the hospital saying that her father was in a coma; the caller wanted to know if they could "pull the plug." Lisa called her mother and Lucille met her at the hospital. Despite the divorce, Lucille was not bitter toward Joe and continued to visit him in the hospital

every night after work. When he came out of his coma, he seemed grateful she was there to see him. She later set up a place for him to live.

When Joe was near death, Lucille's good friend and former secretary at Rivtow, Lisa DaSilva, went to visit her at home:

> He was sitting there with her, panting away. He was probably near his last breath, and I asked Lucille what he was doing there. She said, "You know, this man didn't treat me very well. He really put me through the hoops, but now he is dying." She was looking after him in her home. I just couldn't believe that.

Lucille took the children to Joe's funeral in Washington state.

TWELVE

BC Place and Expo '86

Throughout 1981, although her divorce had consumed an inordinate amount of her energies and her father died in October after a stroke, Lucille was still putting in twelve-hour days at Rivtow Straits. She was by this time senior vice-president, having recently recruited both a vice-president of finance and a vice-president of administration from the ranks to share her ever-growing workload. However, the ultimate responsibility for the company's financial success remained with her. That was a difficult proposition in 1981, since British Columbia had plunged into a recession. The forest industry, which provided 70 percent of the work of Rivtow Straits' marine division, was among the first to be affected by the downturn. Lucille recalled those difficult days:

> At Rivtow we focused on survival and trimmed back at every corner we could. We implemented a program called "The Rivtow Spirit Fund." At that time the tax laws allowed employees to defer wages and lend those monies to their employer and defer any tax consequences on their earnings. Initially I felt the union

would not permit the tug crews to participate but such was not the case. Our employees enjoyed working for Rivtow and wanted to retain their jobs. They pledged anywhere from $10 to $725 per month, and we made the commitment that their pledged Rivtow Spirit money would be repaid to them in five years—with an increase related to the book value of the shares in Rivtow at that time or the amount of their pledged funds with interest at 6 percent—whichever was the greater. In total they pledged over $2.5 million, some of which was used to build two ship-docking tugs needed for Prince Rupert. They were built at our John Manly Shipyard, which provided continued employment for our shipyard workers, and they ultimately provided jobs for the crews who manned them in Prince Rupert. Other Spirit funds were used for working capital.

This money was important, but even more important was the supportive and loyal spirit that prevailed. Employees offered to work overtime without pay, others shut down the tug engines when they did not need to be on in order to conserve fuel and they came up with new ideas for reducing expenses. Such a spirit can't be measured in dollars. It is priceless!

At the same time the company was committed to modernizing its coastal fleet and in 1981 commissioned a new tug and log barge combination. The 990-ton, 44-metre tugboat *Rivtow Captain Bob*, named for the Cosulich brothers' father and destined to become the flagship of the Rivtow Straits fleet, and the 15,000-ton, 122-metre-long self-loading, self-dumping barge *Rivtow Hercules* represented an investment of $20 million. And as usual Lucille had to scrounge for the money to pay for them.

Yet she still found time to be the keynote speaker for the BC Towboat Industry's fifth annual convention in Victoria in March of that year. Typically, she prepared a blockbuster speech, and according to the May edition of the *Journal of Logging and Sawmilling*, she "served up some food for thought" that "quite a few of her listeners found hard

to swallow." Lucille's speech as reported in *Harbour and Shipping News* shows her clarity of mind as well as her sense of humour:

> Nineteen-ninety may sound a long way down the river and there will no doubt be a lot of water under the bridge by the time we reach that new decade.
>
> Time passes quickly, however, and it is my view that if this industry does not start implementing some changes *now*, the towboat industry of British Columbia will be a *disaster* in 1990. This statement applies equally to the small and large company operators. Let me paint a picture of what I foresee in my telescope:
>
> It is March 1990 and old Captain Misery is in a state of shock. His beloved tug *The Ugly Duckling* has just been declared unfit for the service intended by Misery, and he is confronted with tug replacement or personal retirement.
>
> He can foresee neither new construction nor retirement—a distressing plight when he has worked thirty years with *Duckling* and made an adequate income to support him with a normal standard of living.
>
> In 1961 when *Duckling* was built for $143,000, he received a 40-percent subsidy so had an investment of less than $100,000.
>
> By 1980 he had recovered that investment—written the old waddler off completely for tax purposes, and was generating a noteworthy income of $75,000 per year for himself and his mighty ship—albeit that 50 percent went for tax and of the remaining $37,500, it cost him $25,000 per year to live comfortably.
>
> In the ten years from 1981–90 he had carefully saved $12,500 per year, investing to accrue interest at 12 percent (6 percent per annum after tax)—so he had $150,000 set aside to replace *The Ugly Duckling*. However, inflation had continued at an average of 10 percent per annum so that the original cost of $143,000 had increased from inflation, or new safety and

accommodation and environmental regulations, and now he stands—confronted with a $1.4-million cost to replace, no subsidy and only $150,000 cash. What solutions or alternatives are available to him?

1) He could give up and retire—but $150,000 won't produce more than $18,000 per year income, and he and wife Matilda Misery can't live on that. (Scrap recovery from *Ugly Duckling* wouldn't bring more than $3,000.)

2) He could go out and rob a bank—that would get him a warm home of confinement, but he'd miss Matilda's TLC.

3) He could go out and get drunk to drown his sorrow—but in the midst of his hangover he would have to face the facts—"I've been stupid and there is no way to recover."

4) He could figure out a new daily rate for the $1.4-million tug and ask his major customer or customers to give him firm contracts for use of this vessel to impress his friendly or unfriendly banker to put up the money for *New Duckling*. Even though Misery has escalated his rates for fuel and wages, certainly the rates will have to be 60 percent more but after all, he had worn his equipment out performing services in good faith at less-than-adequate rates. So he visits Mr. Sawbucks, his major customer and good friend, with his proposal, and Mr. Sawbucks' response is: "If you need a 60 percent increase to cover construction and operating costs, we might as well build the tug ourselves—then we could have the three-year tax writeoff and own the vessel ourselves. You've given us good service but you really are getting too old to run a boat—it is a young man's game. Hope you enjoy your retirement."

Sound preposterous? Perhaps, but I assure you it isn't. And now is the time to make sure this doesn't happen, not only for tug operations but barges as well.

Lucille went on to give illustrated examples of the currently inadequate rates and their logical consequences for tugs, chip barges, general

purpose scows and log barges. She pointed out that a Rivtow log barge, after a 9 percent subsidy, cost approximately $452,000 to build. Actual revenues from that barge in 1980 were $49,780, but the revenue required to achieve a 10 percent pre-tax profit on its present value was $90,424—an 82 percent increase on present revenue—and $111,449—or a 124 percent increase on revenues—for its replacement value.

Lucille proposed that the towboat industry should gradually remedy the revenue inadequacies by establishing a surcharge on forest products carried by the towboats, basing it on stumpage appraisals, so that they shared in the upside markets when large profits were being made in the forest industry. Alternatively, she urged marine companies to institute an innovative system of "blended prices," a system she was already putting into practice successfully at Rivtow Straits. Under this scheme, an operator with twenty barges who was retiring two craft a year and buying replacements could present the customer with a fleet-average price. Thus, the high cost of new construction and adequate provision for the replacement of old vessels could be softened by using a mean replacement figure for the entire fleet. As the average age of the fleet was reduced, the charges would climb, but there would be no sudden calamitous increase that might persuade the customer he was better off starting up his own towboat operation.

While many of the towboaters in her audience were uneasy with both her prognosis for the future and her proposals for resolving their problems, they knew it must be correct if it was coming from Lucille. Spokesmen for the forest industry were horrified. Mr. R.D. Henderson of MacMillan Bloedel presented a paper in reply, suggesting that customers would simply have to pay higher rates in 1990—that they would not drive Captain Misery out of business but would agree to increase rates "set in the spirit of friendly competition amongst hard-headed businessmen and women." His speech started with a reference to Lucille that reflected the high regard in which the marine community held her:

> Mrs. Johnstone, you have again demonstrated why you are recognized as the leading financial authority in the marine business.

> You have presented some convincing arguments to develop a program of setting rates based on replacement cost of marine equipment.

At the same time that Lucille was devising strategies to make the towboating industry more viable, she was also embarking on new adventures beyond Rivtow, one of which brought her immediately into the media spotlight. In August 1981 the president of the BC Resources Investment Corporation (BCRIC), Bruce Howe (former president and CEO of MacMillan Bloedel and later, CEO of Atomic Energy of Canada), asked her to join BCRIC's board of directors, and she promptly accepted. In an interview with Mark Wilson of the *Province*'s Sunday Business Report, she said, "BCRIC is a one-of-a-kind corporation and it offers a challenge. Because of the huge number of shareholders, the involvement in BC resource industries and the way BCRIC was founded, it is a directorship which carries with it a suggestion of public service. The remuneration is not overwhelming [$5,000 a year] and there will be a lot of required reading, but I am not one of those people who give token service as directors."

BCRIC was indeed one of a kind. Inspired by the very successful Alberta Energy Corporation, it was intended to be an umbrella for a number of troubled resource companies. According to the original plan, its shares would be sold to provide funds to operate these companies as well as to make minority investments in the province's new resource industries. To create BCRIC, Premier Bill Bennett had assembled three forest companies that had been made Crown corporations by the preceding NDP government, then added certain oil and gas properties and the government's shares in West Coast Transmission. After first giving every BC resident five free shares, Bennett's Department of Finance then sold the remaining shares in the company for six dollars each.

The media heralded Lucille's appointment to BCRIC's board as its "first woman director" and as "the representative of the marine industry," but Lucille quickly put them straight. She said that her gender was

as irrelevant as the fact that much of her business experience was gained in the West Coast towboat industry. She was, she pointed out, invited aboard because of her general business skills. She told the *Financial Post*, "There are very few companies left which do not recognize that women are here to stay and intend to be part of the scene. I don't think women have the battle today that they did before."

It turned out that she would need all of her "general business skills" to manoeuvre her way through the murky waters of BCRIC. The corporation was not a resounding success. First, the board refused to accept the concept of investing shareholders' money only in the core BCRIC companies and in new resource industries because they felt this would not provide sufficient returns. Instead, BCRIC became associated with large enterprises such as Kaiser Coal, and its shares soon had little value.

Another initiative of the Bill Bennett government was the BC Place Corporation, a crown corporation established to acquire and develop land on the north side of Vancouver's False Creek, an area which at that time was a near industrial slum. However, the main focus and major project of this corporation was to be the construction on this site of a stadium capable of holding sixty thousand people; it would replace the old Empire Stadium on the Hastings Street PNE grounds, which was simply inadequate for a growing world-class city. Alvin Narod of Narod Construction was recruited from retirement to be chief executive officer of the new corporation and chairman of the board. Transportation Minister Stephen Rogers was the government's representative while other board members included Bruce Howe, coal-mining magnate Edgar Kaiser and architect and developer Stanley Kwok. It was Grace McCarthy in her role of deputy premier who asked Lucille to serve on the board. Lucille recalled:

> I was somewhat hesitant to accept the appointment because Rivtow was demanding so much of my attention, but I was

assured—as always happens—that it would take very little time, one meeting a month, and that would be it. Well, it started out that way. Quite a bit of our time was spent acquiring the lands from the then owners or lessees as the government was unwilling to make expropriations; this also meant we spent a considerable sum of money on these purchases because these people knew it was the government of British Columbia making the acquisitions. Finally we negotiated settlements with all of the owners, including sawmills and a marina complex that had a long-term lease, in order to make a site for the stadium.

Board meetings were scheduled for once a month at 8:30 a.m., and relevant documents in considerable detail were circulated ahead of time in the expectation that the board would read the material beforehand. However, an issue evolved as we started to move forward into the construction and the divisioning phase of BC Place because it was apparent that not all board members had read the materials. This lengthened the discussions and indeed the board meetings usually went well beyond noon. However, the schedules of many of the high-profile board members didn't allow for three-and-a-half hours away from their own responsibilities and they frequently left in the middle of the meetings. Therefore, as we reached the end of the agenda and had very large contracts to approve, there was often barely a quorum left at the table. I was particularly concerned because I was not a construction expert. At one meeting, a main contract—I believe it was for $40 to $50 million out of our $126-million budget—had to be ratified, and I was not satisfied that we had the expertise present. I stayed after the meeting and suggested to Alvin that we should enlarge the board to have more input in these matters. As well, these high-profile members would not spare the time to hear presentations from major companies who were to supply components such as the stadium's inflatable roof. These people had come from all across America to make their presentations and board members really should have been there.

BC PLACE AND EXPO '86

The BC Place Board of Directors on opening day. Left to right: Paul Manning, Stanley Kwok, unknown, Mrs. Stephen Rogers, Hon. Stephen Rogers, MLA, Hon. William Bennett, Mrs. Audrey Bennett, Edgar Kaiser, Eileen Narod, Bruce Howe, unknown and Lucille Johnstone.

Alvin usually asked if I would make the time and I definitely did so.

One of the reasons we favoured going with an inflatable roof for the stadium is that, even if there was an earthquake or some catastrophe and the 75-horsepower blowers that keep this kind of roof inflated ceased to function, the roof would take at least two to three hours to descend. This would allow ample time to evacuate people, whereas a hardcore roof, if it collapsed in an earthquake, would crash down on the people in the stadium. When you think of the ceiling collapses in the stadiums in Montreal and Seattle, it was a good choice.

So the day finally came when we were to inflate the roof and raise it. I sat there and waited and waited, hoping this roof

would go up as planned. As a board member, I likened it to watching the first man go around the back of the moon and waiting for him to come out the other side. Then it suddenly appeared like a big marshmallow and looked absolutely fantastic. Everyone was fascinated with it, and we allowed charities to auction off dinner for ten on the roof of the stadium so people could go up on it and have dinner overlooking the city. It was quite popular. We did have a problem with seagulls on the roof, and we had to clean their offerings off it to keep it looking respectable.

The original mandate for the BC Place Corporation after the stadium was built was to develop residential towers and other community facilities on the north False Creek lands because the government foresaw great population growth for the city. Lucille continued:

They knew people would want to live in that area because it was part of the city's downtown core and also because it was on the edge of the water, which always has tremendous appeal. So our board proceeded with studies and presentations to the City of Vancouver about view corridors and sites and shade, the usual refinements in community planning.

There were extensive studies done to see what hazardous wastes were on the site and in particular, the area where the old BC Electric Company had a huge gas tank, some four storeys high, that had been there for years. We received this extensive report—it was about three-quarters of an inch thick—and it said there were PCBs where the tank had been. But I thought the final paragraph was perhaps the most meaningful of the entire book. It said "the potential harm from the amount of PCBs on this site is equivalent to a person eating one teaspoon of peanut butter every day for life." That's how serious they viewed the PCBs there. So considering the size of the site compared to some of the other waterfront sites, contamination was not a major problem.

But ultimately the government had all that soil removed and taken out to a proper disposal site at enormous cost.

But right in the middle of this—while the BC Place board was going about its work to build the stadium and develop the lands—we were stopped in our tracks by the government's decision to use the lands for the site for Expo '86.

The story of how it came to be that Vancouver staged Expo '86 is an interesting one. It was Grace McCarthy, MLA, then deputy premier, who conceived the idea and took it to Premier Bill Bennett.

McCarthy tells the story:

> I was responsible for BC House in London and I went over there to see Lawrie Wallace, then Agent General for BC. That visit spanned two or three days. We did business pertaining to BC House. It needed a lot of renovations as it was our province's showcase in London and served all of Europe. Patrick Reid was then posted to Canada House on behalf of the Canadian government and he was living and working in London. We met him over a pleasant lunch. Patrick mentioned that he was leaving the next morning to Paris to go to "the BIE." I said, "What is the BIE, Patrick?" He explained that it was the International Bureau of Expositions [Bureau international des expositions]. I think he was the president of that body at that time. "I will be meeting my board in Paris and we will be making decisions on the next world's fair." I asked, "Why has British Columbia never had a world's fair?" and he replied, "Because you never asked for it." And I said, "Well, we are asking now!" He asked me if I was serious and I said "absolutely." I thought it would be terrific to have a world's fair in British Columbia. I had experience in the tourism portfolio in my time and I thought it would be a great magnet for tourists and would put us on the world stage. I told Patrick that I was very serious and would go back to BC and talk to Bill Bennett. I was sure that he would see that it

would be a boon to have the world's fair in BC. We talked about what kind of a theme it could be. I think it was Lawrie Wallace who mentioned that 1986 would be the one-hundredth birthday of Vancouver and I mentioned that 1986 was an interesting year as well because it was the one-hundredth anniversary of the completion of the railroad from sea to sea. Patrick said, "That would be great, we want a transportation theme, we haven't had a transportation theme for many years."

He asked me to send him a telegram and let him know if the premier would be interested. I said absolutely. I went back to BC in the next couple of days, and on Monday morning I walked into the premier's office and I told him about my terrific meeting with Patrick. "What do you think, Bill?" We had just taken over the government and we were in a terrible state. The NDP had been in for more than three and a half years. (I used to say, "thirty-eight months, seventy-two days and twenty-two hours.") We were in the midst of chaos. The NDP left us bankrupt and we were greatly concerned with the problems we had on our desks. Premier Bill said, "Grace, we couldn't think of it, we have no money." I then reminded him that this would not take place for eight years. We have eight years to plan it and eight years to finance it and I said, "You know, Bill, if we are not successful in building this economy in the next eight years then we are not worthy to be government." The premier said, "You are right, go for it!"

This shift in plans for the use of the False Creek lands caused a lot of problems for the BC Place Corporation board, which already had a management team in place to carry out its project. And, as landlords of the site, they demanded compensation. This led to ill feeling between the management of Expo '86 and directors at BC Place, which caused delays and budgetary problems. This culminated in a disastrous meeting on March 25, 1983, which Lucille attended:

The consultants for Expo '86 had come to make a presentation to the BC Place board, and during that presentation we learned that they had asked the Queen to come to BC Place Stadium to invite the world to Expo. The dignitaries who would be in the welcoming party for the Queen were identified but they did *not* include Alvin Narod or Transportation Minister Rogers. Alvin, as chairman of the Stadium board, was furious, and gave vent to his anger. Unfortunately, this outburst had devastating consequences; he suffered a stroke and died the next day.

At that point it was clear that something had to be done about the differences between the two boards, and Premier Bennett had the solution: he made Jimmy Pattison chairman of both boards. Jimmy met with each board member and determined that any issue that could not be settled within thirty days by the management of each entity would move to a super-committee which would decide and impose its will. He selected half of the super-committee members from the Expo board and half from the BC Place board. A few issues moved to this new subcommittee, but, like magic, within two months management had settled their differences and the super-committee was disbanded.

Jimmy Pattison also brought all of the BC Place board members onto the Expo board, thereby bringing an end to any disparity of interest between the groups. And that was how Lucille came to be on the Expo board when the International Bureau of Expositions awarded the 1986 exposition to Vancouver. Lucille shook her head as she recollected the Expo board meetings:

> They started at 3:00 p.m. and frequently went to 10:00 or 10:30 p.m. with a brief interval for a buffet dinner. I was accustomed to serving on boards where the members received a full package of information to read in advance so as to save board time. Then all that had to happen at the meeting was for the information in the packages to be updated by management and the

chair, and the members could then make decisions. Much to my surprise when this board convened, each vice-president came forward and read his report to the board, a process that took forever, and I wondered why I had bothered to spend three or four hours reading the reports over the weekend. I mentioned this to Jimmy and suggested he announce that he would assume each board member had read the material and accordingly each vice-president need only respond to questions or deal with new issues. I also suggested that the board meeting not stop for supper—on empty stomachs, discussions would be shorter and decisions made more readily. He made these changes and the meetings shortened from as many as seven hours down to two or three, so everyone had done their job and could go home.

Most people are aware of Jimmy's insistence that meetings start on time, well-illustrated by how his star salesman arrived late to a meeting, found the meeting room locked and cut out the panel of the door with a skill saw he'd brought with him. At least that's the story that is told! So I was not too surprised at what happened one day when Premier Bennett arrived unannounced just before a meeting was to convene. Michael Bartlett, who was then Expo's CEO, accompanied the premier to the windows on the south of the building to look down on the Expo site and explain progress. Meanwhile, the meeting time rolled around and I drew it to Jimmy's attention that the premier was still with Michael. His response: "The meeting will start on time. If the premier wishes to attend, he may do so." And indeed the meeting got underway.

Ultimately, Expo board meetings were changed to Monday mornings starting at 7:00 a.m. I always drove in from Fort Langley early to avoid the traffic congestion and arrived at the Expo office at 6:30. Jimmy was usually already involved with his first meeting of the day, having sometimes flown in from Calgary that morning to be at his Vancouver office at 6:00. Such was his dedication to the Expo '86 project that eighteen-hour days were

not infrequent for him. When Premier Bennett chose to put Jimmy in charge, he could not have made a better choice. What a bargain for a dollar a year!

Prior to Jimmy Pattison's arrival on the Expo '86 scene the budget was out of control, and he immediately directed his attention to cost reductions, large and small. For example, fresh orange juice, deluxe muffins and fresh flower arrangements all quickly disappeared from the meeting room. He was also a realist, and during the course of getting ready for Expo whenever it became apparent that we had a weak manager or team member, he did not hesitate to make a change. For example, when we needed somebody to take over the construction phase, he brought in Kevin Murphy, a very strong negotiator, very knowledgeable and very hard-nosed. A contract is a contract is a contract with Kevin, so when you sign one with him, you have to live with it. I give him great credit for being pivotal in bringing construction in on time and on budget. When he left here, he finished a stadium in Los Angeles that was in trouble, and then the same investors sent him to Germany where they were building another one. An extremely talented man.

Management had prepared a detailed and comprehensive budget of $1.4 billion, but I was there when Peter Brown, who was chair of the finance committee and had a knowledgeable committee to assist, informed CEO Michael Bartlett that the maximum investment would be $800 million. Michael left the board meeting, convened a meeting of his VPs and held up the budget and a pair of scissors. "The size of the budget on this sheet is $1.4 billion," he announced. "I am slicing off this portion of the sheet that covers $600 million. I want you to come back in forty-eight hours with a maximum all-inclusive budget of $800 million." And they did! The finance committee, however, kept refining that budget—thirty-four editions of it were produced before a final budget was presented to the board. And thirty-four budgets took a lot of reading, a lot of digesting.

But there was little leeway in that budget for unforeseens, so Jimmy persuaded his old friend Mel Cooper to come aboard to sell sponsorships. Mel Cooper owned a Victoria radio station and was a very successful businessman. If ever there was a super salesman in the world it was Mel... He did a marvellous job. He raised $23 million, getting sponsorships for just about everything. We teased him that he would bring in a funeral service company to be a sponsor with the right to remove anyone who succumbed to the excitement!

Once I was returning by air from Chicago and noticed that the gentleman sitting next to me was reading all about Expo '86. I asked him what his connection was, and he explained he was with the Milton Bradley toy company and he was on his way to Vancouver in response to Mel's request that his corporation sponsor Expo's Science World. We spent the rest of the trip talking about Expo '86 and they ultimately did do a major sponsorship, worth some $3 or $4 million, a lot of it for the production of an absolutely fabulous film made especially for that type of theatre. It was, of course, about transportation. It opened with Eskimos tying frozen salmon together with leather straps to use as snowshoes and then it went on to other aspects of transportation before coming back to the Eskimos finishing their trip across the Arctic with their salmon snowshoes. I had a terrible time watching it because many of the scenes were shot from planes and boats and I have motion sickness. As soon as I would hear the music starting to reach a crescendo, I had to close my eyes because I would have been violently sick. It was quite apparent that what was happening on-screen was dramatic but I just couldn't watch it. That film, of course, was very similar to those at the Omnimax Theatre at Canada Place but the cost of producing it and putting it on in that venue was very high. The theatre is still operating today and I guess technology now makes it much easier to produce the films, but at that time it was very expensive.

Security and internal control were very important, and board meetings dealt with minute details—ticketing, the types of tickets to be sold, the security of the tickets, the security of the money. These things are all very, very specialized and we had to be extremely careful that they were well-controlled. We had to make sure the money got into the right pot and didn't get siphoned off somewhere along the line. The only major loss that I am aware of during the fair was that of a grand piano that somehow just disappeared from the site!

Rivtow Straits' contribution to Expo was the very popular "Boom Boat Ballet." In 1976 the company had acquired West Coast Salvage, which manufactured little one-man log-sorting "boom boats." It was this unique product that carried the Rivtow banner at Expo when, four times daily in False Creek right in front of the BC Pavilion, a squadron of these mini-vessels performed their terpsichorean tour de force. Lucille recalled what happened when she watched one particular performance:

> When each nation came to visit, one of the directors had to act as on-site host for the day of the visit. I got Germany and Norman Keevil Jr. got the Ivory Coast, and he phoned to ask if I would be willing to switch as he was at that time bringing a lot of German investments into BC's mining industry. He is a very good promoter. I quite willingly swapped and as a result I entertained the delightful people from the Ivory Coast, accompanying them while they watched the popular boom boat ballet. I did my best to explain to the gentleman and his companion what these boom boats did normally in the forest industry, and I thought I had done a tremendous job. But when it was all over he said, "Thank you very much. I now know what 'bum boats' are."

Lucille also reminisced about the McDonald's Restaurants' "McBarge":

I believe that the McBarge was extremely successful. I have forgotten how many million hamburgers they sold, but I believe they employed as many as three thousand employees over the summer. It was just an incredibly busy place, right there on the water's edge of False Creek.

But the barge's construction had cost McDonald's about $3 million, and at the end of Expo they wanted to have it remain in False Creek to recover their capital investment, despite the fact they had sold millions of hamburgers. However, their deal with Expo said that they had no right to leave it there after Expo closed. McDonald's took a very strong position that they should be allowed to keep it there for an additional period of time. The City of Vancouver was just as determined that wasn't going to occur. There were fairly lengthy negotiations that never resulted in McDonald's being satisfied, and the barge was ultimately moved into Indian Arm and buoyed there where it was very badly vandalized.

At one point, Rivtow took an interest in it, thinking we might be able to bring it to the river but that was not possible. It was a concrete barge, but it was not built to Transport Canada's specifications and could not withstand open sea weather or anything of that nature. The City of Port Moody also thought they might like to renovate it and make it part of their waterfront but they also backed away. To sell was difficult because you could not tow it in heavy weather. If the City of Seattle was to buy it, for example, they would have to load it onto another barge, and lifting a barge this size is not easy because it is just a shell and you have to be so careful that you don't crack the shell. I think in retrospect that had it been built to Transport Canada standards and registered as a Canadian vessel, its value would have been substantially more after Expo. Last I heard it was still in Indian Arm. I believe it probably will have to be demolished.

BC PLACE AND EXPO '86

The ultimate success of Expo '86 was very satisfying for Lucille:

> If Expo had been a normal business operation, we would have had the luxury of spending the first six months of operation correcting oversights or dealing with unforeseen items and refining and perfecting the operation, but with Expo '86 we had to get it right from day one or we could have been really unsuccessful. All the pre-planning, all the work that was done was indeed very worthwhile as it was a wonderful success. Our board delivered Expo '86 on budget, though of course we did benefit enormously from the $23 million that Mel Cooper raised in sponsorships. And we delivered it on time—the plan was that we would open May 2 and close 165 days later. That's what we did.

It rained the first three weeks of May 1986 and attendance was very poor. Then the sun came out and stayed. Attendance reached 210,000 people a day, a large percentage of them BC citizens. Many of them went in response to a government promotion campaign that saw thousands of personal-looking postcard invitations sent out from Premier Bennett. They also responded to a special $86 "passport" that gave them entry for the whole six months of the fair. It was a brilliant marketing move. Lucille recalled:

> On the final day there were 335,000 people on the site enjoying all the festivities, and we were quite nervous that something disastrous would happen with so many people together in one place. But it turned out that the closing was a most memorable occasion, and we breathed a great sigh of relief at the end of the day that it had gone so well.

Lucille was typically self-effacing about her role in Expo '86:

> I probably did influence some decisions, though one suggestion I wasn't in agreement with was the concrete highway display

where they put in submarines and whatnot and half-covered them with concrete. It was very expensive and I did not think it would have much public appeal. It turned out to be an extreme success and very popular, so my judgment was wrong and it was good that I was overridden. I am not known for being quiet if I disagree with something. On the other hand, when a decision is reached and you are a board member, a majority decision must rule, so even if you feel it wasn't the right move, you have to come aboard and make it happen.

Jimmy Pattison, however, was full of praise for Lucille's contribution:

We had fourteen or fifteen members on the board but she was one of the best. She was very conscientious and always did what she was asked to do on the committees she was appointed to, always did her homework, always took her job seriously. She was a team player and very highly thought of by everybody. She was just a rock-solid kind of person, an excellent board member and very committed to helping the public. I know the BC government had a lot of confidence in her.

When, one Christmas Day many years later, Jimmy phoned Lucille to wish her well, she was very pleased to hear from him. Commenting on that call, he later said:

Lucille packed a lot of freight for Expo and I just wanted to say thank you. She was a quality person, that one. My assistant Maureen was certainly a big "Lucille supporter." Everyone liked her. There were no negatives in her. She was a good-hearted woman.

Shortly after Expo '86 was officially opened, Premier Bill Bennett announced that he would not be seeking re-election. An election campaign

followed and in August, 1986, Bill Vander Zalm was elected premier of the province.

Grace McCarthy was appointed Minister of Economic Development and Minister Responsible for the Sale of the Expo Lands. She formed a board of directors which included some members of the original Expo '86 board, including Lucille and Peter Brown. Chester Johnson and Kevin Murphy were also on the board. This board was given a directive by Premier Vander Zalm to sell the land as quickly as possible. He wanted development to begin, and employment to be the result.

Not all board members agreed with that directive. Land values were bound to rise in the future, and was this really the best time to sell? Lucille and others went along with the premier's wish. Jobs and job creation were the orders of the day.

The new board, with Grace McCarthy as minister responsible and Peter Brown as chairman, faced with quick disposal of the land, asked Kevin Murphy to put together terms of reference for the sale and then proceeded to place advertisements in North America, Asia and Europe. They advertised for nine months while the new board attended to many internal issues, including the decision to sell the land in one piece rather than dividing it into parcels. This decision was based on their desire for an outstanding plan with a cohesive and comprehensive vision of how the land would use its waterfront and fit into the city's central core.

At the very last moment of the advertising's nine-month life, a proposal was received from a local group. The board heard their presentation, and realized that the group of venturists planned to subdivide the property and market the lots at a handsome profit—and an undesirable mish-mash of development.

During the advertising period, Grace McCarthy received a call from George Magnus of Li Ka Shing's office in Hong Kong. Li's group had an interest in the site, and already had investments in real estate in Vancouver. They visited the city, and Murphy took them through the criteria for bidding. One of the stipulations was that they would forfeit their million-dollar bond if they discussed any of their plans or tried to offset their investment by bringing in other developers. The bond was to give

them confidential access to the land and to information needed to design a comprehensive plan.

The board of directors made a decision after the final bidders presented their cases. They chose the bid with the strongest possibility for success, and it was evident that Li Ka Shing's model, plans and presentation were the best.

As Lucille tells it:

> Li Ka Shing's crew actually came from their San Francisco office to make the presentation, and you could see they knew the value of foreshore. Every foot of it was important to them and if they could create more foreshore that was what they intended to do. They came with a demonstration model, and as a person who has been in the marine business and really values waterfront for the fact that it is so limited, I was very impressed with their ideas. They not only planned to develop the waterfront along the north side of False Creek but to create at least two new islands in the middle of the creek with cross-bridges. Thus you would have more waterfront on which developments could be placed and community access would be readily available. I found their plan exceptional. Unfortunately, after they acquired the land and their model was viewed by City Hall, many of the awesome features of it that I had so enthusiastically accepted were turned down and the islands were never created. I still think it's a pity because another couple of islands in False Creek with public access and/or other residential towers and a yacht basin, for example, would have been great for the city.
>
> I believe the price they paid for it was $370 million and it was payable over a number of years. In retrospect it was really very cheap. If you look at the number of buildings going up on that site now and at the price being charged for a condominium or strata ownership in one of those buildings, it is unbelievable compared to what was paid when the land was acquired. However, that was in 1987 and land and houses were cheap

compared to today. A house sold for $150,000 then would likely be $600,000 now.

After the lands were sold, the BC Place board was merged into the BC Development Corporation and Lucille sat on that board along with other former BC Place board members. This was not a happy experience for Lucille:

> What BC Development wanted to do was really not always in keeping with the wishes of the board and it became troublesome. So at the fiscal year-end annual meeting when directors were to be re-elected or reappointed, it became obvious that they would rather have a new board that took orders. Therefore, we all declined to run for reappointment.

THIRTEEN

Moving to the Top

On May 17, 1984, when Lucille Johnstone accepted her YWCA Women of Distinction award, she observed that most companies were willing to bring women onto their boards, but that there were only a limited number with experience in large operations. "Time will correct this," she told the audience. She did not think she would ever quit working, she concluded. Instead, she planned to begin another career: "I'd like to write some books that make people laugh." She intended them to be bestsellers.

～～～

However, Lucille Johnstone was far from finished with her present career, and in 1984 she had a lot on her hands at Rivtow Straits. According to the company profile published in the *British Columbia Lumberman* in March that year, the winds of recession that had been howling through BC's resource-based economy since 1981 had seriously rocked Rivtow. Although the recession's effects on the company had been mitigated by its involvement in shipbuilding, aggregates and industrial equipment, its

marine division and fleet of some 275 vessels remained Rivtow's foundation. The *Lumberman* pointed out that the forestry and mining sectors "had been operating at very reduced levels when, in fact, they have been operating at all. Considering that forestry alone represents 70 percent of [Rivtow's] marine division's business, the size of the blow is immediately obvious." Norman Cosulich admitted that the company's volume had been down considerably and that the company had been operating at about 60 percent of capacity. And the lockout that had started in February in the pulp and paper sector was "not helping." Still, he was cautiously optimistic. He said 1983 had been better than the previous year, and he expected that 1984 would be even better.

The fact that it was Norman Cosulich and not his brother Cecil who discussed Rivtow Straits' problems with the *Lumberman,* and that it was Norman and Lucille's photo that appeared on the journal's cover, was not accidental. Cecil had, in fact, been gradually letting go of the business, announcing his retirement several times—then repeatedly returning to take the reins. And though he had always preferred to leave the finer points of company transactions to Lucille, as he reached his late sixties this habit became far more pronounced. According to Cliff Julseth, he was having "a terrible time" making decisions. He would "rather move away from the subject or actually leave than make a decision."

By this time both of Cecil's sons, John and Paul, had executive positions with the company, as did Norman's sons, Bill and Bob. John, who was forty in 1984, had graduated from UBC in commerce and held his captain's ticket as well; he was vice-president in charge of marine operations. Paul, ten years younger, was the manager of the company's real estate activity. Bill was marketing manager of coastal operations in the equipment division, and Bob was assistant manager of shipbuilding. Lucille had known all of them since they were born and her relationship with them was very complex—part friend of the family, part employer, part mentor.

Paul Cosulich's earliest recollection of Lucille was that she was the person who had established the amount of his childhood pocket

allowance. He remembered her always being in the office when he went with his father on weekends and played on the tugboats tied up on the river.

> You could usually find some form of pornographic magazine under the mattresses [on the tug's bunks], which were a great fascination to a guy my age. I was a sort of dreamy young fellow and not much for a hard day's work in those days. So I would go down there on Saturdays and hang around, and Lucille would be there. I don't have much of a recollection of her being overly maternal in a demonstrative way, but in a sense she was—now that I think of it—more paternal than maternal... Because my mother and father had been divorced early and my mother was alcoholic and my maternal grandmother had died, I had a natural inclination toward Lucille. I think it might have been the little boy inside me who had been asked to grow up a little too quickly. And there is also probably a fundamental part of my nature that likes to get close to the controlling element... We [Paul and his siblings] were never wanting for anything. If I asked my father for something, I would usually get it. He was never one to bring home a present or a toy or that type of thing. We were not lavished upon, but we were basically bought off... We were a working-class family, though a snobbery developed in me in later years when I went to private school.

Paul Cosulich worked for Rivtow during the summers of his university years and after graduation went to work in the shipbuilding division. "I didn't work directly with Lucille at that time," he recalled, "but she would have been a force in my life. She already had a legendary status." He came under Lucille's direct tutelage when, at twenty, he was transferred to the company's marketing division. By fluke, he found a property buyer who was willing to pay more than Rivtow was asking; his reward was more responsibility, though Lucille still checked his work.

"The Big Three" in 1981 (left to right): Norman Cosulich was known as "the doer," Lucille Johnstone "the fixer" and Cecil Cosulich "the thinker."

> Nothing much went out of those offices without her seeing it, even correspondence, and for somebody with an independent sort of mind like I had I took some umbrage with the fact that I should have to be checked. I remember taking Lucille a water lease that I had perfected, and then she corrected it, but when she handed me the corrected version back, I handed her my actual final product because I had been pretty convinced that my corrections would be the same as hers. That was a watershed day for her, and afterwards I had the sense of being an adopted lieutenant. There was a specialness of working for her because of her central importance to the firm, and being a lieutenant to her was an ego-gratifying thing, though there was also some notoriety about having a privileged relationship with her . . . There was a sharpness to my character then, which I probably haven't lost completely, that for some reason she tolerated when few other people would. I don't think it was through deference to my father because probably at that point her level of deference to him had declined rather dramatically. I think she was losing respect for him.

Paul saw Rivtow's growth as deriving from Cecil and Lucille's combined talents and personalities in the beginning:

> That expansionary tendency would have been from the two of them, though I think originally it would have come from my father. He would have been pushing forward and she would have been supporting his initiative, but she was way smarter than him, and for many years he knew that the way to manage her was basically "get the fuck out of her way and let her get on with it"—because she was not the type of person who would work *for* anybody. In the first few years she may have been "working for Cecil," but that wasn't how their world worked. That was Lucille's show, there is no doubt about it. We were all riding on her coattails.

Paul stopped short, however, of agreeing that Lucille was the absolute *sine qua non* of Rivtow's success.

> It's like arguing that the growth of a plant is solely the result of the fine quality of the water you put on it. I think that the three personalities [Cecil, Norman and Lucille] involved worked sufficiently collaboratively and that was combined with excellent timing and luck. That team, the three of them, and the times they were in, were buoyant. The joy that existed in commerce in those days and the fun in business that you had is gone now. There is not that kind of fat in the pan.
>
> It was the heyday of British Columbia's commercial excess and Rivtow was a resource-based business in an unrestrained economic environment. The only thing to keep you from getting something done was your own initiative and the thickness of the thing you were trying to cut or drill through. There was a "can do" spirit that Lucille embodied and engendered in the people around her. I think those three found themselves in unique circumstances with some very unique people. I have never really considered whether she or my dad or uncle were actually catalytic to the company's success, but as I think about it now, I believe that their core integrity was magnetic and charismatic.
>
> As for Lucille, I used to think of her as the sleeping cobra, charming but with an agenda too. The old hands, those who would go in to negotiate a raise and walk out thanking her after having got nothing or less, knew that was a fool's game. Those who knew her longer recognized that there were some things you didn't waste your time on with her, and one was asking for more money. As a result of that there was probably some level of frustration on some people's part. There may have been even a degree of "woundedness" on not being respected for the energy that they were putting out because not being recognized financially can often translate into someone thinking that he is not appreciated. Though I think that would have been doing Lucille

an injustice because I believe she appreciated the effort that people put in. She was a fair and honest employer—but tough.

By the end of the 1970s both brothers, John and Paul Cosulich, had become convinced that they were ready to take over the company. The fact that they didn't make a concerted move to do so had more to do with the times than anything else. Lucille would later remark:

> By 1980 the second generation, Cecil's sons John and Paul, deemed it was time to take the helm and put their father, their uncle and me out to pasture. Their plan was well underway when the natural resource industries—forestry, fishing, oil and coal—plunged into a disastrous market and interest rates climbed to 22 percent. It was a catastrophe for a leveraged company like ours with over $100 million in debt. To say it was a difficult time would be an understatement, and the pressure from John and Paul subsided because they had never been exposed to a "depression" of any nature.

However, John had not lost his belief that his father's presidency was his by right of inheritance, especially whenever Cecil would announce yet another "retirement." Unfortunately, neither he nor his brother had the experience or all-round business acumen needed to take over the reins of such a diversified company during such a difficult period. As a result, in August 1985 when Cecil finally and formally moved into a half-time role as chairman of the board, it was Lucille Johnstone that he appointed to replace him as company president and chief operating officer. The suggestion contained in a 1986 cover feature in *BC Business Magazine* that this was merely a "transitional presidency" must have provided only very slight solace to Cecil's sons. The headline read: "Lucille Johnstone, president of a sleeker, downsized Rivtow Straits" and then, after acknowledging Rivtow's successful emergence from the recession, continued:

The wheel and binnacle prominently stationed in the reception office of Vancouver's Rivtow Straits suggest there's a firm hand at the helm of this $200 million company, evenly divided between marine (tug and barge, and shipbuilding) and land-based (real estate and heavy equipment) operations. As it happens, it's also a hand that has rocked the cradle and doesn't belong to one of the four younger members of the three-generation Cosulich family that has built Rivtow. But Lucille Johnstone has built along with them, and last August when Cecil Cosulich assumed a half-time mode as chairman, Johnstone became president.

"Almost since the beginning," said Cosulich, "Lucille has been involved in every phase of our operation—the decision-making as well as the planning." And more. As chief financial officer for more than fifteen years, her money dealings have made most of the company's developments possible.

In one sense, while very much the lady in the wheelhouse, Johnstone sees herself as a sort of transitionary president between the Cosulich generations. While Cecil and Norman were both ready for retirement, Johnstone was the logical successor while their sons advanced in the organization...

If you hear references to "The Godmother" around Rivtow's Southeast Marine Drive head office, it's a term of endearment. They all love Lucille, partly because her typical deal is an offer that can't be refused... Her appearance belies her tough interior. A gentle person, Johnstone comes on like somebody's mother. She doesn't even raise her voice. Maybe it was her accountancy training that developed her inner fibre...

It's always been recognized, says Cecil, that he and Norman plus Johnstone made up the management triumvirate. "Cec the thinker, Norm the doer," says Johnstone. To which both brothers add: "Lucille the financial planner." And the administrative glue that holds the whole thing together.

In 1980 Rivtow's total revenues were $175 million; by 1985 they had grown to $244 million. Total depreciated assets, at approximately $200 million, had kept pace with growth in sales. By 1986, *BC Business Magazine* pointed out, Johnstone was "presiding over a strong, well-balanced corporate entity":

> Her corporate philosophy at this point is clearly evident in the company's leaner stance, while still maintaining its presence in all divisions it has established since 1975. Says Johnstone: "Our strategy right now can be summed up in one word—downsizing. And that is related to our recognition of the outlook for the western Canadian economy at the moment. We felt, for example, that we had too many shipyards—three—so we reduced that number to one, the Manly yard. We're winding the other two down."

Lucille then explained that Rivtow's three shipyards had formerly specialized. BC Marine had concentrated on repair and maintenance; West Coast Salvage had made boom boats for the forest industry and the Manly operation had specialized in the construction of superior aluminum and steel fishing and towboats as well as vessels for government agencies. In rationalizing shipyard operations, the surviving Manly yard would work as priorities presented themselves. She continued:

> "We're selling off some tugs and barges that aren't up to contemporary standards. This is taking place while we actually have a new and bigger towboat on order, demonstrating that we're not just scaling down but rather improving our ability and efficiency while we're at it. None of this means we intend to be less diversified or profitable—quite the reverse, as a matter of fact. In addition, we're selling two of our ready-mix operations and consolidating our equipment division. It all adds up to a refining of our operations, both land-based and marine, improving quality while we scale down size."

The article finished with a summation of Lucille's place in the industry:

> Everywhere that financial fine-tuning has been required to permit Rivtow to roll with the punches of BC's economy, the fine hand of Lucille Johnstone "massaging the plans" has been evident, whether funding acquisitions or planning cutbacks. Johnstone's expertise has not been lost on the rest of the business community. She is currently a director of BC Resources Investment Corporation, and a member of its executive and audit committees, a director of Hiram Walker Resources, BC Place, Expo '86 (and its finance committee) and the BC Forest Foundation.
>
> The outlook of the company isn't the source of much doubt for Johnstone. She says forcefully: "Nineteen-eighty-six will be better. With the refining we've done in all our operations, better results will show up. For instance, though our shipbuilding exposure is being reduced, there are several profitable areas such as design and fabricating that we are performing for eastern fishing boat operations. The expectation for Komatsu and other heavy equipment lines is exceptionally good. And as for the towboat business, forestry should be doing better and that's good for us. We have the fleet honed down to fighting shape now, with one new ship on order and another undergoing major repairs. All in all, more than a satisfactory outlook."

Predictably, the *BC Business* article concluded with a reference to Lucille's Achilles heel.

> Johnstone, who served a hitch as a tug dispatcher early in her career with Rivtow, maintains the same bias toward the marine side as do all the other principals in the company. But does she really like the sea, marine life, the rakish little tugs that grace the Lower Mainland's waterways?
>
> An unqualified yes—almost.

"With one qualification," she admits. "I don't seem to be able to outgrow seasickness."

Not to worry. They say Admiral Nelson had the same problem. And it didn't diminish his strength at the helm at all, either.

FOURTEEN

Bad Things Happen to Good People

When *BC Business Magazine* listed Lucille's directorships, they omitted one: the Northland Bank. But that directorship was, in fact, uppermost in her mind at the time because the bank was playing a starring role in a drama that was unfolding in Alberta. It would have serious consequences for her. She explained:

> Back in the mid-1960s Rivtow required some major financing for marine equipment, and we negotiated a substantial loan through Royal Marine Insurance of Montreal. Peter Sanderson was one of the people we dealt with there, and so I was pleased to hear from him about ten years later when he phoned to say that he was in Vancouver. Over lunch he told me that he had joined the Calgary-based Northland Bank [incorporated in 1974], and he wanted to know if I would let him nominate me for appointment to its board. I had never been on a bank board so I thought I would try it as a new challenge. In due course I was appointed and started attending the meetings in Calgary, and it wasn't long before I began to have my doubts about this bank's operation.

The chap who was the head of the Northland Bank—whose name I know but will not repeat—appeared to be spending 75 percent of his time travelling first-class around the world and entertaining in countries throughout Asia and Europe. This did not seem appropriate for a western Canadian bank that was supposed to be serving the needs of western Canadian businesses. Of course, if I don't understand something, I find it necessary to question it. In this case, it was not a very popular question, and the answer I got was that I really didn't understand the situation. This didn't satisfy me in the least. Eventually, I also found that the amount and size of loans going out were growing out of all proportion to the economy—which was going downhill. Other financial institutions were being somewhat more cautious on real estate loans, whereas our credit people were still giving a very high percentage of loans for real estate acquisitions. So after considerable badgering on my part, they did agree to lower the number and size of these loans. At that point the extravagant head of the bank left.

He was replaced by an ex-Royal Bank man, a very dominant person who liked to be totally in charge, and he moved us into new premises, but while the board had approved the move, we were not prepared for the capital overrun for leasehold improvements. The new man had spent money on absolutely the most expensive furniture, things like elephant leather chesterfields!

The economy of Alberta then went completely downhill, with the real estate market being a particular disaster, and we at Northland were striving to keep these loans current. At the same time the Canadian Commercial Bank (CCB) in Edmonton was in dire straits, and in early September 1985 [federal Minister of State for Finance] Barbara McDougall announced that she was putting CCB into receivership and putting Northland into a soft receivership or monitoring situation. Well, that was the kiss of death because, once she made that announcement, our depositors fled and we were left in a terrible position.

What we as directors didn't know was that at the end of July our directors' and officers' liability insurance had expired, and though there was a provision in it for renewal, the management had not attended to it. It wasn't until after Ms. McDougall announced this receivership package in the first week of September that we discovered our D&O insurance was not in place. We proffered the renewal premium to the insurance company, but it was rejected. We were then in the position of having no liability insurance protection.

On September 29, 1985, the federal government commissioned The Honourable Willard Z. Estey to investigate the failure of the two banks, particularly the causes of the failures and the regulatory approach to them, and to make recommendations to improve the overall regulation of the Canadian banking system. The report issued by the Estey Commission claimed that management, directors, auditors and regulators were all seriously lacking in the performance of their duties. In the meantime Deloitte Touche had been appointed receivers for the Northland Bank on behalf of the Canadian Deposit Insurance Corporation (CDIC), and in 1991 they issued suits against forty-two individuals, including Lucille, jointly and severally, claiming liability for $1.2 billion owed to CDIC. Lucille recalled:

> I joined with nine other board members to pool our defence, and in the course of that I spent one hundred thousand dollars as my share of the legal fees. Finally I came to the conclusion that, no matter whether we won or lost in the end, this was going to take years. Even if we won, it would probably be appealed because the other side had more money than we did, and my children would end up with no income from my estate. So in 1994 I flew to Toronto and met with the Deloitte-appointed receiver, who informed me that he understood I had a very nice farm in Fort Langley and they might be prepared to accept the farm as part payment in settlement. I came back, withdrew from

the group action, and hired Ladner Downs law firm to seek a settlement for me. I was told that I could get my release by paying out a half-million dollars. I went home and thought about it, then cashed in some investments, paid them the money and received my release. This enabled me to move my assets into a holding company for my children, one that would be managed by the lawyers in the event of my death.

I must say that I felt absolutely no guilt about Northland because I firmly believed then as I do now that I had done my work thoroughly. The one mistake I made was relying on the bank's chartered accountants. I had asked them for assurance on loan loss provisions and so on, and they said they were satisfied with it all—which they should not have been. So I felt I had been more than dedicated in carrying out my duties as a director. The lawyers for our group felt that we were wrong to have accepted the accountants' opinion.

Ironically, I had kept copious shorthand notes of every meeting I attended and had collected a basement full of these old documents and notebooks. But by the late 1980s I thought I was finished with Northland as nothing was happening on that front, so I loaded up all the documents related to it and other companies that had passed the seven-year mark for tax review and took them to the dump. The lawyers felt I did it purposely to bury my evidence. This was not the case, of course. I really wish I had kept those notes because they would have shown the intensity with which I questioned management about their shoddy practices.

Lucille later suffered another similar setback. Again, she was quite blameless. On June 30, 2001, she received a writ naming her as a defendant in an action to do with a management pension fund for Westar Mining Company and a supposed shortfall of contribution back in 1985. Lucille had joined the board at the behest of her friend Bruce Howe, after she had served on the boards of the BC Resources Investment

Corporation and BC Place with him. But the writ came as a great surprise to them both because the Westar board had never actually been involved with the pension fund in question. Lucille explained:

> On the advice of Wyatt Insurance Brokers, the actuaries and the Royal Trust Company, this fund had been managed by the management themselves, not by the board of directors. So we went through the process of defending ourselves as board members in a pool, but apparently they were really looking for recovery from the deep pockets of Royal Trust and Wyatt. I am not privy to what kind of settlement they finally got, but it was at that point that they agreed to discharge the board members on the basis that we had to pay our own legal fees. It cost me twenty-five thousand dollars. People should remember when they agree to go on a board with a pension trust that there is no statute of limitations to protect them against claims for supposed breach of trust.

Bad things do indeed happen to good people.

FIFTEEN

Vancouver International Airport

Lucille's experience with the Vancouver International Airport board was far happier than those with Northland and Westar. Like all of Canada's airports, the one on Sea Island had been owned and operated by the federal government since it was built in the 1930s. Although there had been minimal improvements made to it during that time, by the 1980s it was channelling some $270 million in profits into federal coffers every year. Grace McCarthy, who was BC's Minister of Economic Development from 1986 to 1989, wanted that money for airport improvement. According to McCarthy:

> Recognizing the potential of Asian trade, I appointed a board to form the Asia Pacific Initiative. We put forward several ideas and one included the devolution of the Vancouver Airport. Pat Carney as federal representative and myself as provincial representative co-chaired the API. Our idea was that the federal government should allow the airport to be operated by a board of directors recruited from business, with representatives from the provincial and federal governments on it. It would be run

as a business by this board, and the only thing that the federal government would keep would be the control tower because the towers had to be operated on a uniform basis across the country. Though there was a movement right across the country for the transfer of federally owned airports to local authorities, we were the very first province to go to the government and suggest they do that. We lobbied the ministers involved, lobbied the prime minister, lobbied everybody in sight to get the airport into private hands so that we would have a free hand to enhance it.

Lucille continues the story:

> As a member of the Asia Pacific Initiative, I was asked to help with the negotiations for this airport devolution. I worked with other API members such as Darcy Rezac, managing director of the Board of Trade, and Graham Clark, who had been very involved in the Board of Trade airport study. Grace and Pat felt my broad business experience would add to the team.

Chester Johnson, former head at BC Hydro, had a reputation as a very successful bargainer and was asked to head up the task force. He described how he was recruited:

> Grace McCarthy and Pat Carney came to my office and asked if I would negotiate the Vancouver International Airport away from the federal government. Frankly, I wasn't really all that enthusiastic, but they said, "It won't take very long—perhaps six months!" I asked what were the conditions and they said we would have a budget of $50,000 and would have to formulate plans for the structure of an authority to own the airport and negotiate to acquire it and operate it. I asked them where our office would be, and they said, "Oh, we don't have an office for you."
>
> "You mean you want me to use my office to put this together?"

"If you would."

So I said, "Well, okay!"

As far as I was concerned Grace McCarthy was a fine person who had done a lot for this province . . . and I guess this is really why I took the job.

Lucille had agreed to serve as vice-chair, and Chester provided her with an office in the Marine Building. He also hired a secretary/receptionist. Lucille outlined the background of what the task force faced:

> The federal government had not seen fit to spend money on this airport. The combined domestic and US terminals were totally inadequate, and there was no parallel runway to cope with the ever-increasing number of aircraft coming into Vancouver as the gateway to the Pacific and from the US and Europe. It had been designed to serve a maximum of three to five million passengers a year and it was already coping with nine million.
>
> In 1986, to accommodate people coming to Expo '86, the federal government had converted the underground parking area of the building into an international arrivals level and moved parking out onto the adjacent property at ground level opposite the terminal. We knew that a great deal more than this was needed. We could see that, with proper capital investment, there was a tremendous opportunity for Vancouver to compete for the Pacific and Asia traffic with Seattle, Los Angeles and San Francisco since the great circle air route was considerably shorter and therefore cheaper for the airlines. The federal government had done a tremendous cost study on the future of the airport looking twenty years ahead, which was provided to our task force and reviewed by airport accountants and KPMG, but it was so convoluted that we never did find a way to make use of it and proceeded to do our own.

The federal government was determined that the airport should be taken over by a not-for-profit business corporation formed under the Canada Business Corporation Act, even though it would be impossible to operate the airport without making a profit because money had to be made to modernize it and cope with growth. It could be non-profit only in the sense that there were no private shareholders, and as a result the federal government insisted that any money made in excess of expenditures would be reflected in increasing rent payable to Ottawa rather than reinvested in the airport. This policy had consequences Lucille found it difficult to accept:

> The basic principle they proposed was that, as forecast in their study, there would be automatic growth for the next twenty years. Therefore the amount of rental we should pay them would not be an economic "day one" rental but rather one that reflected what their forecast said would be the additional traffic over those years. Further, if we found ways and means of expanding the airport and bringing in thousands, if not millions, more passengers than they had forecast, we had to pay anything we made on the new passengers as well. If we managed to make any money by leasing to third parties, there was also a formula under which the rentals we generated would be shared with Ottawa. And there was a provision that, if we built a multi-tiered parking lot, they would share in it, too. In fact, every initiative that the entrepreneurial types on this new YVR board would implement would be for the benefit of Ottawa. At the same time there were certain elements in Ottawa that really didn't want the government to divest itself of these major airports, and therefore as the agreement was negotiated and the documentation evolved, when it went to these departments it was rejected for all kinds of reasons.

The BC government had given the task force fifty thousand dollars for the project—which had been clearly inadequate—and long before

the five years of negotiations were over they had no funds left. Lucille recalled:

> Here we were acquiring a $1.4-billion asset—with no money! So the irony was that for the last few months I was writing reports, doing minutes, doing the photocopying, and paying postage for the process to go ahead to acquire this magnificent asset for the Pacific coast. Looking back, no one is going to remember the amount of devotion that this group of eight to ten people put into it. It was just phenomenal. They would fly to Ottawa on their own bucks and so on.

Chester Johnson commented:

> I told the board that we had to get out and get some money because the fifty thousand wasn't going to be sufficient to carry this project through. So I went to the Royal Bank—they had been my bank for years—and they really disappointed me. They wanted all the directors' guarantees and this and that and the other thing. I said, "Is that the best you can do?" They said, "Yes," so I told them, "Fine, you are out." So I went to the [Canadian Imperial] Bank of Commerce and they gave me $3 million because they knew the people that were involved. They didn't ask for guarantees, just $3 million with no strings attached.
>
> Later I went back to talk to the Commerce again and negotiated a $450-million long-term bond. When and if we took over the airport we had to have capital funds because there were certain things we couldn't live with. It was a Mickey-Mouse airport, as far as I was concerned, and now it is number one in North America.

Lucille continued:

> After four and a half years we were left with a set of documents that were unacceptable. The section that dealt with rental

income that would be shared with Ottawa contained formulas that were two hundred pages long! It was an absolutely awesome document to live with and totally unfair, and we fought bitterly to get changes. However, as business people we eventually came to the conclusion that if we declined to sign these documents, this airport would sit with no expansion for another twenty-five years. And so, with gulping throats, we signed. Even with severe reservations about the federal government's stipulations, we were determined to turn the airport into a success.

Chester Johnson described the process as "an elephant fighting a mouse. We were the mouse." The federal government would later say they had turned over $1 billion-plus in assets to the local group and had an obligation to generate a return to the taxpayers who had paid for these assets. However, in every other country where privatization of federal properties had occurred, there had been an auction for the assets either in highest annual payments or in an up-front payment. Lucille did find one clause in this contract that was in the task force's favour. "Because we signed up early, there was a provision that, if they made a deal with another airport authority that was more beneficial to that authority than what we were given, we were to get the same advantage. I don't think that was ever honoured."

The new Vancouver Airport Authority took over the ownership and operation of the airport on June 30, 1992. Johnson continued as board chairman with Lucille as vice-chair, and many of the original task force also became members of the new board because they knew the background and the board needed the continuity. Lucille said:

We didn't want this airport run by politicians or political appointees. We wanted it run by business people who understood entrepreneurship and how to make investments and how to make money. So the bylaws included a provision that there would be

a representative from the chartered accountants' institute, one from the engineering institute, one from the law society, one from the Vancouver Board of Trade and one each from the City of Vancouver, the City of Richmond and the Greater Vancouver Regional District. The rest would be bona fide business people like Chester and myself. So that became the formula for the board.

Chester Johnson brought in David Emerson to be CEO of the Authority as a salaried employee. Emerson had been a deputy to former premier Bill Vander Zalm in Victoria and was later CEO of Canfor. (In 2005 he was Minister of Industry in Paul Martin's Liberal government and in February 2006 retained his seat at the cabinet table, becoming Minister of International Trade in the Conservative government of Stephen Harper.) Frank O'Neill, airport manager for Transport Canada, retained his position. Johnson also recruited engineer Henry Wakabayashi, who had built the Crestbrook Pulp and Paper Mill for him. It was Wakabayashi, operating as a paid consultant, who negotiated all the construction contracts for the upgrading of the airport and who Chester credits with those costs coming in $45 million under estimates. Lucille and Chester had worked as volunteers on the task force for five years, but after the formation of the Authority they were paid modest fees to act as vice-chair and chair, respectively. Said Lucille:

> When we finally acquired the airport in June 1992 and it became a big business challenge—and obviously a lot of responsibility—we paid a fee to each of the board members and an additional fee for those acting as committee chairs. If I remember rightly, the chairman of the board got about thirty thousand dollars a year. It wasn't a giant stipend, considering the millions of dollars we were acquiring in assets, the millions we were spending and approving and what we were undertaking and achieving.

Chester Johnson credits the success of the project primarily to the work of himself and Lucille as volunteers and to Emerson, Wakabayashi and Frank O'Neill as paid staff.

Henry Wakabayashi developed a deep admiration for Lucille. He commented:

> On any major project we manage, including the new International Terminal Building and parallel runway, we prepare a project definition report (PDR). This articulates in a very comprehensive manner all the details of the scope, the budget, the schedule, the policies and procedures for implementation and, of course, the business plan. In December 1992 we presented the six-volume PDR to all the board members to review during the holidays, so they could come to the workshop in January to discuss and clarify it, then approve it at their end-of-January board meeting. Chester was in Hawaii so Lucille chaired that workshop, and it became very obvious that other than Lucille not many of the board members had even opened up the report. Probably the number of volumes and the size of the documents—about eighteen inches high—had intimidated them. But not Lucille. While the others were looking through the report and flipping pages, she was asking one question after another, starting each query with "Henry, can I ask one more small question?" And her questions were very well thought out and based on a complete understanding of what we wanted to do. This was typical of how she accepted her responsibilities. Chester was the "big picture man," but he always had Lucille there not only to worry about the big picture but all the details as well.
>
> On another occasion, Chester was seeking approval for the $55 million commitment we had just made for structural steel, elevators, escalators and apron drive bridges—one of our early major commitments. Chester said, "Henry has committed to this $55 million. Let's have a vote of approval." All the board members obediently put up their hands in approval—except Lucille.

She quietly said, "Mr. Chairman, shouldn't we be advised what we are approving before we vote?"

Chester replied, "We will vote first and then get an explanation from Henry."

Lucille countered, "Then I abstain."

I asked Chester if I could take five minutes to explain the details and he agreed to five minutes. After I explained, Lucille said, "Now I understand." And Chester concluded, "Well, then it is unanimous." Again this was how seriously Lucille took her job, even when she was volunteering her expertise. She was one of BC's most formidable business people and someone for whom I had tremendous respect.

The $45 million that Henry Wakabayashi saved on the main construction project enabled the Authority to build a parkade that had not been in the original plans. Lucille explained:

> We spent $30 million for our multi-level parkade. In checking with airports such as Portland, Oregon, we found that when their multi-level parkade opened, they charged nine dollars, and it was full. When they raised the price to eleven dollars, it was full. And when they later charged thirteen dollars, it was full. No matter what they charged, people used it because they loved the convenience of it, and so we felt that in Vancouver, with our variable weather, we needed to build this parkade to cut down the distance that people had to walk or take a shuttle from the outlying areas. That was an extremely profitable investment. Of course, because of the formula we had agreed to, a percentage of that profit went to Ottawa even though they never intended to build a multi-level parkade.

When it came to deciding on the right concept for the retail side, Chester Johnson, Frank O'Neill and David Emerson did research around Europe. The Copenhagen Airport became their model because it used

the "street scene" concept that O'Neill had always wanted for Vancouver. Johnson was fascinated by it and told his companions, "That's it! That's what we are going to do. We are going to develop an airport with a street scene second to none!" Lucille was also happy with this decision:

> Retail was a key revenue source to the bottom line of the airport. Without it, the Vancouver Airport might have had to operate in the red, but David Emerson insisted that all retail stores there must charge street prices. If you go into Boston Pizza at the airport you pay no more than if you go to a Boston Pizza in Marpole or Langley. That in itself was a new concept for airport operations. In many other airports you get gouged.

The retail sector could not return enough revenue to the Authority, however, to pay for all the construction that was necessary, and Lucille was intimately involved in finding a solution.

> A major problem, of course, was how the airport would generate enough money to pay for all the needed capital improvements. Our analysis showed that the only way would be to institute an airport improvement fee (AIF) that we would devote entirely to paying for capital expansion. We knew that the Federal Aviation Authority (FAA) in the United States had put in airport improvement fees, but some of them were included in airline ticket prices so they had to rely on the individual airlines to remit their AIF revenue to the FAA. Well, right about the time we were implementing our AIF we were told that the US had a billion-dollar shortfall between the number of tickets sold and what the FAA was getting. We didn't want to work ourselves into that situation. And that is why passengers pay our AIF in the Vancouver terminal. We didn't have to worry about not getting the cash that was so critical to making our capital expansion repayments.

Robert D'Arcy, the aviation chairman for insurance brokers Reed Stenhouse, remembered Lucille's part in the financial calculations that led up to setting the amount of the AIF:

> We had been appointed as the brokers for the Canadian Airport Council after a big competitive fight, and another Reed Stenhouse executive and I sat in on a number of the Authority's discussions regarding insurance issues. As a result, we were in on one meeting on overall financing. These were *big numbers*: federal government rent, landing fees, insurance, construction of a new international terminal, that kind of thing. When the debate over the AIF came up, it was not just whether to include the fee in the tickets or to collect it separately. There was talk as well of charging a fee instead for anyone coming on the site, and I seem to recall that initially several at the table, including Lucille Johnstone, supported that idea as being more fair since the fee could be as low as fifty cents. It was finally decided that it would be a departure fee and there was debate on whether to charge one fee for all departures, and I remember commenting that local people just heading for someplace like Victoria would see this as a huge load on their trip cost. It was finally settled that there would be different levels for provincial, domestic and international. But what I remember most about that meeting was that Mrs. Johnstone was able to instantly project the total revenue that would be generated *net*—that is, she seemed to have some handle on the costs of collection as well. She was very impressive and made an otherwise sleepy meeting interesting.

Frank O'Neill was a great supporter of First Nations art and very keen that the Vancouver International Airport should have a major piece of Haida artist Bill Reid's work. In 1986 a major piece of Reid's sculpture had been installed in the Canadian Embassy in Washington, DC. *The Spirit of Haida Gwaii*—more frequently referred to as *The Jade Canoe*—is made of patinated black bronze, and it depicts a group of

travellers—some human, some animal—in a Haida canoe. The board agreed it was the perfect expression of both the West Coast and the travelling public, and they empowered O'Neill to negotiate a price for an exact replica. The deal he and Reid signed was for $3 million.

While Chester Johnson and Lucille Johnstone remained strong supporters of the project, other board members were lukewarm in their support because of the cost. Chester resolved the problem by putting on a dinner at the University of British Columbia, raising enough to start a fund that would enable the acquisition of all the art and artifacts displayed at the airport. Chester is particularly proud of the famous Reid sculpture. "You don't get a sculpture like that very often, you just don't. We have been offered $10 million for it, but no, it's not for sale. If you go out there any day of the week, there are always fifteen, twenty, thirty travellers leaning on the railing or sitting looking at it. That was a good move." Indeed, the location of the Haida Gwaii sculpture was specifically chosen by the architect so it could serve as a focus and a meeting place. Just as people used to arrange to meet friends by the Birks Clock in downtown Vancouver, now the Haida Gwaii sculpture is the airport meeting place.

Lucille was a fan of the art from all the First Nations at the Vancouver Airport, but she was happiest with one in particular. "I am proud particularly of the recognition of the Musqueam First Nation and their welcoming figures and their artwork throughout the terminal which brings us accolades from people who travel here from around the world," she said.

The consulting arm of the Vancouver Airport Authority came into being because Lucille noticed a loophole in the massive federal government contract that the Authority had been forced to sign. In this great mound of legal documents there was a section called the "basket clause" that covered every aspect not specifically mentioned in any other clause, thus ensuring Ottawa would get a share of all accrued revenue. But Lucille, having concocted so many multi-layered contracts for Rivtow, knew that in any agreement there are small escape hatches. She realized that the basket clause only referred to the Airport Authority's operations on Transport Canada's Sea Island property:

So after we finished the runway and the first expansion of the terminal and the multi-level parkade, we realized that we had in our construction group some subcontractors and staff who were absolute whizzes at running a proper airport. We wanted to keep them, so we formed a YVR entity—Vancouver Airport Services or YVRAS—that operated on private land off Transport Canada property, and Frank O'Neill became head of this new entity. We offered to enter into management contracts with airports throughout the world. The first contract we won was to take over the Bermuda Airport. We had a one-year contract to go down and help them set up their systems, their retail and so on. At the end of that year they were so pleased they renewed the contract. In the meantime we were invited to bid on many other contracts for airport facilities around the world and, more importantly, airports across Canada. So we took contracts, for example to help manage the Hamilton airport, and it was all handled through this side management company. It has been extremely successful and helped us retain these marvellous people who know how to do it and how to do it profitably. So that in itself is something the people of British Columbia should be particularly proud of.

By 2006 YVRAS was managing eighteen airports in six countries and was the undisputed leading global airport operator based in North America. In 2000, the *Global Airport Monitor* reported that in the annual survey conducted by the International Air Transport Association (IATA), Vancouver International Airport was rated as the best airport in North America. It was also voted third-best worldwide for overall satisfaction among business travellers, just behind Singapore's Changi Airport and the Copenhagen International Airport. This ranking was the same in 2002 and 2003. Lucille was very proud of the fact she had been part of this story:

> It was an interesting challenge and we were fortunate to have David Emerson and that whole terrific team. A lot of those

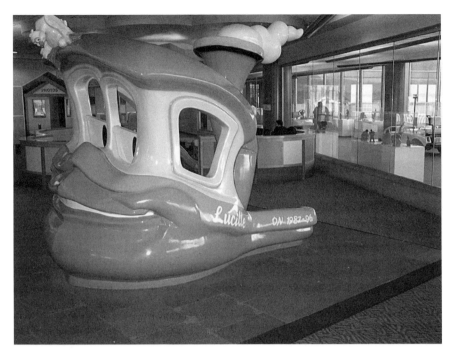

In honour of the outstanding changes that Lucille helped to make at the Vancouver International Airport, she was asked what she might like to have named after her. She said she would like something that children might enjoy. Today a 6-foot cartoon-like tugboat, with bright eyes and a broad grin, complete with "Lucille" emblazoned on its side, can be found on the departure level.

people were staff we inherited from Transport Canada, all very capable people, but frustrated and thwarted because they knew what should be done and couldn't get Ottawa to let them do it. This was a whole new world for them and they put their minds and their spirit and their efforts into it and now you see what happened.

There is a lovely park at the Vancouver Airport named in honour of Chester Johnson. When Lucille was asked what she wanted to have named after her in recognition of her service to the airport, she said she'd like something that children would enjoy. You will find that "something" on the departure level: a model of a tugboat with the name *Lucille* emblazoned on it. That's Lucille for you.

SIXTEEN

The Parting of the Ways

On Thursday, July 20, 1989, a small item in the *Vancouver Sun* headed "Rivtow Straits Limited Announcement" shocked the BC business community. The story read:

> Lucille Johnstone is stepping down as President and Chief Operating Officer of Rivtow Straits Limited after forty-five years of dedicated service to the company.
>
> During this time Mrs. Johnstone has served in almost every administrative capacity from secretary to tugboat dispatcher to Senior Vice-President, Administration, and since August 1985 as President and Chief Operating Officer. At the outset of her career, Rivtow was solely a towing operator in the upper Fraser Valley; in the ensuing years the company has become one of the largest marine transportation companies in British Columbia as well as having major operations throughout Western Canada in industrial equipment sales and services, marina and aquaculture products and marine safety equipment.
>
> Lucille will continue to pursue her other charitable and

business interests. She is presently a director of the Westar Group, Westar Mining, Vancouver Board of Trade and Grace Hospital. She has recently been appointed president of the Canadian Association of Equipment Distributors and is also a director of the Associated Equipment Distributors. She is a member of a SAGIT Group (Sectoral Advisory Group on International Trade), the Pacific Advisory Regional Council (PARC) for the Federal Minister of Fisheries, and the Vancouver International Airport Advisory Group.

Lucille's outstanding contribution to the growth and success of Rivtow is gratefully acknowledged.

After an initial flurry of interest on August 1, a *Vancouver Sun* columnist suggested "Lucille Johnstone could not stay forever at Rivtow Straits, although after forty-five years it may have seemed possible." He pointed out that she had stood out for a reason not mentioned in the company's original announcement: "She was one of only two or three women who have run large companies in BC—ever. As a role model and inspiration she has been invaluable." He concluded by saying that "her successor is likely to be named Cosulich. Cecil and Norman built the tugboat company and their sons now want to take over." In fact, Cecil's sons had wanted to take over for the last ten years and had now decided it was time.

The media, however, were not privy to these reasons for her "resignation" from the company. It would be another fifteen years before she publicly disclosed the full story, beginning by explaining that John and Paul Cosulich had delayed making a move because they had been discouraged by the recession.

> Towards the end of that decade, recovery was made and our balance sheet was restored to its position as at 1980. The second generation now reactivated their desire to take over and in particular to have me retire and their father and uncle semi-retire, but in my case, they wanted my shares as well as my departure.

So I prepared a list of all the issues that needed to be resolved and met weekly with Paul as he acted as the family's representative, although John was really the stronger one pushing for my departure.

Paul Cosulich recalled being given the role of negotiator for the family because "my brother had very strong ambitions to succeed, and when all this friction developed between him and Lucille, my father started pulling me into it because I think he trusted me." Paul described the job of negotiating with Lucille as being "like the sophist dealing with the master, and during that process Lucille became so embittered, particularly with me, that I lost my best friend. I don't fault Lucille at all through any of this." There was, he said, considerable sibling rivalry also complicating the issue:

> There was some rivalry between my brother and me that actually shouldn't have been there because... well, Christ, I was a dope-smoking dreamer who had little interest in commerce, although I was pretty proficient at it because I am not stupid. My brother is an absolute driven guy in the marine business and a good operator. He knew how to run tugboats well, he was a good cost-cutter and he understood the business.

Norman Cosulich, watching from the sidelines as the battle built, saw the conflict in very simple terms:

> Cecil's two sons didn't get along, and as John, Cecil's older son, had graduated from university in commerce, he got more involved in the business, and he and Lucille had different philosophies, I guess. John disapproved of the fact that the company was always almost broke. Because of our rapid expansion every cent had always gone to more boats and more work, and when the bank got a little restless, John disapproved. So it became a struggle between Lucille and John and

the fact that the other son didn't get along with him didn't help either.

Little progress was made in Lucille's meetings with Paul Cosulich, but she was determined not to give up her claims to fair compensation. She continued her story:

> It soon became apparent from these meetings that many facets could not be agreed upon. The family, through Paul, then asked me to meet with Linda Wager and then with Jim Kosh of KPMG. Meanwhile, the situation was becoming completely unworkable at Rivtow. Although I was president and chief operating officer of this diversified company, John declined to share with me his five-year strategic plan for the marine division for which he had responsibility. And John and/or Paul would travel to Alberta and Saskatchewan to our industrial equipment branches without advising me of their plans to do so, although they had no direct responsibility for those operations. Their father would not intervene because he found it difficult to stand up to John's aggressiveness and determination. I really feel he should have stood up against those sons and not let them treat me in the way they did. I phoned him once and said, "Cecil, what have I done to deserve this?" He said nothing. Not a good enough answer. As has been said throughout history, blood is thicker than water.
>
> John and Paul had decided to move the Rivtow office down to a redeveloped building on the Vancouver Harbour. The deal was negotiated, and they took my staff down for a tour but I was not invited. There was no office there for me so it was apparent to the staff that I was not included in the Cosulich boys' vision for the future. Moving day was June 30. The staff helped to load my files into my station wagon and many tears were shed, but I assured them everything was going to be fine.
>
> Norman interceded with the other family members and

insisted that I be given an office at the new premises, but although I appreciated his efforts, I was not willing to enter a door that was not welcoming. Meanwhile, George Abakhan offered me a spare office at Henfrey Mason, and Maureen Chant called from Jimmy Pattison's office to offer me space there for which I was grateful. I actually continued working as president and COO for the next few weeks from the most convenient office offered to me downtown. Clearly not a satisfactory situation, but I had no choice.

After almost two years of negotiations, it was apparent to me that we could not settle the impasse between the Cosulich family and myself. Even such basic requests as a pension for me after forty-five years of service was rejected, and though they wanted my shares, they claimed that they needed to pay for them over a long period of time. Cecil said the company did not have the money—slightly over $2 million—to pay me. And when I suggested that I really deserved a decent pension, they said, "Surely you have saved enough out of your salary to look after yourself in old age." Well, my salary had never been that great, and I finally asked Ken Bagshaw of Ladner Downs to help conclude a settlement. I will be forever grateful for his assistance.

During the many discussions, a joint meeting was arranged at Davis & Company at which Lucille was accompanied by Ken Bagshaw. The Cosulich family was represented by David Hossie, Cecil, Paul and John. As the meeting concluded, Ken commented that he had been at the negotiating table for virtually three hours and during that entire time he had not heard one word of gratitude for the fact that this woman had devoted forty-five years of her life to this family's benefit and had made millions for them. Cecil attempted to respond to Ken's remark, but John quickly silenced him. The meeting ended on this sad note.

Lucille later said:

> One of my concerns was that if I did not get paid upfront for my shares of Rivtow Straits and the company subsequently ran

into difficulty, Cecil would insist I return to Rivtow to ensure that the company would survive in order to pay what was owing. But after the protracted negotiations and the frigid atmosphere I did not want to even contemplate that happening, and I went to the Royal Bank to explain my situation. The bank agreed that I deserved to be paid out and they would make the money available to the company to do so. Thus a final settlement was reached, the documents were signed and a cheque arrived at Ken Bagshaw's office at 6:00 p.m. on July 10, 1989.

When I settled with the family, I did so to avoid the ordeal and publicity of a court action and the ultimate stress this would place on me beyond what I had already endured. I concluded that a tax-free figure of about $2.2 million for my shares, along with the pension that Ken Bagshaw had finally negotiated for me, would be sufficient for me to live comfortably.

I admit without hesitation that I enjoy wheeling, dealing and making money. Unfortunately, I have made many millions for others—not just the Cosulichs—but I have been told by advisors that I do not take care of *me*. This is probably true as I do not covet a high lifestyle, yet I never contemplated that my failure to look after my own needs would be taken advantage of by others.

A great joy to me is the fact that even fifteen years after my departure, I still get calls from Norman Cosulich and Rivtow employees wanting to see if I am doing okay. Employees tell me I was the best boss they could ever have had, and one cannot put a price on that.

As for the Cosulich family, by acquiring my 10 percent of Rivtow's shares, they now had over 90 percent of the company's stock and were therefore able to make a buyout of the remaining shares at a price based on the figure I had been paid. But after their success in removing me from the company, John and Paul fell asunder in their disagreements.

Lucille's secretary Lisa DaSilva was shocked that the Cosulich family could treat Lucille in this manner after all the years they had worked together:

> At Rivtow, if you went in to ask Cecil about anything, he would just say, "Ask Lucille. She knows it all. Ask Lucille." It was like Lucille was Rivtow. That's how I saw it anyway. No one could do anything without Lucille. I thought that Cecil and Lucille had this strange close relationship. The way it looked was that these two were inseparable, that these two were real good buddies, because they had worked together for such a long time. That's how I saw them until the year that she was forced to retire. Then I realized there was more to it. Here I was working in this company, these two people practically running the show, and they are just so close and then all of a sudden, before you know it, it's like a divorce. It was really nasty. It sort of changed my perception, changed a lot of my thinking about business and put me on my guard.

Paul Cosulich described what then happened to the company:

> It was not long after Lucille left that the same initiative and the same momentum that catalyzed her leaving catalyzed my leaving as well in a similar unceremonious way. I was drummed out of the boardroom. The financial state of the company continued to deteriorate and the divisions between the marine and equipment sides of the business became clearer and clearer. The bank's support for my brother's activities on the marine side and his seeming operational and financial acumen became stronger as their dissatisfaction with my performance, my style and our operational results on the industrial side of the company declined. This prompted the request on the part of my family to have me leave. And I left. Eventually they sold off the industrial assets [to Komatsu], and then my brother sold the majority of the marine

business to Smit [Internationale N.V.] of Holland. That was the tugboat business—the shipbuilding operations had been closed by that time—but he continued to hold onto the company's real estate assets [in Cosulich Holdings]. I took a business off my uncle's hands and continued with a life raft manufacturing business and a marine window business that we successfully parlayed into a vehicle sufficient to feed a family or two.

When Paul Cosulich was asked how his family could have thought it appropriate to squeeze Lucille out of Rivtow after forty-five years of marvellous service and achievement, he replied:

> My father had promised my uncle and Lucille a stake in the business. But as the succession issue came more and more to the forefront, it became pretty clear that my father was not going to be respectful of the verbal undertakings that he had made. So that would have been the start of it. So I think it was the combination of an unrealized undertaking on my father's part, increasing succession pressures, probably Lucille's perception of my father's increasing incompetence, my father's consideration of her lack of focus because of her increasing outside activities and because she was starting to get public notoriety for being Tugboat Annie, the Leverage Queen, and all that kind of stuff, the increasing pressure by the bank for us to rationalize the company's activities which basically meant selling off some bits and getting this thing narrowed down, and then I think my brother's skill at charming the bank and the bank's increasing frustration with Lucille's bamboozling style because she was very good at pulling rabbits out of the hat. And I think that there was a lot of subterfuge on my brother's part as well to undermine Lucille. Why did she have to go? She had to go because she was no longer effective in the role that she was trying to play and it was as much her doing as anybody else.

However, he readily agreed that Lucille had every right to feel she was treated badly:

> Absolutely. My God, first of all, the overtures that were made to her verbally by my father were not realized. That would be one thing. I mean he would argue that he never made those promises and all that, but that's horseshit! He did. She was dealt with indelicately and . . . I mean, I was the spokesman for that indelicate treatment and as loving as I can try to be at times I have got a tongue that's cutting and horrid. I have realized, as a result of her attitude towards me subsequent to that, that I must have been brutal. Well beyond the pale. I think she went out of there deeply hurt and I think she probably felt that her old friend Cecil had turned on her and that I had turned on her as well and that it was a grossly unfair situation. But frankly, from the legal position that she had at the time and the ownership that she actually had versus what she had been promised, she was treated very fairly. The disconnect was between her expectations of what her equity stake in the business was and what it actually legally was. I was forced to deliver the reality pill that "despite all your expectations and despite all our promises, this is what you get and this is how it's going to be dealt with." I can remember the level of stress that she was having at that time because it was evidencing itself physically.
>
> It was one of those situations that when I look back on it now, I think, God, what a blessing to have gone through that as far as a character-enhancing and character-building exercise for me! You know, lose my best friend of that many years—half my mother and half my grandmother—and delivered by my own sword!

Norman Cosulich left Rivtow shortly after Lucille was forced out, though he said that he "never retired. I just sort of faded away." He credited Lucille's efforts with the fact that he did own some shares in Rivtow:

I received a lot of benefits that I wouldn't have got if she hadn't gone after them for me because my brother didn't think about it too much. If it wasn't for her, even my share of the business wouldn't have been there. She had a very good sense of fairness . . . She would say, "Norman, you need a holiday," and then she would book us something and off we would go. . .

Norman Cosulich died in the summer of 2005. He was eighty-six. Cecil Cosulich had died in spring 1998. Remarkably, in a full-page obituary of Cecil that appeared in the April 1998 edition of the *Harbour & Shipping News*, Lucille's name is not mentioned.

It is easy to say, but often very hard to accept at the time, that "these things happen for the best," but looking back it would indeed be the case with Lucille and Rivtow. The people of British Columbia clearly benefited to a far greater extent when Lucille began to devote her energies to the public good—working for St. John Ambulance, the BC Ferry Corporation, the Airport and the Fraser River Discovery Centre—than if she had continued to devote herself to the further financial enrichment of Rivtow.

Nevertheless, having her career with Rivtow end this way was a devastating blow to Lucille. It is a truly remarkable testament to her character and strength that she was able to carry on. Lucille's ability to look on the bright side and keep a positive attitude is reminiscent of the attitude of Sir John A. Macdonald, who, after one particularly hard reversal in life, reportedly said: "When fate empties a chamber pot over your head, you look around, smile and say—we seem to be enjoying a summer shower."

SEVENTEEN

Life After Rivtow

Lucille's life had not come to an end with her departure from Rivtow. She recalled:

> After receiving the cheque for my Rivtow shares on July 10, 1989, I stepped out of the elevator from Ken Bagshaw's offices into the fresh air and realized that for the first time in forty-five years I would no longer be living, breathing and working Rivtow. How to celebrate such a culmination? I spotted a sale of patio furniture as I proceeded home along Lougheed Highway, stopped and purchased two comfortable patio chairs with high backs. I would now have time to read the many books that I had accumulated over the years. But that was not to be. Within days my phone started ringing and a whole new and challenging life unfolded. As one ex-Rivtow employee said later, "Lucille, you turned lemons into honey."

In the depth of Lucille's winter, there lay within her an invincible summer.

About a month after Lucille's departure from Rivtow in 1989 she was honoured at a surprise tribute dinner at the Wedgewood Hotel organized by her friend, lawyer Anne Stewart. The invited guests were women who recognized that Lucille had helped pave their way.
From left to right: Back row: Mary Ruhl, Mary Hamilton, Vy Rice, Linda Parsons, Ann Gourley. Middle row: Anne Stewart, Bev Breuer. Front row: Paulette Miller, unknown, Lucille Johnstone, Lucille Giles, Carolyn Weiler

The first call came less than a week after she left Rivtow. The voice on the line belonged to Dennis Hurd, an engineer who had been working for the Industrial Development Bank (IDB) back in 1963 when Rivtow had applied for a loan to finance the conversion of the *Rivtow Lion*. As that venture had been highly innovative, the IDB had sent him to investigate the company in depth, and he had found himself working with Lucille. He had quickly developed enormous respect for her abilities, and as a result when he started his own company, Atlantis Submarines, in 1984, he called to ask for her help. She knew instantly who he was:

I said, "Of course I remember you and will never forget you! You saved me from a fate worse than death." I told him how every morning while we waited for that loan approval Cecil had said to me, "Well, you've really done it this time! You have finally bankrupted the company." So it had been a great relief to put that loan approval on his desk and shut him up.

Dennis Hurd told Lucille that, after leaving the IDB in 1972, he had gone to work for International Hydrodynamics, a company that built the Pisces submersibles, then started his own company in Texas, using submarines to inspect pipelines. Finally, having raised $11 million, he had started Atlantis Submarines in BC. His company had built the world's first submarine especially for the tourist industry and had put it to work in the Cayman Islands. He wanted Lucille to become a company director and help with the company's growth. However, Rivtow was at that point just easing out of the recession and still losing a million a month, and Lucille could not spare the time to help Atlantis. Reluctantly she had turned him down. Then, said Lucille, "A week after I left Rivtow, Dennis was on the phone again. He said, 'Now you have the time and we still need you.'"

Since his last call Atlantis had expanded into Barbados and St. Thomas, then into Guam and Hawaii, becoming the biggest providers of tours to cruise ships. However, looking back on that time, Dennis Hurd recalled that despite this success, they were "struggling a bit with St. Thomas and having difficulty with projections and with some bank loans."

> When I was looking for another director, I thought of Lucille because, given her interests and the Vancouver business community's opinion of her, she would be a great addition—if she was available. I might add that I told her from the outset that we wanted access to her knowledge and experience base, so she effectively agreed to sign on in somewhat more of a consulting basis than just a traditional director. Besides being extremely

knowledgeable financially, she was technically confident and understood what people were doing in the marine field.

Lucille was happy to put her expertise to the test again:

> So I went to help him. Atlantis was looking to expand and didn't have the funds to do it. As I analyzed the situation, it became apparent that we had to improve the profitability at our sub sites, otherwise the future for Atlantis was dismal. First of all, despite the cost efficiencies and marketing to "fill the seats," there was still insufficient profitability to cover all costs and depreciation on the capital investment. If we continued in that way, we would survive until the assets wore out but would have no capital cash to replace them and Atlantis would be out of business. Second, since it cost about $5 million to set up each submarine operation, the strategic plan was to entice investors in tourist locations to invest as partners with us. But how could we entice investors when we could not demonstrate that they could achieve a return on their investment? Facing the facts, we could not.
>
> I told Dennis and his site managers that we could continue and run ourselves out of business in five to ten years or we could bite the bullet, put our ticket prices up and become sufficiently profitable to continue Atlantis and persuade investors to partner with us at new locations. No one likes change, particularly increased prices, and the first reaction from the managers was "we'll lose all of our customers!" But after weighing the facts, they all agreed to increase their prices by 10 to 15 percent. They didn't lose their customers, and they went onward to expand the fleet.
>
> Atlantis was confronted with many other problems as they moved into other countries. One was the deflation of the Mexican peso when our Mexican operation was indebted in US dollars. However, we managed to survive these situations and as of 2004 Atlantis was the largest tourist submarine operation in

the world and will move its 10-millionth submarine passenger some time this year. However, the total number of guests entertained far exceeds that number because Atlantis determined that the tourist market was changing and there was a need to provide other adventure-type entertainment at prices lower than that charged for a sub ride. Now, Atlantis offers forty-five marine tourist adventures in the Caribbean, Mexico, Hawaii and Guam.

I feel that the Atlantis management group do not need me now but they insist that I stay on and I am happy to do so. They are a great group and I admire what they have accomplished and their continued innovation in the product that they offer.

Dennis Hurd concluded:

Certainly through all those years she was just invaluable. She had so much experience with other boards and she was basically the driving force behind the growth of Rivtow, which made a pretty dramatic growth into a large conglomerate. All of the vast experience that she had with acquisitions and doing deals certainly taught her a huge amount, and she was able to really help us a lot in areas where using her experience and sometimes her mistakes—and she would be the first to admit where she had learned a lesson from some mistake!—saved us a lot and provided terrific guidance. We had a huge opinion of her and she was very instrumental in our company's growth.

EIGHTEEN

The Ferries

In 1990 Lucille received a phone call from Terry Godsall, who had been involved with Dietrich-Collins in the heavy equipment business when it was taken over by Rivtow. Aware of Lucille's knowledge of shipbuilding, he was calling to tell her that his current company, Greenshields, the owners of Versatile Shipyards (formerly Burrard Dry Dock) in North Vancouver, had been awarded a contract worth $250 million to construct two "superferries" for the BC Ferry Corporation. Each vessel would be 167 metres long and would carry 470 vehicles and 2,100 passengers. The project was to be undertaken by a Greenshields subsidiary, Integrated Ferry Constructors (IFC). Would Lucille act as chair of the board of IFC?

Lucille was interested but cautious:

> I agreed to meet him at noon the next day at the company's North Vancouver offices to discuss the chairman's role and responsibilities for this challenging project. Terry met me at the reception desk and directed me into the adjacent boardroom where the table was fully occupied by about twelve executives—

the IFC management team. Terry immediately introduced me as their new chair, president and chief operating officer. I was stunned—this was a far more comprehensive role than he had indicated on the phone. Afterwards I met privately with him to clarify my position. He explained that an important and essential aspect of the contract award was that IFC had to provide bonding for the project—$120 million for IFC Construction plus $30 million for engines and other equipment to be purchased by BC Ferries and installed by IFC. However, IFC had been unable to procure bonding and had gone back to BC Ferries to seek relief from this requirement. But the only way the Ferry Corporation would agree to forego bonding was if IFC could come up with a chair, president and CEO acceptable to them. Naturally, they wanted to be assured that the project would be overseen properly by someone who they could rely on to assure them that milestone payments were being advanced appropriately and for value, and it appeared that they considered me as a suitable candidate for these roles. It was arranged for me to go to Victoria the following morning to meet with Frank Rhodes, CEO of the BC Ferry Corporation. IFC's new vice-president of operations, Don Nicholson, accompanied me to the meeting and the corporation agreed to our appointments.

We then set about finding a way to deliver these ferries on time and on budget. The contract and prices had already been committed to before I became involved, so a means had to be found to live within those figures. This was not easy. The superferry challenge was unique because the Ferry Corporation's plan was to spread out the shipbuilding work in the Lower Mainland as well as on Vancouver Island. The superstructure was to be built on the riverbank in Delta by Pacific Rim Shipyards, the bow section at Allied Shipbuilders—the McLaren family—in North Vancouver, and the stern section at Yarrows in Victoria, with the ultimate goal of assembling the pieces together for a

perfect fit. One can appreciate how many times measurements were checked and double-checked.

When I came onboard the project, the terms of the contract with Pacific Rim Shipyards (PRS) had already been agreed to and it was ready for signing. We could not refuse to proceed because time was of the essence, but I was very apprehensive about its terms; it seemed like an open book for PRS to render invoices. To further my frustration, an executive of Pacific Rim whose name I won't mention would send insulting and uncouth faxes to our management staff. These were unjustified and incited fury. It was no way to build team spirit. So I faxed him to say that I would be out to see him the following morning. He replied that he would lock the gate. I told him I would climb over it. I went, the gate was open and we met. He admitted that sending a barrage of insulting messages was how he had always bulldozed his way on issues and that it worked for him. I was violent in my objections. Although he did not concede to me, the messages ceased. But it turned out that my concern about the open-ended aspect of the PRS contract was well founded—although their workmanship was good, it proved to be a costly contract.

There were other problems. Generous management contracts were in place, some of which were unwarranted and had to be negotiated for severance. Subcontracts for modules of the vessel had been negotiated on terms that lacked controls and left IFC exposed to increased billings. Contractors and staff were working overtime with no authorization to do so. Departmental engineering was not coordinated. I negotiated severances for a number of contract positions that were not needed or where the individual was not delivering "value for fee." I then began manually signing every cheque sent out by IFC and would not sign without first having all the vouchers or invoices attached. Through this intensive scrutiny of what our monies were being spent on, I worked with Don Nicholson to eliminate thousands of dollars of non-essentials and abusive expense accounts.

As work on the first ferry progressed and we had reduced our costs to complete it, we submitted a request to BC Ferries to start on superferry number two because it would be advantageous and cost-effective to work on both vessels at the same time. The Corporation agreed. When vessel number one was nearing completion and number two was well underway, Terry Godsall and Don Nicholson produced a "Cost to Complete" document that indicated we would be making a profit of nearly $8 to $10 million, and they felt that IFC should declare a dividend of $5 million. I did not concur with their figures, however, and from past experience I also knew that, before a vessel was accepted by the owners, unforeseen costs would inevitably arise, particularly during "sea trials" where problems about safety, speed commitments, and other ancillary matters come up. These can be very expensive as well as time- and labour-consuming. Because of this probability of last-minute costs and because I lacked faith in their analysis I declined to declare the $5 million dividend and Terry and Don were furious with me. Thereafter, the relationship was very strained. However, in retrospect I was proved right. Although we delivered on time and on budget, we did not have a $5-million profit. If we had declared it and paid that amount out, there would have been a deficit before we finished the job.

But I knew that IFC had done a good job on the project and BC Ferries were pleased with the vessels, so I believed that IFC should rightfully have more residual profit. In case we had overlooked some potential items to charge for under the construction agreement, I set about reviewing that document with the proverbial fine-toothed comb. There are very few contracts that don't have holes in them if you really want to find them, and one relies on the integrity of the parties to do the fair thing. In my word-by-word review, I did find a number of grey areas—items that were not stated clearly. For example, the contract provided that IFC had to fill both the fuel tanks and lube tanks prior to delivery, but the contract was not specific about who was to pay

for the fuel and lubes. I therefore included this in my list of "grey area" items that BC Ferries should reimburse us for. In the end, these grey-area items totalled approximately $4 million.

BC Ferries, however, rejected the entire list. When the IFC/Greenshields lawyers in Toronto attempted to reach a settlement they had no success, so I was asked to undertake the negotiations. Since this meant I would be acting against BC Ferries, I sought Frank Rhodes' permission to do so and he agreed. It was a rather interesting ending inasmuch as I was the lead officer of the constructing company, appointed with the concurrence of BC Ferries to ensure that BC Ferries did not overpay for its superferries, and then found myself acting as a claimant against BC Ferries for "grey-area" payments. IFC authorized me to settle at $4 million, but I could only get the agreement of BC Ferries for $2.2 million plus interest, and I recommended that the owners agree. And they did. Ironically, about that same time a Toronto company launched a lawsuit against Terry Godsall and Greenshields, and in doing so "froze" these settlement funds until that lawsuit was settled. Thus, it was a further three years before the monies were actually paid.

However, the superferries did get finished within budget and on time in 1994, and the *Spirit of BC* and *Spirit of Vancouver Island* are considered very successful. Every time I go to Victoria on one, I feel a sense of pride at the comfort and services that their two thousand passengers are enjoying.

Under the terms of Lucille's contract with IFC she was paid $125,000 a year with no benefits. They certainly got value for money, as did the province of British Columbia. This was not to be Lucille's last involvement with the government and its ferry system. Her next adventure, however, would not prove as successful. Lucille described how it came about:

> In 1996 the provincial government announced plans to build three fast catamaran-type ferries at a cost of $225 million to

operate between Horseshoe Bay and Nanaimo. This was a first in BC and quite a departure from the superferry concept, which had just been completed for the Tsawwassen to Swartz Bay run. Frank Rhodes had been pleased with the work I had done on the superferry project and contacted me several months after the catamaran announcement to request that I act as board chairman of the newly incorporated Catamaran Ferries International, a wholly owned subsidiary of the BC Ferry Corporation. I agreed to do so.

Several more months went by before Frank advised that the project was going to the implementation stage and that outside board members for Catamaran Ferries International would be myself as chair along with Kevin Murphy and Michael Goldberg. Both of these gentlemen were respected construction and business professionals, Kevin having been responsible for the construction of BC Place and Expo '86 and Michael Goldberg the Dean of Commerce at UBC. The remaining board members would come from within the BC Ferry Corporation.

A date was established for the first board meeting and a pre-meeting information package, including a budget for the ferries construction, was distributed. We three outside directors reviewed the budget very carefully as we would be committed to construct and deliver within those figures. At the first meeting we identified elements that were missing or inadequately provided for in the budget line items. We also noted that $20 million had already been spent by BC Ferries in organizing, and it was unclear whether this amount would be absorbed by them as pre-project costs or whether they would be borne by the new Catamaran Ferries within our $225-million budget. We requested management to come back to the next meeting with a revised budget addressing our concerns. This they did, but we found that wherever we had identified appropriate additional costs, they had merely adjusted other line items downward so that the total budget was still $225 million. This was clearly not

THE FERRIES

satisfactory, and again we asked management to return with a realistic budget and clarity on the $20 million BC Ferries had spent on organizing.

A further meeting was held with still no decision on the $20 million. Kevin Murphy, Michael Goldberg and I, as outside directors, insisted that the budget to complete the three vessels should be increased from $225 million to $265 million in order that we could feel confident to deliver on budget. Our request was taken back to management and resulted in the BC Ferries board deciding to seek the resignations of the outside directors. We proffered them quite willingly as we had intended to resign by June if we did not receive firm and satisfactory answers to our requests. We felt a personal responsibility to deliver within a pre-agreed and practical budget figure.

Unfortunately, thereafter the problems of this project proliferated and ultimately, the vessels performed unsatisfactorily. They cost over $400 million, well above the $265 million we had requested.

NINETEEN

Columbia Chrome

Deryol Andrews was one of the next to call on Lucille. His company, Colco International, which he formed in 1967, manufactured machinery and repaired hydraulic cylinders for the mining industry. He had come to know Lucille when his Columbia Chrome machine shops had taken on Rivtow and RivQuip contracts. At one point Lucille had even considered buying Colco but had changed her mind. Now Andrews was in trouble.

> So I phoned Lucille and asked her if she would give me a hand. Everything was going downhill. Kaiser Coal [Westar] in Sparwood that was 20 percent of our business was shut down by a strike. We had our largest factory up there, but with the mines closed, do I lay off all my employees? Do I not lay them off? Do I take their benefits away or not? I'd get to thinking that next week the strike is going to be over, but a year later it's not. Then all of the hydraulic cylinders and components we had on the hill, a million dollars' worth, maybe more—we didn't have liens on them because we were exchanging them all the time—the

receivers took them as theirs and we lost them all. The tax department was after me. I had a $3 million house going up and I couldn't stop it because—what are you going to do with half a house?

So I asked Lucille if she would give me a hand. She came in to work for the company and didn't charge me. We didn't have anything to give her. She just came in to help me out. She lived in Fort Langley and our offices were up on 201st Street in Port Kells, so she came in and started going through my companies. It was the worst time I have ever had in business, but in some ways it was the best of times with Lucille. She came in there and just turned that company right-side-up. She started by cutting costs. One time she came into my office and said, "You know, Deryol, at Rivtow Straits and RivQuip we did $380 million in business a year and we had three partners, and all three partners didn't spend as much as you do." So I said, "What are you trying to say, Lucille?" She said, "You have to get rid of that plane or I can't help you. It's bad enough having the cost of a plane but you are always stopping in Vegas on the way." She was giving me an ultimatum: the plane has to go. I went from flying my own jet to flying first-class to flying business-class to flying economy to driving to Seattle because of Lucille. I went from running up company credit cards to the extent of tens of thousands of dollars a month to going with Lucille into airports and sharing a Caesar salad! She had this victory log for the money we saved. Once she came into my office and asked, "What is your phone number on your private line in Vancouver?" I didn't know. I didn't even know I had one. "I knew it, I knew it!" she said. "I knew you wouldn't know. I am cancelling that line." So she cancelled it and that went into the victory log. And instead of the big lunches and Christmas parties we used to have, we had chili bake-offs at lunchtime and everybody would make their own chili.

I had a Rolls-Royce and I couldn't afford to get the heater

fixed because every time I took it in it seemed to cost three thousand dollars, and Lucille said, "Deryol, you just can't take that car in." So the heater was stuck on hot and I had to drive around with my windows down even when it was raining out. She said, "That will remind you to try to get as much work into the shop as we can so that we can afford to get your heater fixed." I remember I picked up a big-shot customer from Malaysia, and I had the windows up, and he said, "It's awful hot in here." So I said, "My feet keep getting cold all the time so I got to leave the heat on, but we will put the window down." So I ran around in that Rolls-Royce with the windows down in the rain and I am thinking how can I make some money? I got to make some money to get this thing fixed!

She did just a terrific job with the banks—it was the Royal Bank at the time. We were expanding some of our businesses with no money at all, just millions of dollars in the hole, and she went to the bank with the history of the company and she got them to waive the interest charges for a while. We owed a few million dollars at the time. When the company wasn't turning around fast enough, she went back to the bank and they waived all the repayments as well for quite a few months. She got the bank to come to the party and they helped the company survive. Lucille did that.

She did this for no pay, nothing at all, and I wasn't even a particularly good friend of hers either. I just knew her through business. But I think she respected the fact that I was a Vancouver boy who had worked very hard trying to build the company and I had a family and kids. I had started off with nothing, so I didn't really know much about big business and by that time my company was a large business and I was still running it by the seat of my pants. When I started losing that kind of money I had to pull out all the stops and get everything back on track. Lucille pointed the way and taught me how large corporations operate. She had liked the company when she was looking at buying

it, and I think she just thought that since she was retired—of course, Lucille never retired—since she was semi-retired and had some time and it was close to her home that she would come in and give me a hand. She helped me for a little over a year and a half, and whether she got money out of it or not wasn't a factor. She was here every day, I couldn't beat her to work. I would come in at seven-thirty in the morning and she would be here. And paper! Could she generate paper? Holy cow! And she brought in Lisa DaSilva, her former Rivtow secretary to help me out.

Colco International is a busy company and she looked after it all, just took over. We have factories all over the world—twenty-eight factories in thirteen countries, wherever there is a major mine—Papua New Guinea, Australia, Indonesia, Malaysia, Thailand, all through South America. We manufacture and repair hydraulic cylinders for the mining industry, making them on-site rather than exporting them from here because of taxes and importation duties and all that. She said, "Deryol, you do best at sales. I will look after this, I will get it going for you." So I devoted more of my efforts to sales and putting in new factories and trying to get some red meat coming in and let her look after everything else.

She gave motivational speeches. We went to our US offices with Lucille and we had meetings and she put on a motivational talk and put our company policies up and got everybody working as a unit, working together with one company helping another. She would call a meeting for all the managers, and everybody had to go into the room and take their shoes off. She made us all put on these grey work socks. "Now we are here to work," she said. "Those socks represent everybody working and everybody is the same. It doesn't matter whether you own the company or you are the president or vice-president or you are a supervisor. You are all the same here and all ideas are good. It doesn't matter if they don't come out right in the end or we don't use them. Any idea is a good idea." She did things like that.

There were other things she would come up with that she did to motivate people in a nice way, and the staff all used to call her "Mumsy." She had this "swear pot," and she said, "We are all going to put a quarter in when we swear." Of course, she didn't swear. I knew she did it only for me, to stop me from swearing in the office, because she could hear me in my office down the way, and I'm—well, I'm an old mining guy, you know—and I would swear every once in a while, and she told me "Deryol, you know, this pot is for *all* the staff." So after she went home that night, I went out to do something in one of the other offices and put ten dollars in it. I figured I would pay ahead a little bit. Pay for forty good swear words in advance!

There were times we were so tight for money she would make out her own personal cheque to pay the bills. If she had promised somebody a cheque on a certain date, she would not break her word. She would use her own money to prevent that. That's the kind of woman she was.

Then finally the company turned around and Westar opened up again and started coming back, and about a year and a half later the company was back on easy street and going along fine again. After she turned the company around and we had brought in some new management and new accountants and it was doing well, she opted to go on to do voluntary work and help others out like St. John Ambulance. What a great person.

TWENTY

Rescuing Friends

When Lucille was not rescuing businesses, she was rescuing friends. Anne Griffiths, who would work with Lucille for seven years at St. John Ambulance, believes that helping others was unavoidable for Lucille:

> Because of her many life experiences, she was a fountain of knowledge and her advice was regularly sought by many people concerning personal issues, career challenges, financial issues and the like. She always made time for anyone with a problem and tried very hard to help them figure things out in a way that would put them in control of their situation. Over time she made many people wealthy and kept many from the reverse with her sage advice.

Lisa DaSilva, who began working as Lucille's secretary in 1983 and in time became one of her closest friends, remembered:

> Whenever I went to her home, the number of people that walked in there for assistance was amazing. She would say, "I've got to

pay so-and-so because he came around, and he's Charlie's friend and he wanted a job so I made him pick up the leaves." She was always finding something for somebody to do so that she could pay them for their services.

Lucille's friend, lawyer Anne M. Stewart, felt that Lucille's willingness to help others was "often to her own detriment. I know that she got a lot of satisfaction out of doing it, so it was not all one-sided. People who help other people do it because it is the right thing to do, but they also do it because it makes them feel good. Otherwise they wouldn't do it. But Lucille always did more than her share."

Lucille spoke of her willingness to help:

> I am a Scorpio and although many doubt that horoscope signs have any meaning, the description of a Scorpio person fits me to a tee. Scorpios have an uncontrollable compulsion when they encounter a problem—theirs or someone else's—to get involved and resolve the situation. This certainly describes my own tendency, and for some unknown reason individuals gravitate to me with their problems and I find it difficult to ignore them.
>
> In earlier years I spoke with associates in the financial and legal professions about how they handled individuals who came to them for help in their field of expertise. I think the reply of one was typical: "Oh, I have a list of two financial, two legal and two business advisors that I refer them to. I don't get involved." When I asked what he did if the person couldn't afford the fees of those professionals, he shrugged his shoulders and said, "Not my problem." Somehow I can't do that. Whether it is the fact that I am a Scorpio or simply because I grew up in circumstances where we had no money, I find it difficult, if not impossible, to turn away from those in need. This gets me into lots of work but also I feel good about solving problems and knowing I have helped someone in trouble.
>
> One example was Kay Reid. Her husband, Ed, was one of

Rivtow's captains upriver in the very early days. He and Kay lived on Bristol Island, which was Rivtow's upriver operating base. Ed eventually retired but they stayed on in the cottage that they had occupied for so many years.

When Kay was in her early seventies, she underwent abdominal surgery at Chilliwack Hospital. During recovery she suffered severe pain and visited her doctor frequently. This went on for about twelve months. At that time the pain was so severe that Kay's granddaughter drove her to the hospital in Hope, where a doctor x-rayed her abdomen. He determined there was a foreign object in her abdomen and it was probably badly infected and intruding on the bowel. She was rushed back to Chilliwack Hospital and they found that a sponge had been left in her abdomen—thirty-four were put in and thirty-three came out. The infection was major and the doctor felt she would have not survived much longer.

Kay, who had been a very active gardener, cook and hostess, felt she should be compensated for her year of suffering and for the inhibited lifestyle now imposed on her, as well as the difficulty of looking after her husband who now had Parkinson's disease. She engaged a lawyer on a percentage-of-recovery basis. He said the case would require extensive time and had an uncertain outcome, but he offered to sue in Small Claims Court for $10,000. From this sum he would deduct $1,800 for a letter of opinion from a specialist and 30 percent for his fees. Kay would be left with $5,000 and no assurance that the staff at Chilliwack Hospital would take steps to avoid any similar occurrence.

Instead, we paid the lawyer the $1,800 for the letter and took back the case. Kay had no funds to hire a lawyer so I agreed to act on her behalf after the Law Society said that it was probably okay, provided I did not charge a fee—which I had no intention of doing. But the Law Society also suggested I find another lawyer to take the case and that I work with him to do the research to reduce his time. Richard Gibbs of Prince

George, who had done similar cases, liked Kay and me and agreed to do it.

With time running short, I filed the required writ in the Supreme Court in Chilliwack against the doctor and the Chilliwack General Hospital. The case eventually got settled. However, over the past several years Kay has been denied the joy of life that would otherwise have been available to her, and no recognition was given for her unjustified and inhibited way of life, nor any assurance that the hospital has improved operating-room procedures.

Anne Stewart noted that Lucille had one asset that others did not always recognize as a strength: her willingness to ask others for help when she didn't have the answers. Lucille demonstrated this in another story:

In 2002 I received a call at home on a Wednesday evening from a friend I had not seen for some time. She said she was in a serious financial situation and would like to meet with me as soon as possible. The following evening when she came to my house, she explained that on the coming Monday a judge would likely order that the farm she and a partner shared be seized and turned over to a secured creditor. An investment of over $5 million was involved. I immediately phoned a friend who is a trustee in bankruptcy and persuaded him to meet with her on Friday morning. After his quick assessment of the situation, he brought in his accountant and a lawyer who specialized in such matters, and they worked all weekend preparing for a court appearance on Monday.

The situation was extremely complex and there was a lot of anger in several quarters, but the court set aside the foreclosure for a stipulated period of time. Through a major effort, the farm was saved. Had I not met with my friend on that Thursday evening and arranged for the right expertise to be involved, all would have been lost. The partners were indeed grateful.

RESCUING FRIENDS

Another person who Lucille helped greatly was Luba Fillipoff:

> I met Lucille back in 1980. At that time she was at Rivtow Straits and I was working for the Bank of British Columbia. I started a small organization called the Western Business Women's Association. Our goal was to try and reach women of Lucille's stature who could perhaps mentor us and share their knowledge with up-and-coming business women.
>
> Everybody was in absolute awe of her and told me how busy she was—"you'll never get Lucille," they told me. Once I explained to her what I was doing in our organization she was just so willing to come. She was willing to help our organization

Dr. Jeremy Greenfield, a Langley veterinarian, had provided sheep for Lucille's farm many years before. He recalls:

Shorty came to visit me and said that Lucille was interested in buying some of my sheep. I went down to see her and came across her house with its tennis court and swimming pool. Her husband Joe came to the door and invited me in for coffee. Lucille was there and was very slim at that time. I started out lending her some sheep and eventually she bought some but I looked after them and took them back over the wintertime because she only wanted them to mow the lawn. She would keep meticulous accounts of how much she owed me—maybe one of the sheep had lambed or died and she would account for it all—even though it was probably only fifty dollars! I developed a friendship with her. I'd pop in and have coffee and she would confide with me and ask me my opinion because she knew that I had no involvement with business. After she stepped down as vice-chairman of YVR [Vancouver Airport Authority] I asked her why didn't she just retire and have a good time and travel. She said, "I just love business." She never looked after herself, just after everyone else. Her family was everything to her, very very important to her.

of young women even though she barely had five minutes for herself. She always gave of herself, no matter how many commitments she had to others, she always was willing to give to somebody who showed initiative and some drive. She loved that. What was extraordinary about her—one of the many many things—was her unselfishness. She was never concerned with herself as much as she was with others . . .

Later on I was going through some personal problems and I had quit the bank. I was a little bit at loose ends and she sensed that, and invited me to come and stay at her house until I sorted myself out. It was such a huge house—there was lots of room, the kids enjoyed me and I enjoyed the landscaping so it was sort of a retreat for me. The rooms that I occupied were 1,200 square feet. It was like the size of a home, it was so huge. It was the master suite but she didn't want to stay in that, she stayed with the children at the other wing of the house. I did the landscaping and looked after the house and did a lot of repairs. I loved it. I was sort of a workman there. Our friendship just sort of evolved from there. She helped me get into another little business. She was so helpful in that. Her mind was just incredible. You could tell her a problem, she could take it down and write out a solution or give you some ideas to think about.

Besides Lucille's huge heart for humanity and helping people, she loved nature. Her farm was her refuge. She loved to come home and work in the garden. She would drive up the driveway and she would stop and she would back down and just drive up again and look at all the flowers and everything trimmed and her heart was just at peace. She just loved that. She would walk around the gardens with me at night after supper just to look at all the flowers and the shrubs and how everything was trimmed, and you could just see how much she enjoyed this.

The farm was sitting on a little knoll, and parts of the lawn were steep, so we couldn't get the sit-down lawn mowers there. Lucille had decided that using sheep to keep the grass low was

the answer. It was wonderful. We would walk and we would talk to the sheep. It was so beautiful, to sit there on her back patio. We would have maybe a glass of wine or coffee, and look at Mt. Baker and we would listen to the sheep baaing, and the crickets and the frogs and whatever and she was at peace. She just loved it. It was like meditation for her, filled her heart full.

Luba Fillipoff went on to describe Lucille's personal characteristics:

Lucille was, in my opinion, a very modest person, she didn't like the limelight, she had literally hundreds of awards, hundreds of things granted to her, and rarely did I see anything brought out of its case to be in public view. Most of her awards were tucked away. She never spoke of her accomplishments or what she was awarded. She felt that was just sort of part of her life, part of her job, part of what she had to do. That to me in itself was always amazing. Power, in my opinion, never entered her mind, power in the sense that "I am in this position and I can do so much or I can do what I want," that was not Lucille's way. If she was given the honour of whatever position it was her job to do it to the best that she knew how. She always wanted that from somebody else . . . to do the best that they could and do it honestly and ethically. She really admired people who did that and I know she lived that way herself. She was totally authentic. She was true, she was pure, I am not sure what other language or adjective to use. You could trust Lucille, if Lucille said something, you could trust that it wasn't a lie, it wasn't manipulation, that it was what it was. That was one of the many things I learned about her and about ethics in business and to have your scruples especially in business and never to lie or cover up or anything along that line, that was never in her vocabulary, never in her modus operandi, everything was on the table and that's how you dealt with it. Even in her personal life, her children—you just don't lie, you have to deal with issues. Of all the people I have met in my life,

this is one true person that I can honestly say I would trust implicitly in business or my personal life. That there would be no hidden agenda with Lucille, she was who she was, she was who she said she was, and that's it.

Lucille Johnstone's business ventures and charity work were interrupted in 1992 when she suffered a serious injury. She was chasing some sheep out of her garden when a ram charged and struck her left leg, fracturing her ankle. She dragged herself into the house and phoned her sister Betty for help. When Betty and her husband Auguste arrived, Lucille was lying on the kitchen floor with a very deformed-looking left ankle. She asked Auguste to go outside and find a two-by-four that she could use as a crutch to hobble to the car and get to the hospital. Auguste normally did whatever Lucille wished, but this time he flatly refused: "You're going to the hospital in an ambulance." Lucille's son John, who arrived at the house before the ambulance, reported that although she was in intense pain, Lucille was asking for the phone in order to cancel appointments for the next day. At Langley Memorial Hospital her ankle was pinned and she went home with her leg in a cumbersome cast. Housebound for a few months, she occupied her time launching a new project: turning her beautiful home into the Cedar Ridge Bed and Breakfast. Once this new business was established, she hired someone to look after it. And Lucille was soon back to her usual busy life, although her injury made it necessary for her to use a cane for the rest of her life.

TWENTY-ONE

Rescuing Charities

When Lucille was not saving businesses and friends, she was rescuing charities. Shortly after she became involved with Atlantis Submarines, she received a phone call from her friend Joan Lawrence, who asked for her help with an organization called the Planned Lifetime Advocacy Network (PLAN). Its genesis lay in a concern shared by three friends—Al Etmanski, his wife Vickie Cammack and Jack Collins. Like Joan—whose son, Keith, had Down's syndrome—they were parents of children with disabilities, and they worried that these children would not be supported after their own deaths. As there was no organization devoted exclusively to their problem, they formed a group whose main purpose would be to assist families like themselves prepare for their children's future. Other parents and interested parties became involved—Arthur Mudry, Don Duff, Chuck Walker, Peter Bogardous and Mary Hamilton. They elected Jack Collins as president. Al Etmanski told the story of how Lucille came to participate:

(Left to right) Lucille Johnstone, Expo Ernie, Jimmy Pattison and Claude Richmond. In 1991, as part of Lucille's involvement with the non-profit Planned Lifetime Advocacy Network (PLAN), she rallied her old Expo '86 crew in order to organize a five-year Expo '86 anniversary event that doubled as a fundraiser. Lucille networked in her usual way and pulled together a fabulous event, raising $40,000 for PLAN and launching this new charity successfully into the public eye.

We asked all of our founding board members for the names of people who might be able to help us, and Joan put Lucille Johnstone's name forward. We were all aware of Lucille because of her involvement in Expo, and so we asked Joan if she would invite Lucille over for lunch. Lucille arrived with three pages of questions for us. This is the quintessential Lucille, I think. There was never any issue or request that she didn't take seriously. She grilled us for hours about what we intended to do and how we planned to do it. Our organization was only in the formative stage then and we had very little to show for our early months in operation.

Years later, Lucille would explain, "I went to find out what PLAN was doing and why they were doing it, and I liked what I heard. This

In 1991, Lucille received her Honorary Doctorate of Laws from UBC. She addressed the 1991 graduating class and audience, including Clarke Jackson, senior partner at the Caldwell Partners Group. After seeing Lucille's speech and contacting her after the ceremony, Jackson found himself as one of Lucille's successors to the Planned Lifetime Advocacy Network (PLAN).

was a group that had faith that what they were doing was important, not solely to themselves, but for the community around them, and I respect that very much . . . They knew what they were doing and where they wanted to go but didn't know how to find the money to do it. It was my pleasure to lend a hand."

Al Etmanski continued:

> Thankfully Lucille decided that our cause was worthwhile enough—or perhaps she just took pity on us—and said she would help. I think she liked our purposes and our philosophy of not wanting to take any money from government. Before we knew it, she had arranged for our president and I to go with her to a meeting of the former board members of Expo. This was the old boys' network, and they were telling raunchy jokes and chit-chatting among themselves, and it was a delight to watch Lucille

PLAN is now a significant organization of national and even international importance, and Al Etmanski is justifiably proud of what it has become:

In our early days we were exploring the proper way to discharge our function, and certainly saw that estate planning and wills were critical. In those days there were very few lawyers who knew anything about discretionary trusts; they really had a limited understanding of the relationship between the discretionary trust and government benefits and the like. I like to think that one of the successes that we have had in this province has been the elevation of the level of interest in the legal profession around disability and will and estate planning. One of our first functions was to make a lifetime commitment to a certain number of PLAN family members to monitor all of their plans for their sons or daughters. (We have about 120 of these lifetime members.) Our second major function is future planning consultation. We stay on top of all wills and estate-planning issues. We created the guardianship coalition that led to the four new Guardianship Acts, one of which is the Representation Agreement Act, and so we have been instrumental in bringing concepts of guardianship out of the nineteenth century and into the twenty-first century.

As our philosophy developed, we have come to understand that the most profound handicap is in fact isolation and loneliness and so we organize networks of support. We call these personal networks our "Circle of Friends," and we bring men and women out of isolation and loneliness. Many of these lonely disabled people have had no friends other than the people with whom their parents were acquainted, people their parents' age, and thus they often have no social life outside of their parents' circle. The irony is that we spend hundreds of millions of dollars in British Columbia alone on programs and services for people with intellectual disabilities—roughly between $500 and $600 million every year—and it is all spent on programs and services that in most instances do nothing about the isolation and the loneliness. People with disabilities need to feel they belong as much as the rest of us. Unless you belong, it is really hard to move into having a life of meaning.

Now for the first time in history people with disabilities are outliving their parents, and we began receiving requests for help from across Canada, the United States, Australia, the UK and Europe. We responded by setting up a separate organization called the Plan Institute for Citizenship and Disability; its primary function is to respond to requests from families around the world, assist them in developing similar organizations and provide them with whatever mentoring and support we can. As a consequence we have

a thriving consulting business across Canada and around the world. There are now about forty organizations that we mentor directly. We have written two books that have been translated into French and will be published in Geneva.

We have also initiated conversations with both provincial and federal governments to improve or increase the number of tax and trust tools that are available to families as they prepare for the future because the discretionary trust is the very crude tool. For example, we convinced the federal government to allow a rollover of RRSPs into a trust for a child or a grandchild with a disability. There are still some limitations on those rollover provisions so we are lobbying for improvements. During the 2004 election we proposed the establishment of a Disability Investment Fund and created an online petition. The *Toronto Star* did a feature on us and said we were the only positive thing about the election. We got the federal government very interested in it, and we are working with economists and researchers and Ministry of Finance officials, looking at ways to craft something like a disability savings plan that would be a cross between an RRSP and a RESP. Another proposal on the table was inspired by John Ralston Saul, the husband of former Governor General Adrienne Clarkson. As our patron, he suggested that a phrase we had used in our literature, "No One Alone," should become our motto. So we now propose creating a fund that would directly target this challenge of isolation and loneliness.

We have travelled very far from being a committee that thought we could support maybe fifty or sixty families to being an international resource. We have won awards for being a leading social enterprise organization, combining a social mission and a set of business skills and disciplines. Along the way there were many junctures when we could have folded quite easily. But this is a made-in-BC success story that in many ways would never have happened without Lucille. She gave us our early momentum. It was her skills that gave us the crucial combination of the social and the business that made our concept attainable. We had the original idea of taking no government money but we had no idea how we were going to survive as a non-profit. I think we have shown that there is another path to survival. Nowadays it is much more common for organizations to strive to be self-reliant as a non-profit.

In the end Lucille became a cheerleader for us more than anything else and I am happy to say that we have tried to give back to her for the incredible gift she gave us in our early days. We nominated her for a national volunteer award, and she won.

in the background manipulating the agenda, getting Jimmy Pattison, who was in the chair, to call the meeting to order and then to see her, in her very gracious, delicate way, getting them to agree that there should be an Expo anniversary celebration in 1991 and that the money raised should go to charity. She had decided that Science World should be a co-beneficiary with PLAN because we were so new that nobody would be motivated to help PLAN by itself.

It was completely her idea. I think she probably wanted to do a reunion of Expo anyway and along we came and she just put one and one together. That's the way she worked. She had made us a promise that she would arrange this event with no cost to us and no dent in any of our very limited resources. She went out and found various people and groups to organize it, and it was a great success. It was a fabulous celebration. She had organized an auction, and Expo Ernie came out of hibernation. It was a chance for people to touch that magic again, and it was obviously a great event for us. It raised about forty thousand dollars for PLAN and ratcheted us up from obscurity into public view.

We put that forty thousand dollars aside in a rainy-day fund and still haven't touched it. It's the "Lucille Johnstone Fund." She went on to chair a Corporate Relations Committee for us and began to introduce us to the corporate community. We had several breakfasts with bankers, lawyers, and the like. She scripted me, taught me to pare down my ten pages of notes to half a page, just use one transparency, speak only for eight minutes and then sit down and shut up. She took care of the rest in terms of getting funding commitments from the bankers and lawyers and other professionals who were there.

Not only did Lucille help PLAN get well established, but she also found a successor for herself to ensure the group would continue to grow. When she received her Honorary Doctorate of Laws from UBC

in 1991, Clarke Jackson, senior partner at the Caldwell Partners group, was in the audience. His daughter was in the graduating class that Lucille addressed that day, and both Clarke and his daughter were moved by her speech. The next day he called Lucille to congratulate her on her honorary degree and on her speech. Lucille spotted an opportunity.

"What are you doing these days?" she asked him.

"Well, I am about to retire," he said.

Lucille, surmising that he would have some time on his hands, suggested that he might want to get involved with PLAN.

Clarke Jackson had placed many executives in the city over the previous twenty years, from middle-management on up, and many of these people were now CEOs and presidents. He held breakfast gatherings once a month for all the new senior executives who came into town, so he was exceptionally well-connected and therefore a great find for a fledgling organization like PLAN. Al Etmanski explains:

> There then proceeded a courtship between Clarke, Lucille and myself over many months, and eventually he gave in and replaced Lucille as chair of our Corporate Relations Committee, though for a long time he and Lucille worked together for the benefit of PLAN, developing lists of corporate and professional connections. We are in the business of helping families plan for the future, as are law firms, insurance companies, financial institutions and life insurance companies. Lucille and Clarke would identify prospects, sort them out, rank them, decide who would take the lead in going to meet them. Between the two of them they developed a list of about one hundred people. They were inexhaustible with their voluntary time.

Despite even this achievement, Lucille's greatest rescue operation of a charity was yet to come.

TWENTY-TWO

St. John Ambulance

Early in 1995 Lucille was approached by Anne Stewart, a friend of hers who had done legal work for Rivtow. Anne was first vice-president of the St. John Ambulance Society board; she asked Lucille to take a look at the society's operation to see what might be done to salvage the situation. But what started as a quick consultation resulted in Lucille taking over the operation as CEO by April of that year.

By 1995 the British Columbia Council of St. John Ambulance had twenty-three branches throughout the province but it was in a rapidly deteriorating financial position. The report of the treasurer, Ronald W. Royston, CA, to the annual general meeting in May that year painted a bleak picture:

> St. John Ambulance continues to operate at a deficit. While significant efforts have been made toward improving the operating results, more effort will be needed.
>
> Training has been and must continue to be the primary business activity on which the organization relies to generate the funds to support the Brigade and the costs of administration.

ST. JOHN AMBULANCE

The Order of St. John is the oldest charitable organization in the world with over one thousand years of international history. It began in Jerusalem in 600 AD, after Pope Gregory the Great ordered a hospice to be built as a resting place for pilgrims travelling to the Holy Sepulchre. The founding group of Benedictine monks became known as the Brothers of the Hospital of St. John. They adopted the emblem of the Amalfi of Italy—a white, eight-pointed cross later known as the Maltese Cross. In 1113 these brothers became a separate order of hospitallers known as the Order of the Hospital of St. John of Jerusalem. During the crusades of the early twelfth century, while continuing the work of the hospice, the brothers also took on the protection of the pilgrims, and the members became known as the Knights of St. John or the Knights Hospitaller. In 1291 they were forced to flee to Cyprus; they were granted the Island of Malta in 1530, but after it was captured by Napoleon in 1798 their power waned and from that time onward they devoted their energies solely to works of charity.

During the Franco-Prussian War, several members of the Order of St. John in England offered their services for ambulance work in the field. Their valuable efforts illustrated that the only way to obtain effective ambulance and nursing services in wartime was to provide facilities for training and practice in peacetime. As a result, in 1877 they formed the St. John Ambulance to teach first aid, home nursing and related subjects. The humanitarian work of the British branch of St. John Ambulance spread to Québec City in 1883. First aid was introduced to the logging camps of BC as early as 1906 and into the province's mines four years later. That year twenty-one employees of the Crows Nest Pass Coal Company at Michel received St. John Ambulance certificates. By 1917, 850 mining employees had passed the first aid course and similar numbers in the logging camps had received instruction. The Workers' Compensation Board in BC adopted regulations in 1920 making it compulsory for all establishments with fifteen or more employees to supply first aid equipment and training, and eight years later they decided to recognize only the instruction given by St. John Ambulance.

Contribution margins on first aid training have continued to be eroded and major changes in this business activity will be necessary to reverse the financial deterioration St. John Ambulance has experienced.

The organization has become overly dependent on non-core income and must extricate itself from this dependence if there is to be any chance to continue to serve our communities in the future. Significant decisive action is warranted if St. John Ambulance is to survive. Management, staff and volunteers must recognize that the present situation is unacceptable and work in unison to overcome our dilemma. The financial results of the past few years indicate St. John Ambulance can no longer rely on its tradition and members' optimistic rhetoric. Our business needs to be better understood and better managed.

This is not a traditional treasurers' report outlining the financial highlights of last year's operations, nor is it intended to be. This report is provided to draw everyone's attention to a serious financial crisis precipitated by continuing poor results in our core business activity of first aid training. There is no branch or region which can avoid the realization that St. John Ambulance must achieve better, more profitable training performance if St. John Ambulance is going to sustain a place in our communities.

The report showed a gross profit from operations of $2.2 million but expenses of $3.2 million, and there were insufficient donations and income from investments to cover the shortfall. To add to the seriousness of the situation, the board had fired the management for inappropriate behaviour and installed Victor Irving, past president of the BC Council and retired RCMP officer, as CEO to clean house. Irving, however, was accustomed to sending a budget to Ottawa and having money flow back to him. He didn't know how to generate money, and he told the board that they had better find somebody who could. The only person the

board found who would tackle the job wanted $125,000 a year, but they had no confidence this person could do it.

Lucille described the start of her time at St. John:

> With her knowledge of my track record for turning "ugly ducklings into graceful swans," Anne Stewart asked me to come and assess what St. John Ambulance should do to bring itself back to profitability and stability. I had taken St. John Ambulance home nursing training in high school back in 1938, and my brother-in-law Auguste and my nephew were volunteers with the New Westminster St. John Ambulance Brigade, so I had a sense of the value that the organization brings to communities. After meeting with Dr. Marco Terwiel, who was council president at the time, I agreed to spend three weeks at St. John Ambulance headquarters at 49th and Cambie interviewing staff and making recommendations to the council for remedial action.
>
> As it turned out, I spent a full four weeks in the office learning the operation. Victor Irving was still in charge, and I went in every day and talked to the staff individually. It was a whole learning curve for me because I didn't realize there are two major sides to St. John. I knew about the Brigade's work, but I didn't know about their business side as Canada's leader in first aid training. I soon grasped that the society had gone very much downhill over the years, that it had no long-term plan, and that its leadership didn't recognize that the practices of fifty years ago were not acceptable today because they had competition. Eighty years ago they were the only industrial first aid training agency for the province, but by the 1990s St. John Ambulance had 260 competitors in BC. It was losing money year after year, the staff had taken pay cuts, they had no donor database or support and their buildings were run-down. Since they could only afford basic rent, all around the province they were housed in substandard facilities that weren't of a calibre to represent the organization with pride. And they were just generally demoralized. The

Brigade people who do community services were very unhappy because they couldn't get money for supplies or training. It was a very unsatisfactory situation and it was getting worse.

After a month I made my recommendations and told the board that if they implemented them immediately they could stop the losses. I said I felt confident they would be making a profit by their fiscal year-end in December. That was when a board member asked me, "Do you think we can save St. John from bankruptcy?"

I said, "Yes, you can. But you can't sit around. You've got to do something now."

The next question was: "How would it be if you came in and did it for us? Will you come in as CEO and straighten it out?"

Well, I was seventy-one at the time, but I said okay. After all, if I say my recommendations will work, I had better prove it. I agreed to come in for a year.

For the first month, April 1995, I worked alongside Victor. We moved a desk into a corner of his office, and as they had no computer for me, I brought in an old 286 from home and a Roland printer. Whenever somebody came to see Victor, I worked on an Arborite kitchen table in the outer office. After Victor left, I set out to move quickly from operating losses to operating profits.

How Lucille set about turning St. John Ambulance around should be required reading for every executive in a voluntary organization. Her leadership style was based on the gospel message that he who would lead must be the servant.

> The day after I took over the phone rang and I answered it. There was bit of a silence on the other end, and then a voice said, "You answered the phone."
>
> I said, "Isn't that what I'm supposed to do?"
>
> "Well, not if you are the CEO of St. John! I'm supposed to

go through the switchboard and then through the secretary and then she comes and knocks on your door and asks if you will take the call."

"That was yesterday," I said. "Today is today. What can I do for you?"

This was quite a culture shock because the director of training had the same system. It was just a waste of time and to my mind the stature of the position simply did not warrant it. We were all there as a charity. We were all there to serve mankind and this was just something that I did not approve of. So we went into this very informal atmosphere and I think that started a chain reaction.

The staff at St. John were very knowledgeable and dedicated to our mission "To Serve Mankind." But when I convened the first of many management meetings to discuss challenges and solutions and announced "we had to be profitable to be charitable," it was obvious this was a departure from their focus on "serving mankind." But it was now the end of April, and remedial action had to be started within that month in order to have any chance of breaking even that year.

You never get to your destination until you establish what that destination is and decide how to get there. So at that meeting the staff agreed on four priorities: developing a five-year business plan, reducing costs, improving morale, and increasing revenue. Clearly, to achieve the first of these, we needed to convene a representative cross-section of St. John Ambulance staff to build a consensus on an achievable and appropriate plan for the next five years. But business planning conferences are usually expensive. Our counterparts in Ontario had spent seventy-five thousand dollars on such a conference and they never implemented the action plan that emerged from it. We in BC did not have seventy-five thousand dollars, and at the end of the process we certainly wanted to have a plan we could follow every day.

It was my habit to use my commute on the freeway from

Fort Langley to Vancouver every day as my thinking time. No radio or distractions. On one of these mornings I worked out the solution to our essential planning conference problem. First was the question of a facility. We needed about twenty-five members at the conference, some from branches outside the Lower Mainland. I still had my large house at the time, and I quickly worked out a way to hold twenty-five people in my dining room for joint sessions, with breakout groups in my den, living room, upstairs family room and kitchen. My house was on a quiet country dead-end road—so no distractions. Second was the question of accommodation for the out-of-towners. I had seven bedrooms and six bathrooms and I was set up as a bed and breakfast, so I could house six delegates and others would stay with relatives or friends. Third was food and beverages. Having the sessions in my home made it easy to cater the meals on the premises. I would provide the food and get some local volunteers to prepare and serve and clean up. Fourth, we needed an external facilitator and recording secretary. I'd had the privilege of working with Jack Edwards of BC Hydro on the Canadian Council for Aboriginal Business. I decided to ask him to help. Fifth was travel costs, and I decided to leave that for each branch to resolve.

Accordingly, the group convened for dinner on a Friday evening at my house, ready for workshops all day Saturday and all day Sunday. This was a first-time experience for most St. John people but they rallied to the need. Jack Edwards had kindly agreed to facilitate priority one—the planning session—and his wife, Roberta Kawasaki, recorded the entire proceedings on her laptop. These two did a fabulous job in preparing materials and facilitating the conference and at the conclusion provided full documentation of the goals and objectives—with a superb *single-page* synopsis of our priority goals with key measures and strategies to achieve each goal. We laminated this single page and gave a copy to each branch and each department. My copy

was scotch-taped to the cabinet beside my desk so I was confronted with it every morning. A far cry from the usual plans that get plunged into a file and are not looked at for months. Then, in order to be certain that the plan would be followed and would evolve in the times established, we undertook a review at mid-year to see that we were on track and, if not, decide how to correct the situation.

To reduce costs—our second priority—I had to identify what St. John Ambulance purchased and at what cost. I learned that the national first aid course manuals and materials were purchased through our national headquarters and that BC Workers' Compensation course materials were purchased from WCB. But what were we spending at branch and head office levels on other goods and services? The first step in getting an overall look was to have every cheque run come to my desk with the invoices attached to the cheque voucher, so I could read through them and see where our monies were being spent. This review quickly revealed a multitude of areas where we could reduce costs by eliminating unwarranted expenditures or where we were purchasing large volumes of the same item throughout the province but buying locally at local prices. For example, province-wide we used seventy-five thousand pairs of latex or vinyl gloves in our first aid classes. By putting this quantity out to competitive bidding we reduced our cost to five dollars a box instead of the eight to twelve dollars per box we were paying from local sources. We saved over ten thousand per year on this one item. A similar exercise evolved from analyzing courier costs, office supplies, medical supplies, fuel and oil, advertising and printing. I established that no printing order was to be placed for any amount over two hundred dollars without obtaining competitive bids, and we noticed amazing differences. Competitive quotes would range from three hundred to fourteen hundred dollars for one print order. On our annual printing costs we saved over ten thousand dollars, and every dollar saved went straight to the bottom line.

I give the staff and management full credit for climbing aboard and becoming enthusiastic cost-cutters.

We decided to maintain two cost-savings logs, one for one-time savings such as print orders, the other for year-over-year savings such as volume discounts on gloves and couriers. Staff enthusiasm was such that when director of finance Carolyn Brazier was checking out of the Delta Hotel in Ottawa—where the checkout time was guaranteed to be within three minutes or you got your room for free—she noticed that her checkout had taken far in excess of three minutes. She requested her room be without charge and happily recorded the $115 she saved in our one-time savings record book. Within twelve months we had saved $250,000 in administration costs without laying off a single person.

Our third task was to improve morale. The staff had sustained rate cutbacks and were given no cost-of-living adjustments for several years, but it was apparent we could not correct this shortfall immediately. However, to build new team effort and involvement, we devised a profit improvement plan (PIP) in which branch staff would receive 10 percent of every dollar improvement in their branch operating results, whether this was a reduction from previous losses or profit improvement. Head office staff would similarly receive 10 percent of improved provincial operating results. In order to keep this pot boiling, the PIP was calculated quarterly and 50 percent of it advanced while the other 50 percent was retained to cover downturns in the following quarters. At the end of the year the total PIP was calculated, advances deducted and the balance paid to the appropriate staff members. This plan was based on the potential of achieving 5 percent of annual salaries in PIP bonuses. This program was still in place when I left St. John Ambulance eight years later and with improved profitability the PIP bonuses were indeed in the range intended.

The PIP improved morale but there was still a problem with

salaries: there was clearly a major inequality in compensation. Branch managers and branch staff salaries were set by the local branch executive committee (also called the community board of directors), and it was apparent that in some instances managers operating small branches were being compensated beyond managers operating larger branches with several more staff. We began to rectify this by altering the reporting rules so that branch managers reported directly to provincial headquarters, though they continued to be involved in and responsive to the branch executive committee in the community. This was not a popular decision but an essential one. I could see that an overall study had to be done to ascertain what the rate levels should be for each type of position/situation. We had no money to hire a consultant but I did prevail upon one to give us the tools and the "how-to." A task force was then formed from a cross-section of staff positions, and job fact sheets were prepared to show the duties, responsibilities, educational requirements and other experience needed for each position. The task force reviewed these job fact sheets (on a no-name basis) on ten elements, giving weightings to each. After they completed this process, the staff were divided into eight administrative levels, a low, medium and high level was established for compensation within those categories, then each staff person and their position was slotted into the appropriate category of the eight levels.

Only at that stage did we look at what the compensation should be versus what was being paid. Some staff were much too high—some by as much as 30 percent—and others were too low by a large margin. Those that were too high were not cut back but rather placed in a "freeze" until salaries increased to their level. Those who were too low could not be moved into the appropriate group in one step; instead, the shortfall positions were increased by 7 percent a year until they were in line. Within three years all shortfall levels were in line. In addition, a cost of living adjustment was established for January 1 of each year. We

also reviewed performance on a quarterly basis and where a special merit bonus on a one-time basis was warranted, we sought to issue a thank-you and a modest cheque.

During the loss period, branch managers' meetings were discontinued and there had been no funds available for the branch coordinator to travel. This was simply not satisfactory. However, the Farmer family of Stay 'n Save Motor Inns (now Accent Inns), which operated in Kelowna, Kamloops, Victoria, Richmond and Burnaby, donated ten thousand dollars in accommodation to St. John Ambulance personnel. This assisted tremendously in having the CEO, director of training and branch coordinator visit the branches. It also enabled us to convene annual branch managers' meetings in Vancouver. The budget for the first of these was twelve thousand dollars, but local operators donated almost ten thousand in sponsorships, thus reducing our out-of-pocket costs to two thousand dollars for a successful two-day meeting—a very small outlay for the benefits achieved!

When it came to the task of increasing revenues, Lucille realized she would have to find out which of the many St. John Ambulance first aid courses were profitable. The first step was to analyze the real costs of each course offered.

We had branches running courses with one or two students enrolled—clearly at a loss for St. John Ambulance—so Greg Jenkinson designed a short computer program that would tell us what enrolment level was essential to a break-even in all our courses. We discovered that several courses required significant increases in order to justify teaching them, and rate changes were implemented immediately. At this time our competitors were also suffering as they always offered rates lower than St. John Ambulance, and they quickly reacted to our increased rates by moving theirs up as well but, of course, still slightly below ours. We then developed the means to print pass certificates for our

courses at the branch level so they could be given to the students the day their courses finished. This not only pleased the students and their employers but also saved us over thirty thousand dollars a year for postage, envelopes and labour. For students who enrolled and then found they wanted to transfer to another class date or wanted a duplicate of their certificate and similar services, we had been charging a five-dollar fee, but an analysis showed us that the true cost was at least ten or fifteen dollars. The increased charges brought in a few thousand dollars more each year. Then, using our class database, we were able to extract a list of expiring occupational first aid certificates and write or contact these individuals to enrol and renew as they needed their valid OFA certificates for employment. This increased our repeat enrolments and the average number of students per class.

Although Lucille was successfully reshaping the day-to-day operations of St. John Ambulance, larger problems loomed. Plans for a new St. John House to replace the 14,000-square-foot building on the site at Cambie and 48th had been drawn in 1989, but development had been delayed for several years by revisions to the City of Vancouver's official community plan and other community concerns and debates. By the time Lucille came on board the City would only allow a 16,500-square-foot building on the site and a major portion of this permitted space was to be basement with no windows, suitable for storage at best. The old building was already grossly inadequate, and it was clear that this new one could not accommodate both the Vancouver branch and provincial headquarters. Despite many submissions, the City would not budge on the allowable size. Lucille tackled the problem head-on:

> In going over the plans one day a light came on in my head. The basement level actually extended from the front edge of the proposed building right under the landscaped area to the edge of Cambie Street. Why not put skylights along the front and side of the building to bring in natural light to this area?

The architects agreed and created a four-foot width of window panels across the entire front with the exception of the tiled building entrance. What an improvement this made for the utilization of this area! As well, on the south side of the building we were able to create a floor-to-ceiling glass wall and entry doors and an outdoor terrace where students could enjoy lunch and coffee breaks. With all this natural light we weren't limited to using the basement space for storage, and we were able to persuade the City to increase our useable space to 27,500 square feet.

Our target was to tear down the old building, rebuild and move back to the site by November 2000. Fortunately for us, rezoning of the site permitted sixty-three strata suites to be created as a residential strata and a commercial section, and we were able to sell the portion of the land with the strata zoning rights for $5 million, which paid fully for the new modern facility—27,400 square feet of first aid classrooms, students' lounge, offices, warehouse, and sixty-two underground parking stalls. We built moveable partitions between the students' lounge and the two classrooms on the lower level, enabling us to hold annual meetings and receptions for up to three hundred people in the area that on the original plans had been of use only for warehousing. St. John is proud of this facility as being the best first aid training facility in Canada.

The Vancouver office was not the only facility in need of upgrading. Many of the buildings occupied by the branches around the province were old and inadequate. In some instances, branches had been paying rent for over seventy years and no action had been taken to purchase the buildings they were in. At the same time they could not afford to pay increased rent for better premises or mortgage payments that exceeded their current levels of rent. Lucille persuaded the board that wherever possible St. John should own its premises, but it was acknowledged that this could only be done if future costs did not exceed present levels

of expenditure. Lucille explained the reason for her insistence on the branches owning their buildings:

> When St. John Ambulance owns its buildings, as a charity we qualify for property tax exemptions. If we are paying a landlord, he can't get an exemption and we have to reimburse him for the taxes he has to pay. Also, often the decrepit buildings that we could afford were just being held by developers until the time was ripe to tear them down. They had no interest in keeping them well-maintained. Some were just disgraceful.

The first to tackle the problem was the North Vancouver branch, which had been providing services to the community for over seventy-three years. Some of the branch's executive committee members, assisted by other community leaders, formed a capital campaign committee to identify a suitable location and to raise funds for a down payment. Once the sum was raised, the committee went after donations of studding, gyproc, paint, plumbing, millwork and doors and major discounts on items such as window coverings. All of these contributions plus money made from selling sponsorship of classrooms added to the existing building fund. The branch moved into a bright, clean and modern facility. Lucille's love of "wheeling and dealing" was very evident when she spoke about her other acquisitions for St. John Ambulance:

> We bought Kamloops, we renovated Vernon, we bought Prince George, we bought Ridge Meadows, we expanded Victoria, and [in 2004] we are building in Nanaimo. In Campbell River we needed more property and purchased a lot. The property we bought in Surrey/Delta was listed at $1.4 million and we negotiated that down to $980,000. I was fortunate to get the Prospera Credit Union to give us a $700,000 mortgage for five years at a fixed 4 percent. The Vancouver Foundation gave us $50,000, LeHigh Concrete came up with $10,000 and Columbia Concrete another $5,000. Cloverdale Paint donated the paint for

~~~~~

*Anne Griffiths worked with Lucille for seven years as the director of Fund Development for St. John Ambulance. She recalled:*

From the first day I met her I was totally impressed and I developed a huge respect for her innate ability to make decisions quickly and with what appeared to be no hesitation. Only rarely did she ever say she "would sleep on it" before making up her mind. And believe me, when her mind was made up that was it and she was seldom wrong.

In the beginning when Lucille and I planned our fundraising strategy, we would meet prospective donors at various restaurants. After several of these lunches—that were in Lucille's eyes expensive—we realized that restaurants didn't provide the privacy we needed and they were time-consuming as well. Then Lucille decided she was a better cook than the chefs in the restaurants we frequented and that we would have lunches in our boardroom. We would deliver our funding requests over the food Lucille had prepared at home presented on Styrofoam plates with plastic forks, though luckily the Vernon branch had extra dishes and cutlery and things improved fairly early on when they gave us a very pretty luncheon set. Lucille and I had huge laughs about the fact that these lunches were referred to as "cheap and cheerful," and they became our trademark. I was dispatched to line 'em up and get 'em in there, and that is just what I did. I recall phoning Nick Geer, who at that time was with the Pattison Group, to ask him to join Lucille and me for a cheap lunch. He roared with laughter, said he had never had a cheap lunch in his life and would be delighted to come. Of course, anyone who knew Lucille knows that you may have a cheerful lunch with her but it is never cheap.

She always told potential donors that she was "protecting them from me" which was cause for more laughter because most of our guests knew there was a purpose to the visit, and no one escaped Lucille's persuasive charms. But from Lucille's lunches I learned to always be respectful of a person's time, be organized, have a planned meeting and never leave without some next steps in place. She also taught me

the value of the notebook. I don't mean a laptop computer—I mean a simple lined notebook. On my very first day she presented me with a "scribbler," as she called it, and a pencil. We shared an office for the first little while as she coached me along and I learned very quickly the power of that scribbler. I am proud to say I have just started my seventeenth notebook and would be completely lost without it. Sometimes I think she was testing me because she would ask me about a meeting or a conversation with a certain person on a certain date and I was able to produce the information because of my dedication to the scribbler. Lucille had a way of sharing the way she did things in such a way that was generous and well-meaning and always with the purpose of having you succeed.

I always looked forward to my "working lunches" with Lucille. She had a tremendous need to be productive literally every hour she was awake so this suited her right down to the ground. I learned much as she was so willing to share what she knew, and I treasured her stories, knowing I was privy to BC business history. She had a wonderful way of telling stories with lots of detail in the most fascinating way but very cleverly leaving out names so as never to offend.

We attended many functions together and I have never seen anyone who could "work a room" like Lucille. The interesting thing was—because she had difficulty walking—she would get comfortably located with a chair with some nibbles, and the throngs would go to her. There she would be, holding court, listening attentively, asking questions of her visitor about family and business, and you could see the delight on their faces as her stories were so interesting and fun. Although she did not care for off-colour humour she loved jokes and could certainly tell one well. It was magical to watch.

St. John in British Columbia would not be where it is today without her dedication, her hard-nosed but fair approach to financial management and her ability to get the very best from those she trusted and worked with. She left St. John thriving, growing and very much in the black.

almost all of these buildings including six hundred gallons for St. John House on Cambie. They were wonderful. Other local companies sponsored classrooms for $5,000 to $50,000 each, and I got free supervision for renovations from a construction company.

Every branch was different. We had a very unsatisfactory building in Prince George. I guess it had been built with what could be charitably called surplus materials, all different kinds of paint and finishing, and no outside windows to provide natural light in the classrooms. The owner wanted $400,000 for it. But at that time Shaw Cable had decided to put up a new building and they were selling their old one. It was just perfect for us—a 4,000-square-foot, two-storey building with a beautiful foyer, a boardroom, two retail storefronts and two paved parking lots. They had been asking $619,000 for it, but because the Prince George real estate market was poor at that time, they dropped their price to $519,000 and then to $489,000. I offered them $425,000, which they rejected. I had applied to the Vancouver Foundation for some help, but the Foundation will not approve money if you have already obligated yourself to purchase. So I was glad that I had not obligated when I learned that the Foundation members were going to make a decision at their December meeting. In the meantime, in November Shaw came back to say they had received instructions from head office to sell this building before the end of December. I said, "Well, I can't pay $425,000 because I may jeopardize a grant of $40,000 from the Vancouver Foundation. I can't afford to lose that, so if you want me to buy it before the end of December, you have to drop the price to $385,000. And I don't want to close until after Christmas." They agreed to $385,000, and I put up a non-refundable deposit that would be forfeited if St. John Ambulance did not buy in December. I wanted to have the option to close but I didn't want to be obligated to close. In mid-December the Vancouver Foundation Committee met and approved the $40,000.

In essence, I now had the price down to a net $345,000. Then Canfor gave us $25,000 and Carrier Lumber gave us $5,000. A successful family in the Prince George community gave us $5,000. One of the local construction companies gave us his construction superintendent, and he oversaw all the changes and code requirements necessary to meet the city regulations. They also got a lot of materials donated to us. Ultimately, we had this marvellous building we are so proud of, and I think at the end of the day it cost us about $325,000. When you drive down the street, there is this tremendous backlit sign saying "St. John Ambulance" on the parking lot side of the building and another on the front of the building. Both signs had been installed in Shaw's time; we just had to change the faceplates—a considerable savings.

In Maple Ridge, a patient of Dr. Terwiel's wanted to leave him her estate, but when he told her that ethically he could not accept, she asked what his favourite charity was. He named St. John Ambulance. When she died, she divided her estate between St. John and two other charities. This provided St. John Maple Ridge with $250,000. The branch invested it wisely at excellent interest rates during a high-rate period until they had enough to buy their branch—the main-floor commercial strata of a new, combined residential and commercial strata building just a short half-block off Lougheed Highway. It has underground parking, storage—and no mortgage.

It took me several years to get even an option out of the owner of the Kamloops building, who was a challenging character. I negotiated with him, bought him coffee, invited him and his wife to my house, and eventually obtained a fixed price option for $400,000 less an amount for the rent we were paying until we exercised the option. In return I agreed to give him a $20,000 non-refundable deposit. I couldn't obligate myself to buy the building unless I obtained some money from a foundation, but when the Vancouver Foundation agreed, we were able

to exercise the option in spring 2004. Other than our $20,000 down payment, the vendor is carrying the purchase price secured by a mortgage for interest only for the first three years, and then St. John Ambulance has to make a lump sum payment. A building campaign committee has been formed to raise the money to make these additional payments.

St. John Ambulance's ownership of its branches has become infectious. The ones that have their own buildings are very proud of them—they give the staff and volunteers a sense of permanence. Those that haven't purchased are asking themselves, "if others have bought one, why shouldn't we?" The Penticton group formed a capital campaign committee and I am confident that they will raise money to buy a building. Kelowna is in leased premises in a shopping mall and they have outrageous rent. They are locked in for three years but plan to raise money within those years to buy a building. St. John Ambulance now has over $12 million in premises, and though some have mortgages, more of these are being retired each year with the goal of being encumbrance-free on all branches within ten years. With that accomplished, St. John Ambulance can weather future unforeseen challenges.

In the business plan that Lucille created for St. John Ambulance there was also a provision for a St. John Ambulance BC/Yukon Foundation with an endowment of $5 million within ten years. The income from this would be used to support the Brigade and other community services when and if funds from the BC Gaming Commission were reduced or eliminated. To build the foundation, classrooms and other features in the new St. John House were offered as naming opportunities. These and various other fundraising events achieved $1 million in cash by the end of 2003 and there were to be another $1 million in planned bequests, placing the foundation 40 percent of the way toward its target.

What Lucille—age seventy-one when she became CEO of St. John Ambulance—accomplished for that society was close to miraculous.

And she did it all for what can only be regarded as token remuneration considering the amount of work, skill and dedication involved. Just as at Rivtow, she worked twelve hours a day and often six days a week as there was so much remedial work to be done. "In essence, my hourly rate was probably less than the receptionist," she said. "However, when I tackle a problem situation I become totally focused on moving forward and hours take on no meaning."

TWENTY-THREE

## *Fraser River Discovery Centre*

In 1994, the same year that she was awarded the Order of British Columbia, Lucille had been approached by Marilyn Cassady and Colonel Bill McKinney to join the board of the Fraser River Discovery Centre Society. It was not the first time they had come calling. In 1987 their organization was known as the New Westminster Tourism Development Association, which had evolved from the Royal City 86 Committee. During Expo they had put on "Transporama," which included an antique car show, organized a shuttle service between New Westminster and Expo, and set up a trailer park where the Justice Institute of British Columbia now stands. After Expo the group undertook studies to find ways in which New Westminster tourism could be enhanced, and it became clear that the city's unique feature was its position on the Fraser River. Some attraction honouring its history and importance would be an appropriate project, and because of Lucille's strong connections with activities on the Fraser, the committee approached her to join in their efforts. However, she had been totally absorbed with Rivtow's problems at that time and declined.

The Fraser River Discovery Centre Society was formally incorporated

on July 11, 1989. Bill McKinney served as first chairman until Marilyn Cassady took over. The two approached Lucille again in 1994; this time she agreed to come on board. While Rick Mudie had been chair a few years earlier, the society had secured a piece of land on the New Westminster waterfront. It was part of a huge parcel owned by Larco Developments, and the City had given the company some enhanced zoning concessions in return for making a portion available for a discovery centre.

Mudie did not want the society to have the responsibility of property ownership since members did not know if they would be able to raise the money to build on it; as a result the land was transferred to the City on the understanding it would be leased to the society and that, if certain conditions were met, the society would have the right to the title.

In 1997 Lucille was asked to take over as the society's chair, and although she was already fully committed to rescuing the St. John Ambulance Society and was three years beyond the allotted "three-score years and ten," in typical style she readily assumed this new burden. In October of that same year the Discovery Centre Society acquired its lease on the land and an air space on the Fraser River waterfront next to the Westminster Quay. This lease was predicated on the society erecting and operating an interpretive centre. However, at that time their primary fundraiser was an annual gala dinner that raised about fifty thousand dollars each year. At the gala, an individual with a close working association with the Fraser River would be honoured by being inducted into the Fraser River Hall of Fame.

Then, at the beginning of 1999, the society had a stroke of very good fortune. The Star of Fortune Gaming Management group came to town looking for a place to locate their casino boat, and Mary Pynenburg, city planner, suggested that they might come to an agreement with the Discovery Centre Society. Lucille, as chair, negotiated an incredibly favourable agreement with the Star of Fortune Gaming Management Corporation. Effectively, the casino was to erect a building entirely at its own cost and in return would receive a lease of the lands for three years commencing July 1, 1999. The cost of all improvements would be met

by the Star of Fortune and on the termination of the lease all improvements would belong to the society. All costs would be deemed prepaid rent for the initial term, but subsequently the Star of Fortune would be required to either vacate the site or pay a lump sum of $100,000 per annum in advance on the first day of each year or the sum of $10,000 a month on the first day of each and every month. Lucille subsequently renegotiated this sum to $150,000 per annum.

This agreement enabled the Fraser River Discovery Centre to get its preliminary building consisting of fifteen thousand square feet of space—which must have cost at least $5 million—as well as ongoing revenue to meet its expenses as long as the Star of Fortune casino boat remained at the location.

But this was not the end of the story. With a vision for the expansion of the building by a further thirty thousand square feet—estimated to cost $6 million—Lucille negotiated an infrastructure grant of $1 million each from both levels of government, provided that the society could match the amount. At this point Lucille conceived the idea of obtaining ten founding members who would each put up one hundred thousand dollars for the honour of being recognized. She succeeded in obtaining nine hundred thousand dollars; donors were Ken and Dorothy Mackenzie, Errol Wintemute, Norman and Mary Cosulich and Niki Cosulich-Fairweather, the Koerner Foundation, Ian, David and Stephen McDonald, Rudy North, Robert Osborne, Chick and Marilyn Stewart and Lucille herself. The Infrastructure Grant Committee then said that the Society would have to raise an additional four hundred thousand dollars for exhibitry, and Lucille promptly obtained pledges to cover this amount as well. In addition, she arranged for the society to receive five hundred thousand from her estate via her life insurance policy.

In October 2000 Lucille was honoured by the Fraser River Discovery Centre and inducted into the Hall of Fame. On that occasion Jack Munro, George Abakhan, Bob Brodie, Ron Royston and Michael O'Brien of the Airport Authority gave speeches in her honour. The board of directors sang her a song called "You Picked a Fine Time to Lead Us, Lucille"

(based on the Kenny Rogers song "You Picked a Fine Time to Leave Me, Lucille"). The words were composed by me, Paul E. Levy, with help from my then law partner David Brine and my wife Angela, who helped with the adaptation of words to music.

The song incorporates some of Lucille's trademark sayings, including "I have a button, let's sew a shirt on it."

> You picked a fine time to lead us, Lucille.
> We'd lived thru some hard times,
> We'd suffered some bad times
> When dollars were scarcer than dimes.
> We were out there, deep in the chill
> With nary a drop in the till.
> You picked a fine time to lead us, Lucille.
>
> You picked a fine time to lead us, Lucille.
> The casino men sailed into town
> Seeking a berth to call their own.
> They came to where they'd never been
> Face to face with the Leverage Queen.
> You picked a fine time to lead us, Lucille.
>
> You picked a fine time to lead us, Lucille.
> You told them straight, you told them square
> All I have is a button right here
> But surely it would look real cute
> Sewed upon your full dress suit.
> You picked a fine time to lead us, Lucille.
>
> You picked a fine time to lead us, Lucille.
> When you swapped them our button
> For their full dress suit,
> They can never say that you swiped their loot
> For you're letting them borrow the full dress suit.

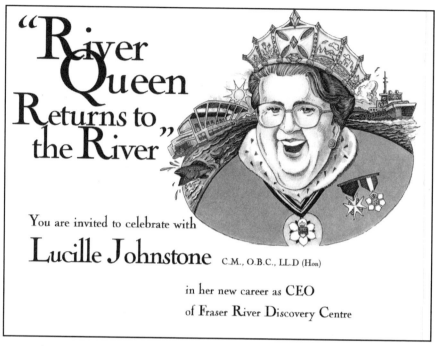

In March of 2004, at the age of 80, Lucille retired from her position as CEO of St. John Ambulance and, in only two short months, accepted a position as CEO of the Fraser River Discovery Centre. To celebrate Lucille's acceptance of the position, Karen Baker-MacGrotty arranged a dinner event at the Westminster Club to welcome her.

> You picked a fine time to lead us, Lucille.
> You picked a fine time to lead us, Lucille.
> The casino men came out of the blue,
> Tugboat Annie chugged into view.
> She nudged and she prodded, she pushed and she parried
> And down the river they got carried.
> But you must never think that she did them dirt
> 'Cuz she's letting them wear their very own shirt.
> You picked a fine time to lead us, Lucille.

In March of 2004 when Lucille retired from her position as CEO of St. John Ambulance, she took up the role of CEO of the Fraser River Discovery Centre. Of the post, she said:

I felt the Fraser River Discovery Centre would not be finished unless I spent my full time there. I am very passionate about this because I know how the river was abused over the last decades. I think it is absolutely crucial that we start to take care of our river through our centre and in our partnerships with river communities.

In June 2004 Karen Baker-MacGrotty, for many years a faithful board member and treasurer who had also chaired the dinner committee for many years, arranged a dinner to celebrate Lucille's acceptance of the CEO post. She called it "The River Queen Returns to the River."

Adopting a tactic Lucille herself had used with St. John Ambulance—of raising funds by selling the right to have parts of the building named in one's honour—Karen Baker-MacGrotty also organized a sale at the dinner and raised twelve thousand dollars. As a result, the boardroom at the centre will be called "the Lucille Johnstone Boardroom."

It was fairly typical of Lucille's way of thinking and networking that during one of the author's last interviews with her in mid-2004, when she was nearly eighty, she said she had persuaded Jimmy Pattison to let her have the Expo '86 mascot, robot "Expo Ernie," for the Fraser River Discovery Centre. She planned to have its voice programmed to welcome people to the centre, giving children a thrill and letting the adults recapture the magic of Expo.

TWENTY-FOUR

## *Final Days*

Lucille Johnstone began the twenty-first century with recognition for her amazing financial capabilities as one of the "business leaders of the century" by *Business in Vancouver*. But as she had done when she was named a "Woman of Distinction" in 1984, awarded an honorary doctorate from UBC in 1991 and named to the Order of British Columbia in 1994 and to the Order of Canada in 2003, she accepted new accolades with quiet appreciation. She then got on with the work—with St. John Ambulance, the Fraser River Discovery Centre, PLAN or any other of the numerous organizations or people who she so willingly helped.

A rude and distressing shock came in June 2004. A few years earlier Lucille had sold her fifty-acre Fort Langley farm on 222nd Street and the eight-bedroom house she had run as the Cedar Ridge Bed and Breakfast. She was now living in a much smaller house opposite the farm, on five acres of land. As she was driving home to this smaller house late one night, she saw the glow of flames in the sky. It wasn't until she was almost home that she realized it was *her* house on fire.

Though a great deal of the building was damaged, it was not totally destroyed, but the loss of so many of her possessions was a great source

# FINAL DAYS

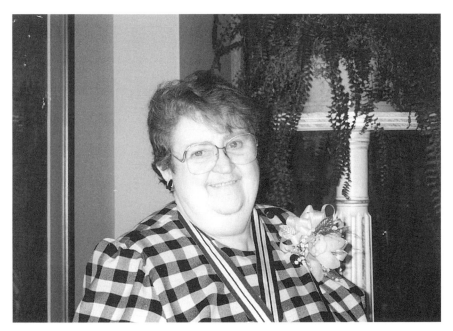

Lucille Johnstone in 1994.

of distress to Lucille. She moved into a trailer at the back of the property while she contemplated rebuilding.

Shortly after the fire, Lucille started losing weight and complaining she had no energy. All her life she had fought her body's tendency to put on weight. In her later years—especially after breaking her ankle—she had become a very large woman, but now she had little desire to eat. She was being interviewed for this book during this time, and it was becoming evident she was not well. By late summer she was more or less confined to bed. In the fall she was admitted to Langley Memorial Hospital, where she was diagnosed with cancer. She remained in Langley Hospital after her second admission and died peacefully on December 31, 2004.

# *Epilogue*

After Lucille's death, Michael O'Brien, a vice-president of the Vancouver Airport Authority, issued a touching and heartfelt statement entitled "Lucille Johnstone: unique, memorable, missed."

> Many of you will have heard or read of the death of Lucille Johnstone. Like many other people at the Authority, I came to know Lucille when she was vice-chair there. In that role, she was one of a handful of people who can legitimately claim credit for the creation of this Authority. Even more important, without Lucille, YVR would never have risen to be among the best airports of the world.
> 
> The full measure of her character is suggested by her prodigious legacy to every organization she ever chose to assist, including Rivtow Marine, the Fraser River Discovery Centre, the Aboriginal Business Network, St. John Ambulance and this Authority. Yet that is just the beginning because Lucille changed thousands of lives quite directly by her work ethic, her wisdom, her clarity, and, above all else,

# EPILOGUE

her example of how a human could be actually and authentically great.

Lucille is recalled at YVR in the Link, by the tugboat on which children play. If you look carefully, you will see her first name painted on the side. It is a perfect reminder of our love and admiration. She was too modest to want any homage of her work, but if the board and executive were insistent (we all were), then it should be something "useful" and only her first name was to be used. Lucille was known as "Tugboat Annie" because she rose from secretary to president of a marine company at a time when women were supposed to be at home, and she took it from two tugs to a vast corporation. She was implacable when pushing for the best, but she never raised her voice and was always polite and kind. So it is that to this day a smiling practical tugboat serves daily airport life.

Yet, over the years I have come to know in my heart that her memorial and legacy is throughout this airport every time someone emulates Lucille by working later, trying harder, helping the needy or aspiring to be the best in a world they are helping to make better.

On October 27, 2005, Lucille was posthumously honoured by the Justice Institute of British Columbia with the Dr. Joseph H. Cohen Award for outstanding service in the field of public safety. This award was intended to have been made in the fall of 2004, but Lucille had been too ill to receive it. During one of our last interviews Lucille wondered why she had been selected for such an honour. She was told that it was for her work for St. John Ambulance. It had apparently not occurred to her that this would qualify her for such an award. However, she was pleased to be invited to receive it. Past recipients of the medal include Dr. Les Vertesi (1998), Captain Terry Abrams (1999), The Honourable Garde B. Gardom, Q.C. (2003) and The Right Honourable Kim Campbell (2004).

The citation at the awards function described Lucille in these words:

> Hers was a life of service. Whether volunteering in a corporate boardroom or providing a hot meal to a less fortunate stranger Lucille never did what she did for any recognition. Lucille's reward came from knowing that she had done something to help another human being and her community.

Al Etmanski of PLAN remembered her as a woman with a huge heart that never seemed to stop giving.

> If she found somebody that she had taken a shine to who was down and out or needing help she would involve that individual in one of her other activities and link them with somebody else, give them a lift or a job or whatever was needed. For her, it seemed to be a pattern almost as natural as breathing. This great heart of hers, on top of her good judgment and prudence, her very strategic thinking and incredible fiscal acumen is what allowed her to excel in a world where men dominated. Certainly in the years she was making her rise in the corporate world, women at or near the top were the exception and so for her to survive she had to be very tactical and strategic. It was her rare combination of energy, determination and especially her most generous heart that made her the truly great person that she was.

For all her extraordinary achievements in business and public life in British Columbia, when one thinks of Lucille Johnstone one is reminded of the words of the poet William Wordsworth: "the best portion of a good life is the little, nameless, unremembered acts of kindness and of love."

Because of their very nature, few of those acts have been recorded here. But their memory will live on in the hearts and minds of many who had the privilege of knowing Lucille.

# Index

Abakhan, George, 200, 260
Aboriginal Business Network, 266
Abrams, Captain Terry, 267
Accent Inns, 248
*Alberni Carrier*, 105
Alberta Energy Corporation, 148
Albi, Paul, 135
Allied Shipbuilders, 212
*Altmore*, 40
Andrews, Deryol, 218–222
Associated Equipment Distributors, 121, 197
Assurance Class rescue tugs, 75–76
Atlantis Submarines, 207–210, 231
Atomic Energy of Canada, 148
Atwood, Bill, 56, 73
Auto Marine, 97

Bagshaw, Ken, 200–201, 206
Baker–MacGrotty, Karen, 262–263
Ball, Bessie, 17
Ball, Dorothy, 17
Ball, Georgeana, 17, 26
Ball, Leslie, 17
Ball, Ella Myrtle *see* Bonar, Myrtle
Ball, William, 17, 26
Ballentyne, William, 77
*Banff Herald*, 79–81
Banff School of Advanced Management, 79–81, **82**
Bank of British Columbia, 227
Bartlett, Michael, 156–157
BC Aboriginal Business Foundation, 10
*BC Business Magazine*, 172–176
BC Development Corporation, 165
BC Electric Company, 23, 152
BC Electric Railway, 32
BC Ferries (BC Ferry Corporation), 205, 211–217
BC Forest Foundation, 10, 15, 175
BC House, 153
BC Hydro, 183, 244
BC Marine Shipbuilders, 102, 174
BC Place, 10, 15, 149–155, 165, 175, 181, 216

BC Resources Investment Corporation (BCRIC), 15, 148–149, 175, 180–181
BC Towboat Owners' Association, 66
BC Trade and Development Corporation, 15
Belzberg, Sam, 118
Bennett, Audrey, **151**
Bennett, Premier Bill, 148–149, **151**, 153–155, 156, 157, 161, 162
Bennett, Premier W.A.C., 43
BIE (International Bureau of Expositions), 153, 155
*Blaine*, 40
Bogardous, Peter, 231
Bonar, Alfred, 16, 18, 26
Bonar, Betty Mae *see* Martel, Betty
Bonar, Harriet (née Tapley), 16, 26
Bonar, James, 16
Bonar, Leslie (Les), 16, 18, **19**, **20**, 21, 24, 26, 33, 88
Bonar, Myrtle (née Ball), 16–18, **19**, 21–29, 32, 61, 90, 122
Bonar, Thomas, 16–18, **19**, **20**, 23, 25, 26, 28, 122, 143
Borowicz, Frank, 135, 141
Brazier, Carolyn, 246
Breuer, Bev, **207**
Brine, David, 261
*British Columbia Lumberman*, 166–167
Brodie, Bob, 260
Brown, Fred, 102–103
Brown, Peter, 157, 163
*Brunette*, 72–73
Burnaby, 28, 32, 122
Burrard Dry Dock, 77, 211
Burt, Harry, 40–41
*Business in Vancouver*, 264

Caldwell Partners Group, 233, 237
Cameron, Senator Donald, 79
Cammack, Vickie, 231
Campbell, The Right Honourable Kim, 267
Campbell River Lumber Company, 40
Canada Business Corporation Act, 185
Canada House, 153
Canadian Air Force, 34

Canadian Airport Council, 192
Canadian Association of Equipment Distributors (CAED), 15, 121, 197
Canadian Commercial Bank, 178
Canadian Council for Aboriginal Business, 244
Canadian Deposit Insurance Corporation (CDIC), 179
Canadian Embassy, 192
Canadian Imperial Bank of Commerce, 186
Canfor, 188, 255
Canyon Towing, 60, 92
Carney, Pat, 81, 182, 183
Carrier Lumber, 255
Cassady, Marilyn, 258–259
Catamaran Ferries International, 216
Caterpillar Inc., 114–115
*Cautious*, 75–77
Cedar Ridge Bed and Breakfast, 230, 264
*Celnor*, 40
Central City Mission, 23
Certified General Accountants' Association (CGA), 60–62, 70, 108
Chant, Maureen, 162, 200
Chief Chassis, 124, 127
Chittenden, Curley, 43
Clark, Graham, 183
Clarkson, Adrienne, 235
Cliff Towing (M.R. Cliff Tugboat), 72–75, 92
Cliff, Murray Robertson, 72–73
Cliff, Paul, 73, 83
Cliff, Wilmot, 72
Cloke, Al, 120
Cloverdale Paint, 251
Coast Cargo Services, 74, 92
Cogswell, Bill, 74
Colco International (Columbia Chrome), 218–222
Collins, Jack, 231
Columbia Concrete, 251
Coneco Equipment, 120
Conner, Herbert and Lorna, 24–25
Cooper, Mel, 158, 161
Copenhagen International Airport, 190, 194
Cosulich, Bob (Robert / Romolo Jr.), 40–41

269

Cosulich, Cecil, 9, 39–42, 45–46, 48, 54–56, 58–59, 61, 64, 66–67, 73–75, 78–79, 82, 83, 92, 98, 100, 102, 103, 107-110, 112–113, 118, 119, 167, **169,** 170–173, 197–202, 204, 205, 208
Cosulich–Fairweather, Niki, 260
Cosulich Holdings, 203
Cosulich, John, 167, 172, 197–200, 201
Cosulich, Mary, 260
Cosulich, Norman, 40–42, 52, 55, 64, 67, 73, 75, 77, 90, 100, 103, 107–108, 118–119, 167, **169,** 171, 173, 197–199, 201, 204–205, 260
Cosulich, Paul, 167–168, 170–172, 197–203
Cosulich, Romolo Sr., 40
"Coyote Bill," 122, 135
Crestbrook Pulp and Paper Mill, 188
Crossman, Harry, 31–33
Crossman, I.L., 31

D'Arcy, Robert, 192
DaSilva, Lisa, 142, 202, 221, 223
Davis & Company, 106, 118, 134, 200
Decco–Walton Logging, 43, 45, 50
Deloitte Touche, 179
DeLong, Colonel Leon B., 37–39
DeLong Engineering, 37–39
Depression, The, 18, 42
Diamond, Jack, 135
Dietrich–Collins Equipment, 9, 111–112, 113–114, 115, 116, 118, 120, 211
Dohm, Mr. Justice, 133, 136–140
Dolmage, Captain William "Bill," 40, 56, 76
Duff, Don, 231
Dunn, Michael (Mike), 34, 42, 50, 52, 53, 67, 83
Dyer, Bryce, 135

Eager, Myrna, 92–97
East Pacific Industries, 116
Edwards, Bobby, 50
Edwards, Jack, 244
Elworthy family, 104
Emerson, David, 188–191, 194
Estey, The Honourable Willard Z., 179

Etmanski, Al, 231–236, 237, 268
Expo '86, 10, 15, 153–163, 175, 184, 216, 232, 233, 236, 258, 263
Expo Ernie, **232,** 236, 263

Fairview High School, 26, 27, 30, 31
Family Relations Act, 134, 140
Farmer family, 248
*Farm Journal,* 28
Federal Aviation Authority, 191
Federal Power Commission (FPC), 38
Fillipoff, Luba, 227–230
*Financial Post,* 120, 149
Finning Tractor and Equipment, 114–115, 117
First City Capital, 118
Five Roses Flour Mill, 17, 18
Folgers family, 77
Fording Coal, 119
Forrest, Harvey and Eve, 42, 44
Forrest, Nellie, 44
Fraser River, 9, 39, 40, 41, 45, 48, 49, 58, 65, 68, 72–73, 81, 92
Fraser River Discovery Centre Society, 10, 11, 15, 92, 205, 258–263, 264, 266

Gambier Island, 99–100
Gardom, The Honourable Garde B., Q.C., 267
Garret, Norman, 54
Geer, Nick, 252
General Accountants' Association *see* Certified General Accountants' Association
General Paint Company, 103
Gibbins, Charles W., 80
Gibbs, Richard, 225
Gibson, Jimmy, 42, 50–52, 83
Giles, Dr. Lucille (née Conner), 24, **207**
*Global Airport Monitor,* 194
Godsall, Terry, 111, 211–212, 214–215
Goldberg, Michael, 216–217
Goulich, Margaret, 70, 80
Gourley, Ann, **207**
government of British Columbia, 43, 99, 148–154, 161, 162, 174, 179, 215, 235, 260
government of Canada, 17, 74, 182–185, 187, 188, 192–193, 235, 260

Grace Hospital, 10, 197
Greater Vancouver Regional District, 188
*Green Cove,* 40
Greenfield, Dr. Jeremy, 227
Greenshields Ltd., 211, 215
Griffiths, Anne, 223, 252–253
Griffiths Towing, 58
"Gus," 122

Hamilton, Mary, **207,** 231
*Harbour and Shipping News,* 145, 205
Harken Towing, 44, 58, 68
Harnischfeger Corporation, 111–113, 115
Harrison Lake, 49, 55–56, 60, 65, 67, 68, 73
Henderson, R.D., 147
Henfrey Mason, 200
High Ross Dam, *see* Ross Dam
Hiram Walker Resources, 15, 175
Hoffars, 54, 97
Hope (town of), 37, 38–39, 42, 45, 49, 52, 55, 60, 64, 65, 73, 82, 89, 90
Hossie, David, 200
Howe, Bruce, 148–149, **151,** 180
Hurd, Dennis, 77–78, 207–208, 210
*Hustler,* 40

Imperial Oil, 48, 68, 98
Industrial Development Bank (IDB), *see also* Business Development Bank of Canada, 77–78, 207
Inland Towing, 55
Integrated Ferry Constructors (IFC), 10, 15, 211
International Air Transport Association (IATA), 194
International Bureau of Expositions, *see* BIE
International Hydrodynamics, 208
International Joint Commission (IJC), 38–39, 43
Irving, Victor, 240–241
Island Tug and Barge, 104

Jackson, Clarke, 233, 237
*James Carruthers,* 40
Jeffrey and Jeffrey, 35–36
Jenkinson, Greg, 248
John Manly, 109, 144, 174

# INDEX

Johnson, Chester, 163, 183–184, 186–191, 193, 195
Johnstone, Bonnie, 128
Johnstone, Charlie, 12, **89**, 90, 123, 128, 129, 130, 132, 137–138, 224
Johnstone, Jennifer, 124, 125–126, 129
Johnstone, Joe, 83, 84, **85**, 88–91, 122–123, 131, 133–139, 141–142, 227
Johnstone, John, 25, **89**, 91, 122–127, 129, 131–133, 230
Johnstone, Lisa, **89**, 91, 123, 126, 127, 129, 131–132, 137–138, 141
Jones family, 104
*Journal of Logging and Sawmilling*, 144
Julseth, Clifford, 34, 46, 62–66, 83, 167
Justice Institute of BC, 258, 267

Kaiser Coal, 149, 218
Kaiser, Edward, 149, **151**
Kane, Margaret, 80
Kawasaki, Roberta, 244
Keevil, Norman Jr., 159
Kehler, Ernie, 87
Kester Towing (John and Mark Kester), 58
Kibblewhite, Miss, 35–36
Kingcome Navigation, 56, 76
Kitimat, 74, 100, 105
Koerner Foundation, 260
Komatsu, 114–115, 117, 175, 202
Kosh, Jim, 199
KPMG, 184, 199
Kwok, Stanley, 149, **151**

Ladner Downs, 180, 200
Langley, 122, 124, 131, 141, 156, 179, 219, 230, 244, 264, 265
Langley Memorial Hospital, 131, 230, 265
Larco Developments, 259
Lawrence, Joan, 231–232
Law Society of British Columbia, 225
LeHigh Concrete, 251
Leq'á:mel First Nation, 91
Levy, Angela, 261
Li Ka Shing, 163–164
Loutet, Joyce, 61

MacDonald, John A., 205
MacDonald, Ken, 34, 59–60, 70–71

Mackenzie, Dorothy, 260
Mackenzie, Ken, 44, 58, 68, 260
Mackenzie, Sheila, 30
MacMillan Bloedel, 100, 105, 147–148
Magnus, George, 163
Maier, John, 110
Maitland, Doug, 73
Manning, Paul, **151**
Maple Ridge, 83–88, 122, 141, 255
Marion Power Shovels, 114
Maritime Towing, 40
Martel, Auguste, 84, 88, 90, 122, 230, 241
Martel, Betty (née Bonar), 16, 18, **19**, 24, 25, 27–28, 83–84, 88, 90, 122–123, 130–131, 133, 230
Martel, Yann, 11
Mathewson, Dennis, 120
May Marine Electric, 77
McCarthy, Grace, 149, 153–154, 163, 182–184
McDonald, David, Ian and Stephen, 260
McDonald's Restaurants, 159–160
McDougall, Barbara, 178–179
McKeen, George, 102–103
McKeen, Senator Stanley, 102
McKinney, Colonel Bill, 258–259
McLaren family, 212
Miller, Paulette, **207**
Montreal, 32–33, 77
Morrison Knudsen, 37, 39
Mudie, Rick, 259
Mudry, Arthur, 231
Munro, Jack, 260
Murphy, Kevin, 157, 163, 216–217
Musqueam First Nation, 193

Narod, Alvin, 149, 155
Narod Construction, 149
Narod, Eileen, **151**
New Westminster, 11, 12, 46, 49, 63, 64, 241, 258
Nicholson, Don, 212–214
*Nimpkish*, 41
North, Rudy, 260
Northland Bank, 15, 177–180, 182

O'Brien, Michael, 260, 266
O'Neill, Frank, 188–194
Order of British Columbia, 258, 264

Order of Canada, 264
Osborne, Robert (Bob), 52, 260
Osborne, Teddy, 86

P&H, 111–116
Pacific Advisory Regional Council (PARC), 197
Pacific Rim Aggregates, 109
Pacific Rim Shipyards (PRS), 212–213
Pantages, Tony, 135
Parsons, Linda, **207**
Pattison Group, 252–253
Pattison, Jimmy, 155–158, 162, 200, **232**, 236, 263
Pauline Johnson Chocolates, 28
Pearson, John, 106, 118–119
Peebles, George, 40
Pioneer Towing, 56, 92
Plan Institute for Citizenship and Disability, 234–235
Planned Lifetime Advocacy Network (PLAN), 231–237, 264, 268
Port Alberni, 105
Port Moody, City of, 160
Porter, Dr. Arthur, 80
*Powell Carrier*, 105
Powell River, 105
Prince Rupert, 73, 110, 144
Prospera Credit Union, 251
*Province*, the, 77, 81, 83, 100, 109, 140, 148
*Prudence*, 75–76
Purves Ritchie, 9, 110
Pynenburg, Mary, 259

Queen Charlotte Islands, 74

R.C. Purdy Company, 17
Raake Marine Services, 49, 55–56, 60, 68, 92
Raake, Paul, 55
Red Cross, 30
*Red Fir I*, 40–41
*Red Fir II*, 41
*Red Fir III*, 41
Reed Stenhouse, 192
Reid, Bill, 192–193
Reid, Ed and Kay, 224–226
Reid, Patrick, 153–154
Rendell Tractor, 115
Rezac, Darcy, 183
Rhodes, Frank, 212, 215–216
Richmond, City of, 188
Richmond, Claude, **232**
Richmond, John, 111
Rice, Vy, **207**

271

River Towing (Rivtow, Rivtow Straits), 9, 10, 15, 39, 41, 45–121, 122, 142, 143–144, 147, 148, 149, 159, 160, 166–176, 177, 193, 196–208, 210, 211, 218, 219, 221, 227, 238, 257, 266
RivQuip, 9, 15, 109–121, 218, 219
*Rivtow Captain Bob*, 144
*Rivtow Carrier*, 75, 103
*Rivtow Hercules*, 144
*Rivtow Lion*, 76, 79, 100, 207
*Rivtow Norseman*, **98**, 101, 103, 105
*Rivtow Viking*, 76
Rogers, Stephen, 149, **151**, 155
Rogers, Mrs. Stephen, **151**
Ross Dam and Reservoir, 37, 38–39, 41, 43
Royal Bank, 107, 186, 201, 220
Royal Marine Insurance, 177
Royal Trust Company, 181
Royston, Ronald W. (Ron), 238, 240, 260
Ruhl, Mary, **207**
Rumble, John, 113–115, 117, 120

St. John Ambulance, 10, 11, 15, 205, 222, 223, 238–257, 259, 262, 263, 264, 266, 267
Sally Shops, 31–34, 36
Sanderson, Peter, 177
Saul, John Ralston, 235
Science World, 158, 236
Seaspan, 104
Seattle, City of, 38–39, 43, 160
Seaview High School, 26
Sechelt Inlet, 86, 109
Sectoral Advisory Group on International Trade (SAGIT), 197
"Shorty," 122–123, 135, 227

Silver Skagit Logging, 36, 39–44
Simpson, "Simmy," 72–73
Simpsons–Sears, 52
Smit Internationale N.V., 203
Sood, Vin, 115
*Spirit of British Columbia*, 215
*Spirit of Vancouver*, 215
Star of Fortune Gaming, 259–260
Star Shipyards, 48

Stay 'n Save Motor Inns, 248
Stewart, Anne M., Q.C., 106, **207**, 224, 226, 238, 241
Stewart, Chick and Marilyn, 260
Storrow, Marvin, 134–136, 141
*Straits Logger*, 103
Straits Towing, 9, 68–69, 99–100, 102–104, 107, 108, 110, 122 *see also* Rivtow Straits
Sumner, Mr., 116, 120
Sykes, Joyce, 30–31

*Tenacity*, 76, 100
Terex, 111, 114
Terminal City Club, 36, 97
Terwiel, Dr. Marco, 241, 255
Topper Floats, 120–121
*Toronto Star*, 235
Towers Towing, 56, 92
Transport Canada, 160, 188, 193–194, 195
Transwest Group, 120
Ts'kw'aylaxw First Nation, 90
"Two Beers," 122

University of British Columbia (UBC), 60–61, 167, 193, 216, **233**, 236–237, 264
University of Toronto, 80

Vancity Credit Union, 53
Vancouver Airport Authority, 10, 187–193, 227, 266
Vancouver Airport Services (YVRAS), 194–195
Vancouver Board of Trade, 183, 188, 197
Vancouver, City of, 152, 160, 188, 249
Vancouver Club, 119
Vancouver Foundation, 251, 254–255
Vancouver Hotel (Hotel Vancouver), 118
Vancouver International Airport (YVR), 10, 182–195, 197, 205, 227, 266–267
Vancouver Maritime Museum, 10, 15
Vancouver Merchants' Exchange, 66
Vancouver Pipe and Engine Works, 77–78
Vancouver Stock Exchange, 108

*Vancouver Sun*, 61, 114, 117, 140, 196–197
Vancouver Tugboat Company, 104
Vander Zalm, Premier Bill, 163, 188
Van Dusen, Wesley, 79
Vernon, Sid, 97
Versatile Shipyards, 211
Vertesi, Dr. Les, 267

Wabco, 115–116, 118, 120
Wager, Linda, 199
Wakabayashi, Henry, 188–190
Walker, Chuck, 231
Wallace, Lawrie, 153–154
*Wayfarer*, 44
Weiler, Carolyn, **207**
West Coast Salvage, 109, 159, 174
West Coast Transmission, 148
Westar Mining, 117–119, 180–181, 182, 197, 218, 222
Western Air Command, 41
Western Business Women's Association, 227
Western Machine Works, 97
Western Tractor, 9, 110
Western Wholesale Drugs, 60, 70
White Rock Tug Company, 40
Whitworth Ranch, 39
Whonnock Timber, 83–84
Wilson, Leonard, 56
Wilson, Mark, 148
Wilson, Ron, 56
Winnifred's Chocolates, 18
Winram, 99–100
Wintemute, Errol, 260
Woodward's, 23, 31
Workers' Compensation Board (WCB), 239, 245
World War I, 17–18, 56
World War II, 28, 31, 34, 38, 59, 75–76
Wyatt Insurance Brokers, 181

Yarrows, 75, 100–101, 212
Young, Bob, 36, 39
YVR *see* Vancouver International Airport
YWCA, 15, 166